CREATIVE PHOTO
PRINTMAKING

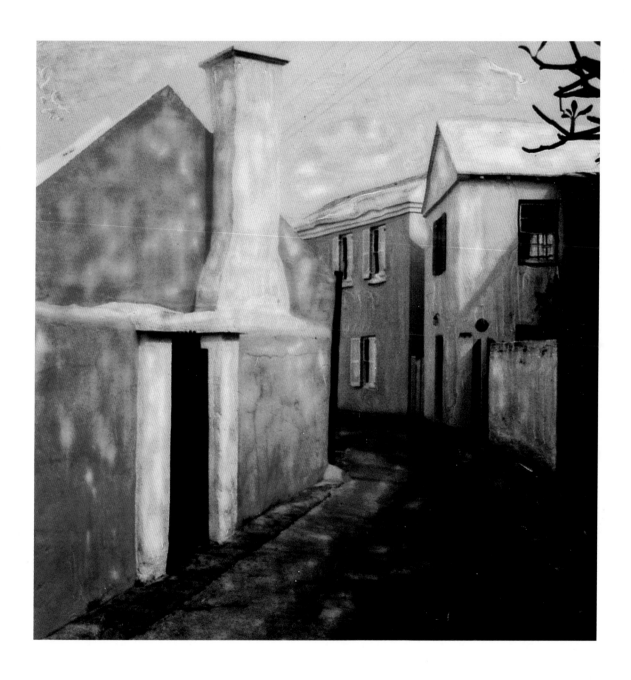

CREATIVE PHOTO

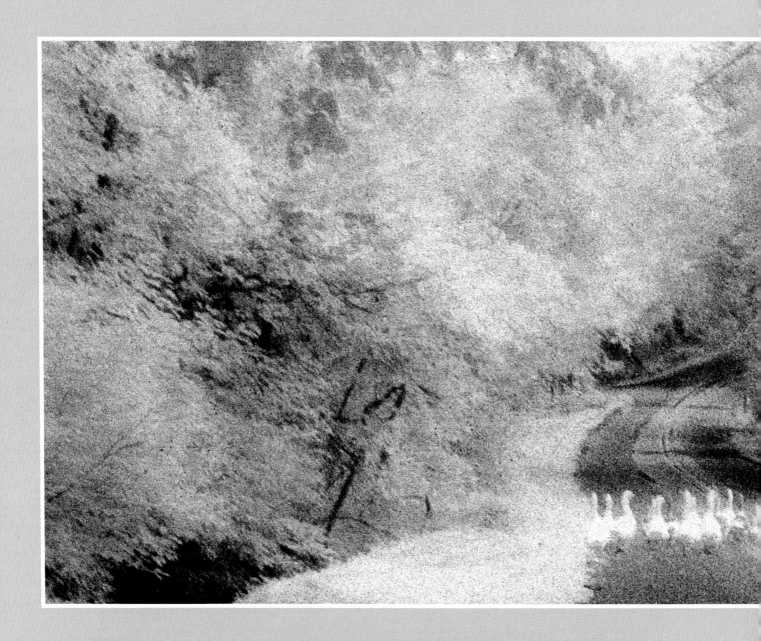

Alternative Techniques Including Infrared, Handcoloring, Selective Bleaching and Toning, Polaroid Image and Emulsion Transfers, Manipulating Time-Zero Film, Printing from Slides, Liquid Emulsions, Photocopy Transfers, Solarization, Copystand Work, Printing on Artist Papers, Wood, and Glass

PRINTMAKING

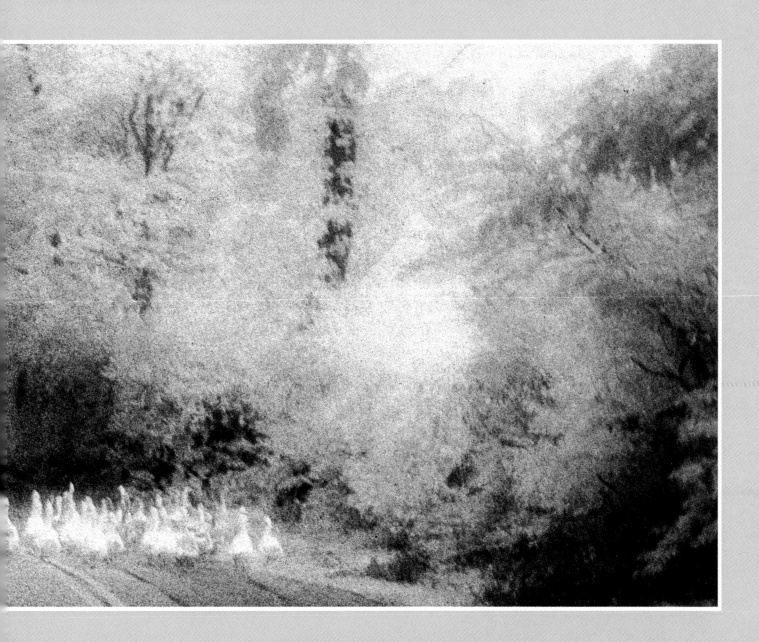

Theresa Airey

Amphoto Books

An imprint of Watson-Guptill Publications/New York

Thank you, Amphoto Books.
A special thank you to Robin Simmen, Senior Editor, for her encouragement and her belief in my work and her time, always so generously and selflessly given. A debt of gratitude to Liz Harvey, Editor, for her skills and patience in reorganizing and editing this text making it a clear, precise, working guide that will (hopefully) be a pleasure to use. These very talented businesswomen have made my first book-publishing experience a wonderful and enjoyable memory.

Theresa Airey holds an MFA in photography and fine art. She exhibits and teaches in the United States and abroad, and conducts workshops for Polaroid. Her work has been published in *Petersen's Photographic, Camera, Darkroom Techniques,* and *Darkroom and Creative Camera Techniques.* She lives in Monkton, Maryland.

Senior Editor: Robin Simmen
Designer: Areta Buk
Graphic Production: Ellen Greene

Picture information:
Half-title page: "Aunt Nell's Alley, St. George, Bermuda," manipulated Time-Zero print
Title page: "Sunday Stroll," infrared image handcolored with oil pencils
Dedication page: "Leaves in Ice," infrared image handcolored with oil pencils
Contents page: "Nun Walking by Santa Maria Novella, Florence, Italy," manipulated Time-Zero print

Copyright © 1996 by Theresa Airey
First published 1996 in New York by Amphoto Books,
an imprint of Watson-Guptill Publications,
a division of BPI Communications,
1515 Broadway, New York, NY 10036

Library of Congress Cataloging in Publication Data

Airey, Theresa.
　　Creative photo printmaking / Theresa Airey.
　　　　p.　cm.
　　"Amphoto books."
　　"Alternative techniques including infrared, handcoloring, selective bleaching and toning, polaroid image and emulsion transfers, manipulating time-zero film, printing from slides, liquid emulsions, photocopy transfers, solarization, copystand work, printing on artist papers, wood, and glass."
　　Includes index.
　　ISBN 0-8174-3725-8
　　1. Photography—Printing processes. 2. Color photography--Printing processes. 3. Photography—Processing. 4. Infrared photography.　I. Title.
　TR330.A36　1996
　771'.44—dc20　　　　　　　　　　　　　96-23298
　　　　　　　　　　　　　　　　　　　　　　CIP

Manufactured in Singapore

2 3 4 5 6 7 8 9 / 04 03 02 01 00 99 98 97

To my "Number One Fan Club," my family

For my husband, Don, my ACE #1 mat cutter, who has always believed in me and loved me for who I am. Thank you for encouraging me to follow my heart.

Special recognition for Lisa Airey, who worked so hard with me on this book. Thank you for turning my feeble attempts at writing into pure prose. I am deeply indebted to you for your boundless energy and writing skills, and I am very proud to have you as my daughter and my best friend.

I love all of you . . . "bigger than the universe."

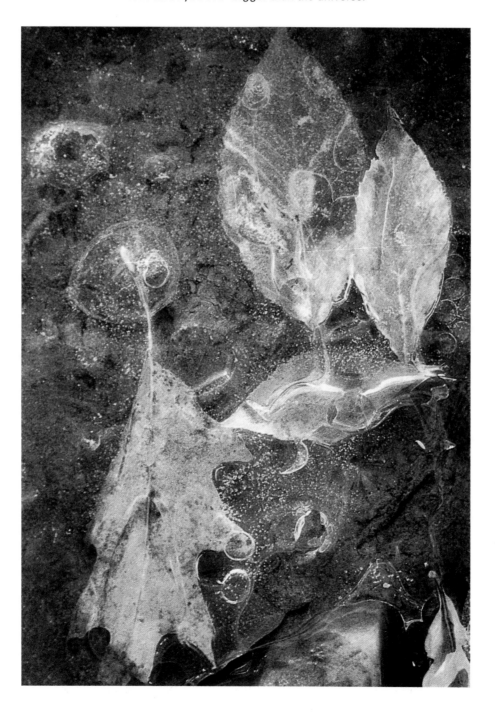

CONTENTS

PREFACE

It has often been said that life is a journey, not a destination. Over the course of my professional life, I've come to view photography, my craft, in the same vein. I took Photography 101 as an elective in college while working toward a degree in fine arts. I was 38 years old at the time. Although, at first, I bemoaned the fact that I'd discovered my artistic medium so late in life—staring into the mirror of my images, the photographic print—I saw the richness and depth given me by all my past experiences as wife and mother, chief bottle washer and cook.

I let life inspire me. Photography became my discipline, my art form, and my passion. In it, I saw an opportunity to merge the world of image-making and painting. Just as photography became a pivotal point in my private life, the negative became the pivotal point in my photographic career. The darkroom was transformed into a place of magic. Like the witches of Shakespeare's *Macbeth*, I mixed my chemistry with "toil and trouble" working to find the best processes to translate a body of work, to enhance a group of images, and to instill a certain mood or feeling in the finished print.

I'm eternally indebted to the creative energies engendered by the photographic workshops taught all over this country. They've never failed to show me a new path on my photographic sojourn. And I wish to thank all my silver heroes and heroines who instilled the spirit of adventure and exploration within me: Ansel Adams, John Sexton, Henry Gilpin, Jerry Uelsmann, Ruth Bernhard, Al Weber, Craig Law, Dick Arentz, Todd Walker and Edna Bullock, Josh Fendell of the Maryland Institute, College of Art/Essex Community College, Jerry Stephany of the University of Maryland/Baltimore Campus, and Haig Janian of Towson State University. They've all encouraged me, taught me, guided me, and inspired me over the years. I am richer for having been witness to their art, both as human beings and as photographers.

I hope that this book, in some small way, sheds light on a few techniques that you can put to the test and incorporate into your own craft.

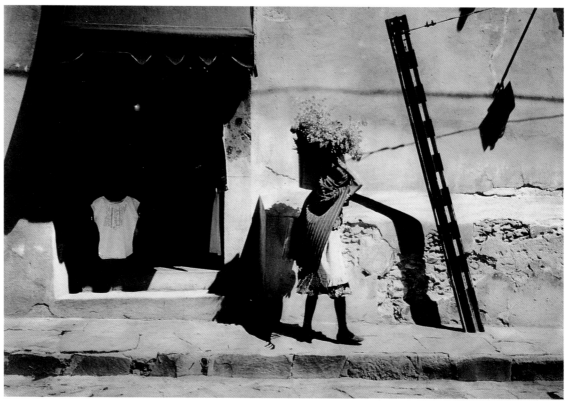

After printing "Mexican Lady Carrying Flowers" on Ilford Multicontrast, Mat Surface paper, I handcolored the image with Conté pastel pencils. I then protected the print with a glossy spray.

INTRODUCTION

Although I've been involved with photography for the last 15 years, it still thrills me to pull a good print, and I still get excited handcoloring an image. In the beginning with my first steps, I learned the concepts and the basics needed for controlling the exposure and making black-and-white prints with a full tonal range. With my eyes well adjusted to the viewfinder and darkroom, I truly saw "the light."

Photography is, after all, just that: captured light. I learned to manipulate it, paint with it, give it texture, conjure up a mood, and convey my feelings about the subject matter. I began to change more than just the paper when translating a negative. The negative became merely a point of departure for my work. Through many creative and manipulative techniques, I realized that I could bend reality or create a new one altogether.

The darkroom became a place of creative experimentation. With bleachers and toners and transfers, as well as all kinds of handcoloring mediums, I discovered that I could make images that are more . . . more than simply a representation of a subject—something magical and in some cases spiritual.

I firmly believe that photographers should change more than the subject when producing a different body of work. I also believe that the camera doesn't have to be the sole dictator of self-expression. The darkroom is an equal partner in the creation of a photographer's art.

Creative Photo Printmaking is the result of my concerted effort in both work and play. This book isn't only a how-to manual with regard to creative processes and manipulative techniques, but also a source of playful inspiration. I hope that it emboldens you as a photographer to push your own limits, to take risks, to release the artist within, and to capture the light.

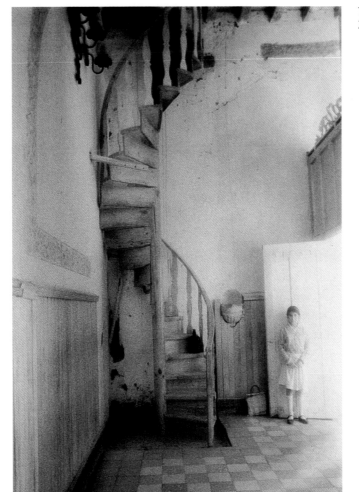

To enhance this image of a girl in a church in Zirahuen, Mexico, I handcolored the print.

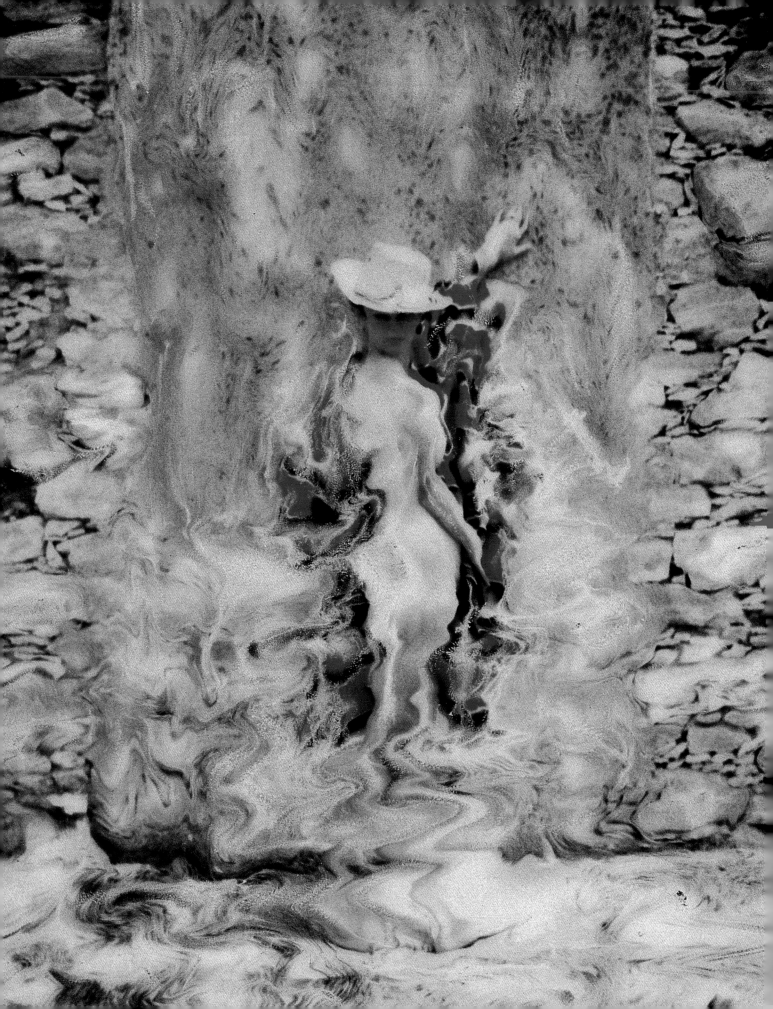

Manipulating Polaroids

Polaroid, through Time-Zero film, has given busy photographers a source of instant gratification. Results come in minutes, and the feedback is immediate. For creative photographers, however, the end result doesn't have to be the end result. Now you can have your shot and manipulate it, too.

Time-Zero film is perfect for both novices and professionals because if at first you don't succeed, you can, literally, try and try again while you're photographing on location. Furthermore, the Polaroid is a finished product, and this appeals to everyone. You don't have to worry about airport X-ray machines or the tedious tasks of processing film or making prints.

By moving the emulsion on a Time-Zero print, you can infuse the image with your response to the subject, creating a specific mood or conveying what you feel. In many ways, you literally become a part of the image, and the photographic image becomes painterly. The mediums of photography and painting truly blur here, like colors that blend on an artist's palette; reality and perception become one and the same.

While manipulating this Time-Zero image, I decided to make the woman standing near a stone wall look surreal.

TIME-ZERO FILM

Polaroid's Time-Zero film is the only instant film that can be manipulated to this extent and that gives you a comfortable margin of time in which to work or manipulate the print. The emulsion takes about 10 to 12 hours to permanently set or harden. The colors can be beautifully saturated and vivid or light and impressionistic according to how you choose to regulate the light-to-dark exposure dial on the camera. The other Polaroid instant films take only a matter of minutes for the emulsions to harden, thereby making it impossible to manipulate the image.

If you are interested in true-to-life colors, buy fresh film. If you're going to manipulate the film and recopy it for enlarging and handcoloring, you can buy outdated film, which is inexpensive. Don't, however, buy outdated film if it is more than four months old. Outdated film is also good for practicing or learning. You'll usually go through one pack of 10 sheets just getting a feel for the technique.

Modifying Cameras to Accept Time-Zero Film

You can expose Time-Zero film in several Polaroid cameras. The SX-70 is the most popular model because of its compactness; it folds down. Other cameras that use Time-Zero film are the Pronto, OneStep series, Encore, Presto, Super Clincher, and Button cameras, as well as Models 1000-5000. You can also modify the 600 Series cameras, like the OneStep Closeup camera, to accept Time-Zero film (see below).

Most of these Polaroid cameras come with an exposure-compensation dial, which regulates how light or dark the print will be. Some of the cameras come with built-in flash, while others, including the SX-70, accept blue-dot flash bulbs. Keep in mind, though, that these flash bulbs are no longer being manufactured. Fortunately, there is also a flash attachment for the SX-70. You can find old equipment at flea markets and in the used-equipment sections of photography stores. Generally, if you ask your older relatives, someone will remember a piece of outmoded equipment that has been in the closet for the last 15 years!

Modifying 600 Series Cameras

You can easily modify the 600 Series cameras to accept Time-Zero film. The OneStep Closeup camera isn't as compact as the SX-70 model. It is, however, inexpensive and has the extra features of a built-in flash and a micro lens.

In order to be able to insert Time-Zero film into a 600 Series camera, you must place a piece of thin cardboard into the film chamber. The first ejected, blue "dark slide" from a spent Time-Zero film pack or even a piece of exposed Time-Zero film itself will work. When the cardboard flattens, it serves to cover a metal tongue on the mechanism that prevents the Time-Zero film pack from going in.

With your thumb and finger holding the cardboard halfway into the film chamber, put the Time-Zero film pack on top of the cardboard. Then simply slide the pack into the chamber. When the film pack is in place, pull out the thin cardboard you're holding with your thumb. Next, close up the front. Once the blue dark-slide cardboard is ejected, the new Time-Zero film pack is ready for exposure.

If you intend to expose only Time-Zero film in this camera, take a pair of needlenose pliers and pull out the mechanism on the bottom of the interior of the film chamber. It will slide out easily. In addition, in the future you won't encounter any obstructions when loading a Time-Zero pack directly into the camera. Removing the mechanism is easy and won't damage the camera. However, if you want to expose 600 Series film, you must reinsert this piece into the camera. Since the 600 Series film that is ordinarily used in the OneStep Closeup camera has an ISO rating of 640 and Time-Zero film has an ISO rating of 150, you have to modify the exposure meter.

Buy a 3-inch-square Wratten #96 gelatin filter with a density of one. You can cut it up into about 15 pieces that will fit over the meter window, which is located under the viewfinder window on the right side of the camera front. Since you'll need only one piece, try to find a few other photographers who may also be interested in this process and split the cost of the filter. A Wratten filter will last indefinitely if you don't scratch or otherwise damage it.

A simple way to cut the filter is to first lay it on the tip of a piece of paper that shows a grid of the meter's dimensions and then use scissors to cut through both the gelatin and the paper. Don't try cutting with an X-Acto knife because the gelatin is brittle and will chip. Make sure that the piece of filter is slightly larger than the grid because you must be able to tape the edges over the meter window. Next, tape the piece of filter over the exposure meter on the front of your camera.

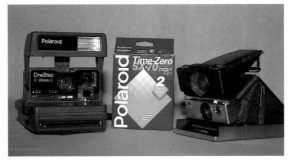

1. Here you see both a Polaroid OneStep Closeup camera (left) and a Polaroid SX-70 camera (right) in the open position. A two-pack box of Polaroid Time-Zero SX-70 film separates the cameras.

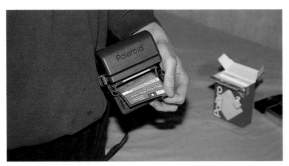

2. To modify the OneStep camera so that it accepts Time-Zero film, first insert a piece of thin cardboard into the film chamber. This will hold down the mechanism that prevents the Time-Zero film pack from entering.

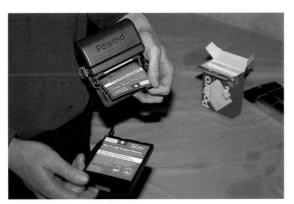

3. Next, insert the Time-Zero film pack over the blue cardboard.

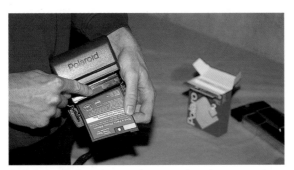

4. Pull the cardboard out at the same time that you push the Time-Zero film pack in.

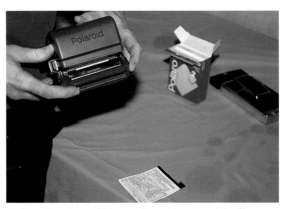

5. Once the piece of blue cardboard is out and the film pack is in, close the camera.

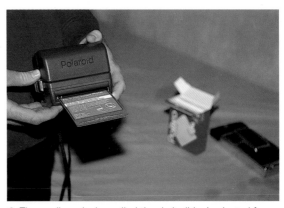

6. The cardboard, also called the dark slide, is ejected from the Time-Zero film pack. The film is now ready to be exposed.

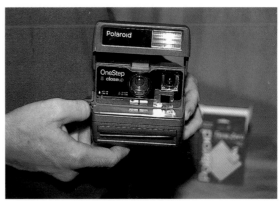

7. With the camera open, you are ready to shoot the Time-Zero film. Note the neutral-density filter, held in place with silver tape, over the meter on the front of the camera.

Warming Time-Zero Film

Traveling often presents a bevy of problems for photographers, and traveling with the goal of manipulating Polaroids is no exception. Temperature, unsavory locations, and time constraints all come into play. When pressed, carry a box to hold and collect your exposed film for later manipulation and remember to warm the film before manipulating it. You can use light bulbs, radiators, coffee-pot warmers, hair dryers, disposable hand warmers, travel irons, and heating pads to warm the emulsion and make it pliable.

Be careful when warming Time-Zero film with light bulbs. Direct contact or even extremely close contact will blister and crack the plastic coating. Don't attempt to microwave the film. It will catch on fire and melt, as well as fill the room with an unpleasant odor.

It is essential that Time-Zero film is warm before and after exposure in order for you to successfully manipulate the photographs and to achieve optimal color. Cold film will produce blue images, and the emulsion will be difficult to move. On cool days, place your camera and film in the sun or on the dashboard of your car. Also, put disposable hand warmers in your insulated camera bag; if you don't have one, you can use an insulated lunch bag or a six-pack beverage holder. Just make sure that the warming devices come into contact with the packages of film.

When the weather is brisk or in the early morning, place a disposable hand warmer in a jacket pocket so that you can stash the exposed film there next to the heat. In lieu of this, there is always your body heat. Place the exposed film inside your shirt, next to your skin. Again, this is critical for good color development.

If the weather or shooting conditions aren't conducive to manipulating the image on the spot, save it and manipulate it in another locale. You have about six hours before the emulsion begins to harden and another six before the emulsion is permanently set. You can, however, delay this setting time by freezing the exposed film. Exposed Time-Zero images can be frozen for up to two weeks, then thawed and reworked or manipulated. Be aware, though, that you can't freeze unexposed Time-Zero film. You can keep it in the refrigerator, but not the freezer.

Take the exposed Time-Zero prints out of the freezer one at a time. Warm them up under a light or on a heating pad, and begin to manipulate them immediately. Frozen Time-Zero prints set within the hour after defrosting and aren't as pliable as those manipulated within six hours of exposure. Nevertheless, sometimes circumstance necessitates manipulating your prints at a later date, and this is the best alternative.

Working with Time-Zero Film

Of course, the best and easiest time to manipulate a Time-Zero image is immediately after it has been exposed. You can do this with your fingernail, a burnisher, a wooden sculpting tool, a golf tee, the tip of a key, a pen with no ink, a dental instrument, orange cuticle sticks, the tip of an old paintbrush—just about anything that doesn't have a sharp point will work.

When you begin to manipulate the print, go slowly and push the emulsion gently. Although you're working on the front of the film, the tough plastic coating is hard to scratch. Be careful, however, not to push the emulsion too far and make white marks in the dark areas (this is the titanium-dioxide undercoating showing through). Also, you want to avoid making black tool marks in the light areas (a result of displacing too much pigment). Remember, if the film is warm, the emulsion is readily moved, so the marks are easy to avoid.

Although the black marks are erasable, getting rid of them takes a little work. Visualize a black mark as a crevice. Simply push the emulsion all around the crevice into it in order to fill it up. And remember this caveat: If at first you don't succeed, try, try again.

You'll obtain different effects and colors depending upon when you begin the manipulating process after the image appears. Mastering this just takes doing it and seeing the various results for yourself. Make use of the exposure-compensation dial on your camera to give you a lighter or darker print. Light colors, which are easily moved and manipulated, give a great impressionistic look.

Dark colors, especially green, are hard to move and more susceptible to tool marks. Generally I leave them alone or deliberately draw in them. You can create pseudo-information in blocked-up areas just by scribbling and making white marks. A final note: Manipulating people's faces without creating monsters is difficult. Because facial features on a 3 × 3-inch format are so small, it is quite hard to alter them without misshaping a subject's face.

You need some basic tools in order to manipulate Time-Zero film, such as a stylus, a burnisher, a wooden sculpting tool, a golf tee, a dentist's tool, toothpicks, and a paper clip.

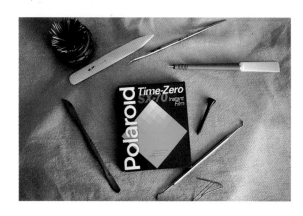

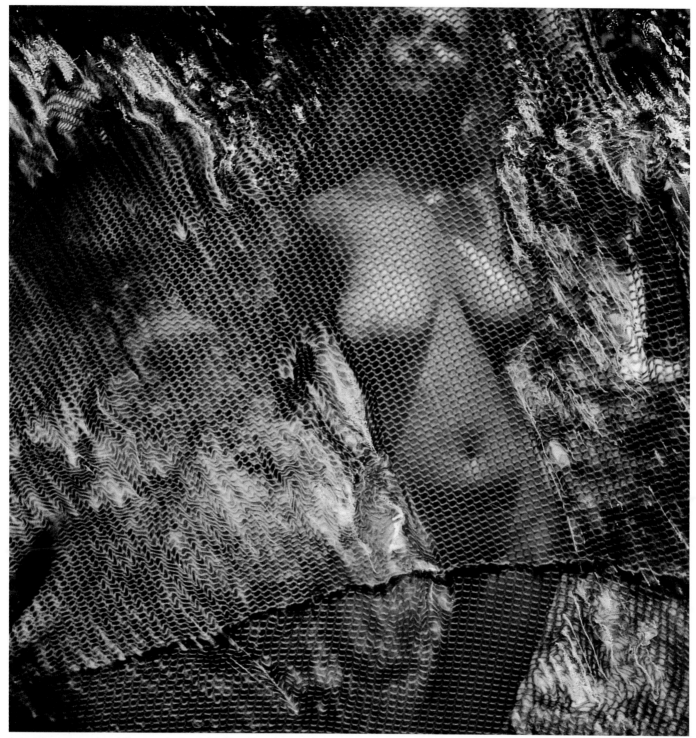

I shot through a net and then manipulated this Time-Zero image of a nude.

WORKING WITH MANIPULATED POLAROIDS

A manipulated Polaroid can be a starting point for other creative photographic mediums. By making slides from the original Time-Zero print, you can either make image and emulsion transfers or have Ilfochrome or Iris prints made. Ilfochrome prints, which have replaced Cibachrome prints, are known for their brilliant, saturated colors; they have excellent dye stability. Iris prints are made from a digital scan made from a slide, negative, or photograph, and can be printed onto fine artist papers or glossy stock. This electronic method for making prints from a digital file is the state of the art as far as printmaking is concerned.

Of course, it isn't necessary to have a slide of the Time-Zero image made for the purpose of scanning. It is possible to have a flatbed scan done from the original Time-Zero print. Here, a scan is taken from a hard copy of an image, such as a photograph or drawing. You lay the hard copy on the glass surface of a scanner that looks like a photocopier. The machine then converts the image into a digital file for the computer. By making negatives from the original Time-Zero print, you can enlarge and print the image on any photographic paper and then bleach and tone or handcolor as desired.

Keep in mind that since the manipulated Polaroids are originals and have no negatives, there are no backups if they're lost or damaged. Even if you want to go no further than the original piece of manipulated photographic art itself, it is a good idea to make a slide or negative of the original image as both a safeguard and a precaution. This also ensures against loss before you send originals out in order to have color copies made. Once an original is gone, it is gone forever.

Although it is helpful to have a copystand when making negatives or slides, it isn't essential. Find a spot where the illumination is even, where there are no shadows from windowpanes, for example. Set up for copying. Put the camera on "automatic," and meter the available light with an 18-percent gray card, and use the indicated aperture and shutter-speed settings throughout the copying process—as long as the light remains the same. If you're copying in natural light, an overcast day is better than a bright one. The light will be more diffused, and the chance for glare and reflections will be less.

When metering the gray card, be sure not to cast your shadow onto the area on which you're working. Taking a gray-card meter reading is performed the same way whether you're using a copystand with photofloods or natural light. Lay down a gray card, set your camera on "automatic," fill the lens with the gray card, and read the combination of aperture and shutter speed that the camera indicates for that available light. Use a large aperture, such as $f/4$. Depth of field isn't an issue because this is flat work.

Use a macro lens, and fill as much of the frame as possible with the image. Again, watch out for shadows and any light reflecting off the plastic coating on the Time-Zero surface. This is where a copystand comes in handy. By lifting the arms with the photoflood light bulbs, you eliminate glare. In addition, the light is constant with a copystand; you don't have to be concerned about the shifting patterns of a cloud cover.

Making Black-and-White Negatives from Time-Zero Prints

Take a gray-card meter reading. Next, manually adjust your camera's shutter speed and aperture to the setting the gray-card reading dictates. Once again, you can keep it there for the entire shoot as long as the available light doesn't change. This isn't a factor when you work on a copystand.

Because heavily saturated color prints have a dark tonality, they sometimes require two or three exposures to ensure that all the information is recorded in the negative. Expose the first frame according to the gray-card reading; when you expose the second frame, open up one stop. For example, if the gray-card meter reading dictates $f/4$ for 1/30 sec., you'll expose the first frame using this combination. You would then expose the second frame at $f/4$ for 1/15 sec. This additional stop will give the exposure more time to record all the information in the print. And for the third exposure, you would open up two stops, so the third frame would be $f/4$ at 1/8 sec.

Using a copystand and photoflood light bulbs when shooting a slide of an original Time-Zero print is a practical idea. The resulting illumination is constant, and glare doesn't pose a problem.

Although I liked the look of this original manipulated Time-Zero print, I decided to alter the image even more.

So I made a black-and-white print on Agfa's Portriga Rapid #118 paper, shot from a black-and-white negative of the original manipulated Time-Zero print.

Next, I handcolored the black-and-white print with Marshall oil pencils.

When you expose your first roll, it is a good idea to bracket. Expose one frame at the gray-card meter reading (normal), open up one stop for the second frame (+1), and close down one stop for the third frame (-1). Here, the normal exposure is $f/4$ for 1/30 sec. When you open up one stop, the exposure is $f/4$ for 1/15 sec. When you close down one stop, the exposure is $f/4$ for 1/60 sec. By doing this procedure, you'll be able to readily see how the exposure is altered when you look at the processed negatives on the light table.

Light-toned images or images lacking in color saturation or tonality also require two or more exposures to guarantee that all the information is recorded and that the negative has good density. Expose the first frame according to the gray-card meter reading, and then bracket the second and third frames, opening up and closing down one stop, respectively.

When making black-and-white negatives from Time-Zero prints, I prefer using Kodak T-Max 100 black-and-white film. I set the ISO dial on 100 and later develop the negatives in T-Max RS developer 1:9 at 75 degrees for 9 1/2 minutes. However, any fine-grain film and its developer will do. Choose a film and developer that you are familiar with and have confidence in.

Making Color Slides from Time-Zero Prints

The first step in this process is to meter the light using your gray card. Then manually set the aperture and shutter speed accordingly. I find that Kodachrome 64 slide film works quite well here when adjusted to ISO 80, used on the copystand with BCA #1 bulbs, and processed normally. When used in conjunction with these blue bulbs, which are referred to as daylight bulbs, the copystand gives much better results than it does in natural light.

If the original Time-Zero print is dark in tonality, expose one frame at the gray card's indicated setting. Then do a second frame at one stop over. This will give the exposure more light, thereby making the slide lighter and more able to record all the dark information. This is color-positive film and is the opposite of black-and-white negative film.

Suppose, for example, you expose the first frame of the dark print at the indicated gray-card reading, $f/5.6$ for 1/15 sec. For the second frame, you would open up one stop in order to increase the length of the exposure, adjusting the shutter-speed setting to 1/8 sec. and leaving the aperture as it is, at $f/5.6$. Remember, when making color slides, more light produces a lighter slide.

Conversely, if the original Time-Zero print is light in color or tonality, expose your first frame at the gray-card meter reading and the second at one stop under (-1 stop, or less time). The shorter exposure time will make the slide darker and saturate its color more fully. For example, the gray-card reading indicates an exposure of $f/5.6$ for 1/30 sec. After you shoot the first frame at this normal setting, shoot the second frame at one stop under, or $f/5.6$ for 1/60 sec. This exposure time is shorter than 1/30 sec., so the second frame will be darker than the first. When you make color slides, less exposure time results in darker images.

Making Duplicate Color Prints from Time-Zero Prints

Once again, you begin by metering the light via a gray card and then manually setting the aperture and shutter speed accordingly. When you adjust Fuji Reala film's speed, ISO 100, to ISO 64 and shoot it under BCA #1 bulbs, you'll get excellent duplicate color prints.

Another option is to send the original Time-Zero film to Polaroid Copy Service (see the List of Suppliers on page 159) and request color laser copies of your prints. Remember to first make a negative or slide from the original in order to protect against loss. You can order 4×4-inch, 6×6-inch, and 8×8-inch laser prints. Be aware that although the copies are true and sharp, the original image does get cropped. You'll lose approximately 1/4 inch off the bottom and 1/8 inch off each side of the original print.

If you intend to have Polaroid do the copies, keep this in mind when composing your shots. Leave some extra space at the bottom of the frame, and don't put anything important too close to the sides.

PROJECTION PRINTING WITH TIME-ZERO FILM

The cameras that expose Time-Zero film have certain limitations, including a fixed lens, the inability to accommodate filters, and a weak flash, if they have one at all. By projection printing from slides to Time-Zero film, you, literally, get the best of both worlds. You can expose slide film in your 35mm camera using your selection of lenses, filters, flash units, and various attachments and easily achieve the composition and perspective most desired. You can then take that image, and through projection printing, transfer it to Time-Zero film for manipulation. Projection printing also gives you a great reason to dig out old slides and put them to good use. Working from your library of images, you can revisit memories and give them a new look or feel. This is fun and easy to do.

You'll need either a black-and-white or color enlarger and a camera that accepts Time-Zero film. You can use a black-and-white condenser enlarger to project a slide onto Time-Zero film. If necessary, you can add color through the use of filters. You can also use a cold light enlarger, but you'll need a 20CC yellow filter to balance the blue light for color printing.

You can opt for a color dichroic head enlarger, which you can use with or without filtration. Make the first exposure without any filtration to see if you want or need any color in the print. The bonus with this type of enlarger is that the color you see on the easel is the color you get in the final print. No guessing is involved.

Because the Polaroid and 35mm film formats are different (square versus rectangular, respectively), you'll have to sacrifice some of the image. You won't lose as much of the square film plane if you print a horizontal rather than a vertical slide.

Make an easel by tracing the outline of a spent Time-Zero film pack in the middle of an 11 × 14 piece of 4-ply mat board. I prefer black. This piece of mat board can be any color—it can even be cardboard—but it should be approximately 4-ply thick. Cut out the outline, and place it on top of another piece of mat board of a different color. I usually use white. Tape the two pieces of mat board together around the edges. You now have an easel in which to insert the film pack under the enlarger. At this point, I sometimes tape the easel in place so that it doesn't accidentally get moved.

Place your slide into the negative carrier. (It isn't necessary to take it out of the slide mount.) Insert the negative carrier into the enlarger. Next, position a spent Time-Zero film pack into the opening in the easel. Always place the film pack into the easel in the same direction. The wide black portion, which is the bottom of the film pack, should always be on either the right or the left. This will ensure that the film square and your image will always be in the proper registration. I prefer to place the wide end of the frame on the left side and the white paper square on the right.

Next, if the film pack doesn't have a white sheet of paper on the square opening where the film used to be, cut out a square of white paper and tape it onto the empty film pack. This will give you a white flat plane on which to compose and focus the image. After you turn on the enlarger, compose the shot, focusing on your white square.

Check the filtration. If you're using a color dichroic head enlarger, zero out all filtration. If you're using a black-and-white condenser enlarger, don't use any filters. Remember, if you're working with a cold light enlarger, you may have to use a 20CC filter under the lens or in the filter slot in order to balance the blue light source.

1. This homemade easel is ideal for holding a Time-Zero film pack during projection printing.

2. The easel fits readily under the enlarger.

PROJECTION PRINTING WITH TIME-ZERO FILM

Close down the aperture to f/22. Set the timer on 5 seconds. This is only a suggested starting point. You may need more or less time according to the density of your slide. Don't be concerned if your print time is 1/2 sec. The length of time required all depends on your light source and your slide. When working with a color dichroic head enlarger without filtration, I typically shoot at f/22 for 1/2 sec. to 1 sec. For you to make black-and-white prints with an average, normal negative, the condenser or cold light enlarger would be f/8 for approximately 10 to 15 seconds.

With your loaded camera in hand, turn off all the lights, including the safelight. With the lights out, take the film pack out of the camera by opening the camera and pulling the blue tab. Then lay the camera down and place the film pack into the easel opening the way in which you focused on it.

Check to make sure that you've adjusted the aperture to f/22. If you don't close down after focusing, too much light will reach the film. As a result, your Time-Zero print will be white, and no image will appear. If everything seems to be fine, make the exposure.

After making the exposure, place the film pack back into the camera's film chamber and close the film chamber door. The camera will then eject the piece of film from the top of the film pack (the one you exposed under the enlarger). You can now turn on the lights and immediately place the ejected piece of film next to a light bulb to give it light and warmth. This will bring up the color. I have a little stand set up next to a 100-watt bulb, at a distance of 3 inches. This arrangement keeps the film far enough away from the bulb so that it doesn't blister, but close enough to the bulb so that the heat and light ensure good color saturation.

The next step is to analyze the print. Ask yourself the following questions: Is the exposure correct? Are you satisfied with the color? Do you need to darken or brighten an area? If your print is light, you'll need less exposure time; if your print is dark, you'll need more exposure time. To lighten an area, you have to give it more light, which is called *burning in.* To darken an area, you have to give it less exposure, which is called *dodging.* Think "BB" (Burn for Bright) and "DD" (Dodge for Dark). Of course, with such short exposure times, burning in and dodging aren't always possible.

When the exposure is correct and you're satisfied with the color, you are ready to manipulate the film. Keep the film warm while you work. Warm up a piece of plain glass, whose edges are taped, by laying it on top of a heating pad. This makes an ideal worktable upon which to manipulate the film.

Polaroids that are exposed through the enlarger aren't as pliable as those exposed in the field, and the colors tend to be different. I miss the excitement of being there and feeling the mood, but in some cases and for some images this is the best alternative.

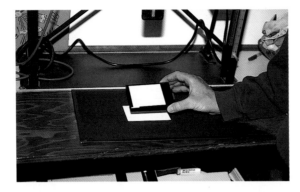

3. I placed a spent Time-Zero film pack into the easel in order to focus on it.

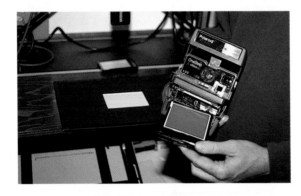

4. I then took a live Time-Zero film pack out of the camera (this should be done in the dark).

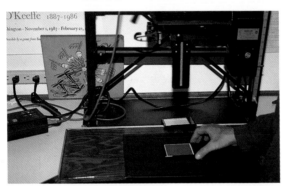

5. Next, I exposed a slide on Time-Zero film under the enlarger (in the dark).

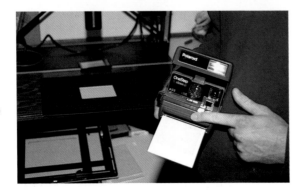

6. After I replaced the film and closed the camera (in the dark), the exposed sheet of film was ejected. You can turn on the lights after the film is back in the camera and the film chamber is closed.

HANDCOLORING TIME-ZERO PRINTS

Manipulating a Time-Zero print whose colors aren't too saturated is easier than manipulating a print with intense colors; however, the finished product often lacks the very thing that drew the photographer to the subject in the first place—color. The manipulation of this image may be outstanding, but the colors, or lack thereof, may leave much to be desired. Since color has such a great emotional impact on viewers, handcoloring the print can pull it all back together.

Adding color to an original Time-Zero print is important if you intend to make color slides or color negatives of the image for later duplication, whether this takes the form of transfers or color prints. You can simply intensify existing pigments or add more colors. You can even alter the existing colors altogether to give your original image a completely new look and feel. The power is literally in the palm of your hand.

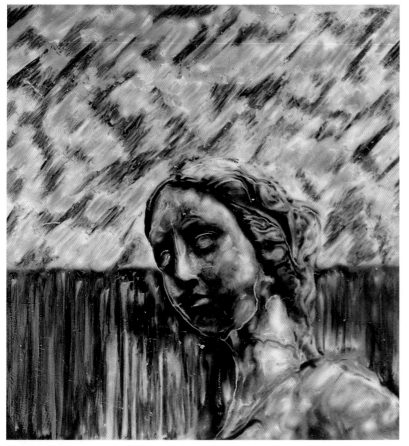

I handcolored this manipulated Time-Zero print with pastels.

Pre-coating the Original Time-Zero Print

Just as you do when working on glossy stock, in most instances you should pre-coat the Time-Zero print before handcoloring it with pencils. This step will make the surface toothy, thereby enabling it to accept and hold coloring. Two good pre-coating agents are Marshall's Pre-Coat and P. M. Solution; the latter is a mixture of linseed oil and turpentine. P. M. Solution takes a little while to dry and leaves the surface of the print a bit tacky. Marshall's Pre-Coat dries almost immediately. Once you've applied the pre-coat, the Time-Zero print will accept Marshall oil pencils, pastel pencils, Prismacolor pencils, and watercolor pencils (see the List of Suppliers on page 159).

When Pre-coating Isn't Necessary

To handcolor Time-Zero prints with oil paint, watercolors, or crayons, no pre-coating is necessary. The surface of Time-Zero prints absorbs color readily and effectively. So the application of a preliminary coating solution is unnecessary. You can immediately apply any handcoloring material you wish: watercolor or oil; oil sticks; or crayon.

Caran D'Ache Neocolor II Aquarelle Crayons

These crayons, which are available in a fine palette of colors, are quite simple to use. You can easily blend or overlay them. If you warm up the Time-Zero print sufficiently first, to the point where it is almost hot, the colors will practically melt onto the print. This will give the image a painterly, encaustic look.

Schwan-Stabilo Crayons

These pencil-like crayons produce an encaustic look, just as Caran D'Ache Neocolor II Aquarelle crayons do. You must use a warm surface to heat up the Time-Zero print. Placing a piece of glass on top of a heating pad provides both a work surface and a heat source. A warming plate also serves well. Although the Schwan-Stabilo crayons are creamy and soft, they are large. This makes them difficult to use on small areas in small prints.

Shiva Oil Sticks

Shiva oil sticks come in beautiful colors and are quite lightfast, which means that they won't fade. You can mix, blend, and overlay them. They seal themselves

HANDCOLORING TIME ZERO PRINTS

naturally, so there are no tubes to clean or open, no drying out, and no mess. Once you scrape off the dry paint "skin" (the self-seal), the oil sticks are ready to use. You can mix a bit of oil paint with turpentine or Turpenoid, which is an odorless turpentine, for a more transparent wash. Other options include dipping a brush in Turpenoid and rub the tip of the stick with the brush in order to pick up the color for a heavier coating, and applying the paint straight from the stick.

The paint will be absorbed into the plastic coating of the Time-Zero print in just a few minutes. So if you don't like the color of the paint, you should remove it immediately with some Turpenoid before it is absorbed. You can achieve an appealing, subtle coloring by applying a heavier coat of paint, waiting a few minutes while it is absorbed into the plastic, and then removing the heavier surface paint.

Here, I'm adding color to both Time-Zero prints and glossy prints with Shiva oil sticks.

Protecting the Handcolored Time-Zero Print

When your handcolored Time-Zero print is finished and dry, spray it with a semi-flat spray. I prefer Krylon Crystal Clear and McDonald Pro-Tecta-Cote Mat Special, made by Sureguard. The Pro-Tecta-Cote is expensive, but it is worth the price because it has a built-in UV inhibitor. This prevents the fading of colored materials by protecting them against damaging UV rays. But as costly as the spray is, purchasing special UV glass for the frame is even more expensive. Furthermore, UV glass tends to be textured and dark, and takes away from the image.

These sprays even out the distinctions between the touched and untouched areas of the colored glossy print. The entire finish will become semi-mat. If you prefer a glossy finish, wait until the finish is dry and then spray it with Krylon Kamar Varnish, for a glossy finish; McDonald Pro-Tecta-Cote Clear, for a high-gloss finish; or McDonald Pro-Tecta-Cote Lustre, for a semi-gloss finish. Blair Art Products carries a good line of sprays, too (see the List of Suppliers on page 159).

Naturally, if you intend to enlarge your manipulated Polaroid onto black-and-white photographic paper and then add color, you don't need to add or adjust the color in the original print. Simply copy the original onto black-and-white negative film, make a print, and handcolor it.

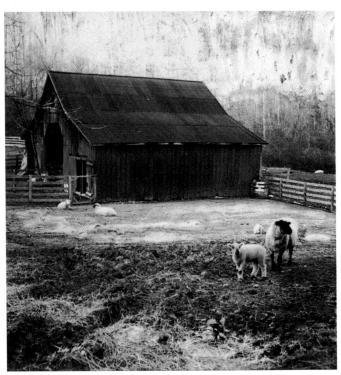
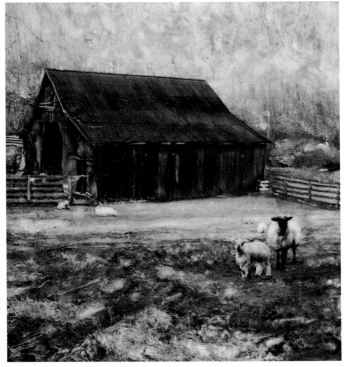

To enhance an original Time-Zero print of a farm scene (left), I manipulated it and added color with Shiva oil sticks (right).

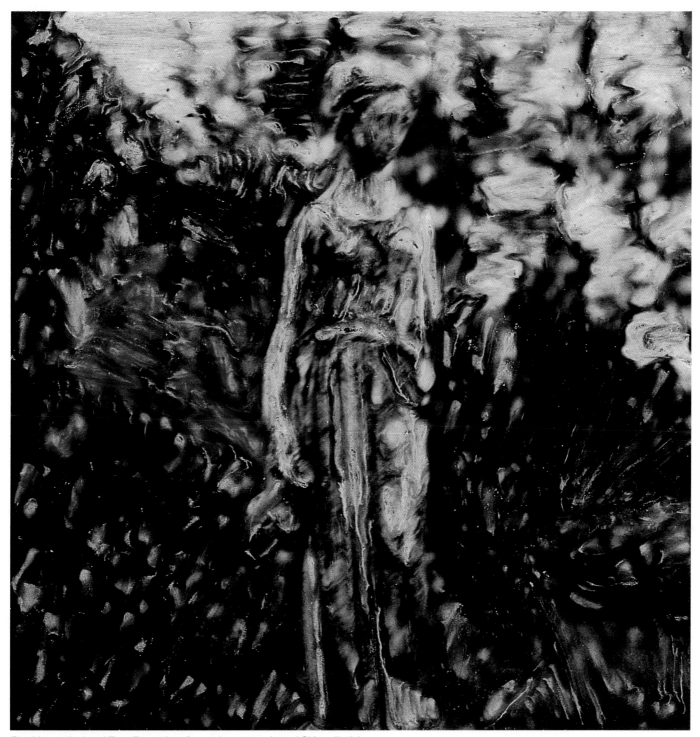

For this manipulated Time-Zero print of a garden statue, I used Shiva oil sticks.

DIGITAL SCANNING

An exciting new way to manipulate Polaroid film is to have it digitally scanned on a flatbed scanner and printed on fine watercolor paper through the advanced technology of an Iris printer. You can adjust the color at three points during the process: on the original Time-Zero print at the start, on the computer after the original Time-Zero is scanned, and on the finished Iris print at the end.

With digital scanning, the original image is enlarged and can be printed on textured, nonglossy artist paper. The Iris print on artist papers, therefore, has a different feel than the original, and it won't suit every image. Moreover, heavy manipulation of the original Time-Zero print tends to be emphasized on a larger scale with this process. As such, you must carefully select images so the technique doesn't dwarf them.

This is a manipulated original Time-Zero print of trees in Ladew Garden, Maryland.

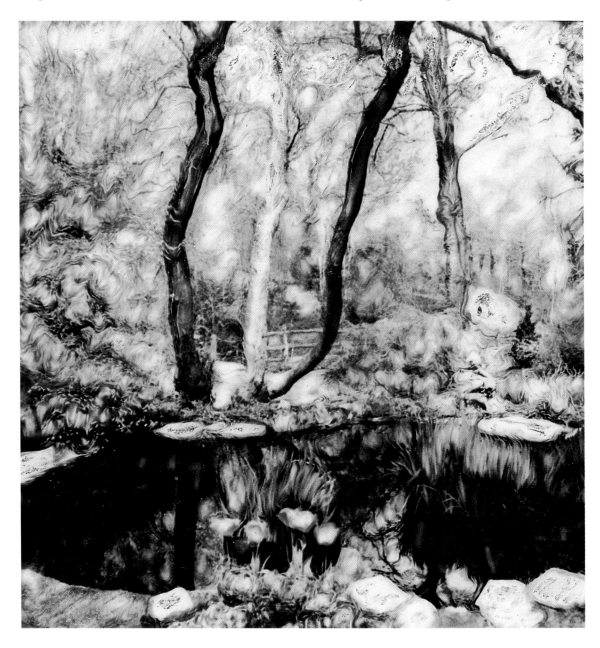

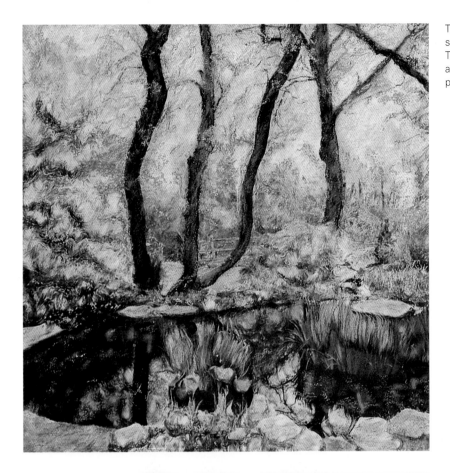

This 20 x 20-inch Iris print was scanned from the manipulated Time-Zero print of the trees and reworked with warm-tone pastels.

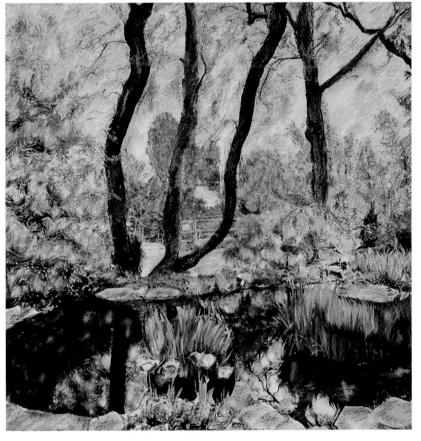

I experimented with the tree image (shown on opposite page) another time. For this 20 x 20-inch Iris print, I used cool pastels.

CREATING NEW IMAGES FROM THROWAWAYS

By manipulating Time-Zero film, you'll accumulate prints that aren't perfect. These throwaways might have little color, be out of focus, or be just too abstract to visually hold up on their own. You should keep these imperfect prints in a box and use them to create new images later on.

When you are ready to work, choose a throwaway that appeals to you on some level. Then cut around the sides of the square image and peel the plastic front away from the black backing. You now have an image on plastic. At this point it is opaque because of the titanium-dioxide undercoating, which consists of a white powder.

Next, put on a pair of gloves; the alkaline substance can dry out your skin or even burn it. Then place the plastic image in hot water and with a soft cotton ball, wipe off the white powder. You now have an image on a transparent piece of plastic.

You can easily remove selected parts of an image by rubbing or scratching the information off the plastic. This will give you a clear area through which a second image can be seen if one is laid on top of another. You can take this transparent piece of plastic with the image removed in chosen areas, and lay it upon another Time-Zero print, a magazine picture, a drawing, a painting, or a textured piece of material. This will make a sandwich of two different images, thereby integrating them.

Lay the transparency on top of another image, either another Time-Zero print or just about anything at all. Rephotograph the new sandwiched image with negative or slide film, and go from there—prints, transfers—the sky's the limit. A warning: After doing a few and getting the feel for this process, you'll be addicted to it for the rest of your life.

Making a new image from two sandwiched prints involves a few steps. First, I peeled apart a Time-Zero print and washed the acrylic backing with warm water to produce a transparency. I then selectively scratched off part of the image to create a blank area in the transparency.

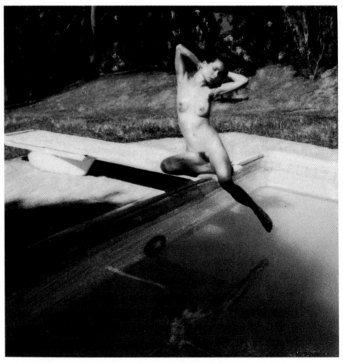

I wanted to merge the shot of the garden with this manipulated Time-Zero print of a nude woman.

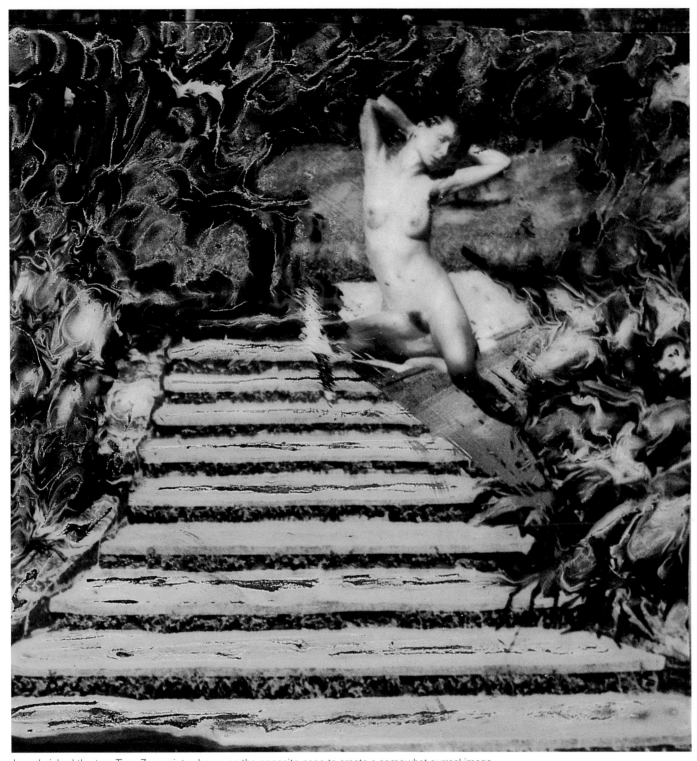

I sandwiched the two Time-Zero prints shown on the opposite page to create a somewhat surreal image.

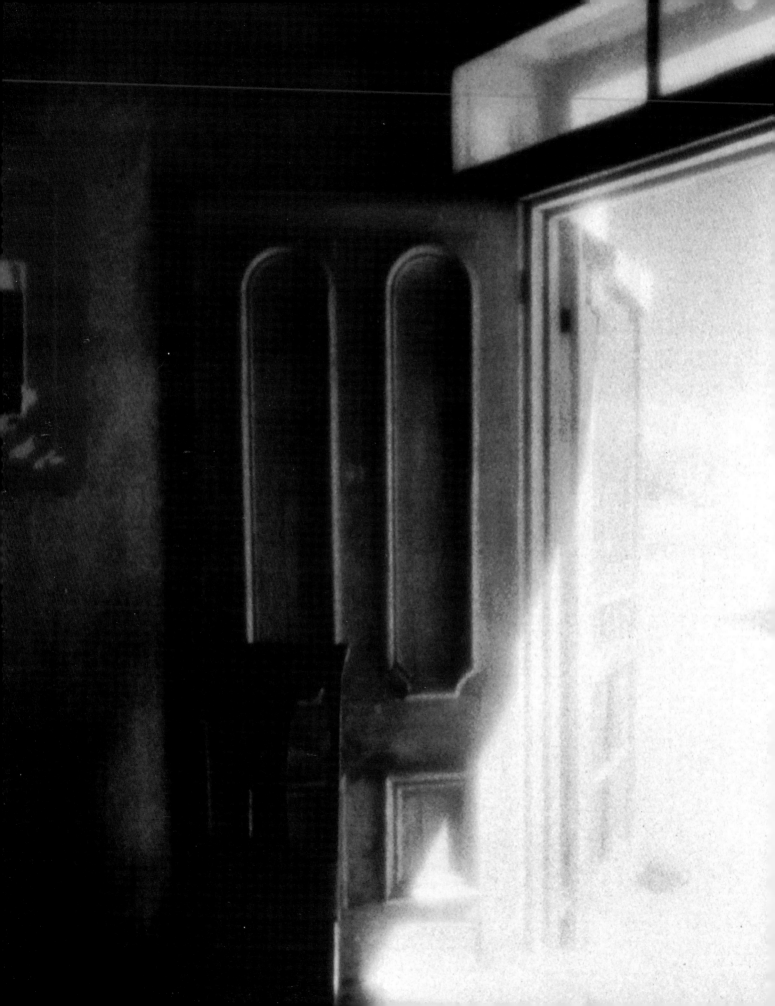

INFRARED PHOTOGRAPHY

Infrared film is unique in the realm of photographic mediums. This type of film moves beyond the world of the visible to catch and portray the invisible, thereby giving photographers a deep appreciation of the complex world around them. Like life itself, infrared film is unpredictable. The images you capture with it are dramatic and surreal. A landscape becomes dream-like. Portraits and nudes take on an ethereal beauty; skin becomes translucent and resembles porcelain.

Suddenly, the world as you know it shows up in print form looking strangely bizarre or wonderfully romantic. This is the mystery and magic of infrared film. It carries you beyond the literal perspective of the eyes on your face into the limitless vision of your mind's eye.

Working with infrared film offers another benefit as well. While everyone else must awaken before dawn to photograph the early-morning light, you don't have to. This is because infrared radiation is best from high noon to late afternoon. So, this film is great for night owls and those who prefer to sleep late in the morning.

I made this shot in Bodie, California, with a #25 red filter and an ISO 320 film speed. The light coming in the door from the outside was very strong. I wanted to record the interior but at the same time to make the light entering the house look eerie. Metering the chair inside the house, I exposed for about 1/15 sec., so the light area outside the door was quite overexposed. I had to burn the little bit of information in the light while printing, but I got the shot I wanted.

BLACK-AND-WHITE INFRARED FILM

Infrared films are sensitive to visible and invisible light and are quite sensitive to heat as well, much more than typical panchromatic films. Knowing this and taking a few precautions will enable you to keep the film fresh and to prevent it from fogging. Being aware of how a particular film reacts to certain climactic conditions will help you capture the mood or feeling that you want to instill in your images.

Precautions

If you use infrared film that has been stored in the refrigerator or freezer, you must let it sit in the canister at room temperature for at least two hours before you load and expose it. Don't try to expose this film while it is cold; the change in temperature will produce condensation, and the resulting images will be gray overall.

Also, be aware of shadows when photographing with infrared film. Because shadows are filled with blue light, they record as prominent, black areas in prints. As such, they look quite dramatic and become a definite part of the composition. If you are aware of shadows, you can utilize them to your best advantage. But if you aren't paying attention to them, they can alter the mood of your print significantly and unintentionally.

For example, I shot a snow scene on a beautiful sunny day after a heavy snowfall in Delaware. The landscape was so lovely and overwhelming that I forgot about the strong shadows going across the lawn. The resulting image had a foreboding look, which wasn't my intention.

If you have a problem seeing shadows, squint. When your eyes are almost completely shut, shadows are quite visible. This tip comes in handy for shooting with all types of film, not just infrared film.

Buying Infrared Film

Buying your infrared film in blocks of 20 will not only get you a better deal pricewise, but also will give you film from the same emulsion batch. During the winter months, buy film out of New York City, and, if necessary, have it sent to you via the United Parcel Service (UPS). Never have infrared film delivered this way during the summer months. If you buy infrared film at this time of year, go to a store and purchase it directly. Then when you get it home, keep it in the refrigerator. If the film isn't refrigerated at the store, don't buy it.

You can freeze infrared film for almost three years without any loss of light sensitivity. To freeze it, wrap the rolls of film in their original boxes in foil. Then place everything in a zip-lock freezer bag.

Traveling with Infrared Film

In airports, always ask for a hand inspection of your infrared film. Since this film has no DX code or ISO designation, you must tell the inspector that it is a special, very-high-speed film. These little exaggerations might save a lot of dialogue. Then cross your fingers that the inspector opens only one or two rolls.

I find that when the film is still in the block wrapped in cellophane, inspectors seldom open the package. And since infrared film must be kept in the black plastic canisters it comes in, I place the film in a see-through plastic bag, the kind used for storing sweaters or linens, and hand it over to the inspector. I also carry my ISO 3200 and ISO 1000 slide films in this bag. I leave these rolls in their canisters, too. If you keep only your infrared film in canisters, the inspector will open all the infrared plastic canisters.

Once in a while, inspectors will hassle you and refuse to hand-inspect your infrared film. Don't ask them not to open the infrared film. If you do, they'll get suspicious and open all of the canisters. Fortunately, most inspectors only half-open and then quickly close the plastic canisters, so little light gets into the metal cassettes themselves. But even if the inspectors take a roll of infrared film completely out of its canister and look at it, you'll lose only three to four frames on that particular roll. The artificial illumination inside buildings is less damaging than direct sunlight.

You should always ask for a hand inspection. Even if your film makes it through security only once without getting X-rayed, it is still one less occurrence. Remember, the adverse effects of X-rays are cumulative. I've never had infrared film X-rayed twice. Once while I was traveling, my unexposed film was X-rayed. So after exposing the infrared film in the field, I processed it in my hotel room. I knew that this would prevent additional potential damage if the film were zapped again while I was going home. The film didn't fog or deteriorate with the one pass through.

If you're traveling in a particularly hot climate, you must keep your infrared film relatively cool. Don't leave it in a black bag in the sun, or in the car or bus. And when you are in the field, you should carry your film, both exposed and unexposed, in an insulated six-pack cooler, without ice. If you store the film on

ice and then take it out in the heat, condensation will form in your camera. So be sure to take your film bag with you wherever you go.

Whenever you travel, you should keep the bulk of your film, both exposed and unexposed, back in your room. Make sure that it is out of the sun. Even if the room isn't air-conditioned, the film should be fine.

Here are some tips for processing film while traveling. Buy a camper's collapsible, 1-gallon plastic jug; these inexpensive jugs are easy to pack in your suitcase because they fold flat. Take along powder-form rapid fix, and mix and store it in the camper's jug when you arrive at your destination. If you aren't sure about the water quality in the area, buy distilled water for mixing. You should also buy Rodinal, a liquid developer that is sold everywhere, including Europe. Since it is a concentrated liquid, you merely add water as needed when you mix it.

Other items you should bring with you when you travel include: one graduate to measure and mix chemistry (make sure the graduate is large if you have a 5-reel tank), a thermometer, scissors, a can opener, a film tank, film reels, travel clothes hangers for hanging the film to dry, film sleeves to store negatives, and light-tight film-changing bags designed for 35mm film. (The tent-like changing bags designed for loading 4 × 5 film holders aren't infrared light-tight, so if you use them, you'll fog the film.)

Keep in mind the following useful tips for processing infrared film on the road. When the plastic canisters in which the film is packaged are filled to the very top, they hold exactly 1 ounce of liquid. To show that you've exposed a specific roll of infrared film, make a tear in the white paper on the top of the plastic canister. This indicates immediately that you've shot that particular roll.

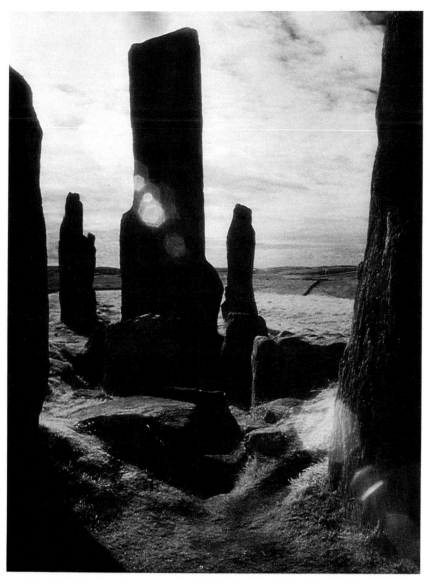

I came upon these standing stones on the isle of Callandish in Scotland. I decided to shoot directly into the sun. The resulting lens flare created an enchanted look, which was perfect for this summer-solstice scene.

THE INVISIBLE SPECTRUM

A beam of visible white light can be dispersed by a crystal prism into a spectrum of colors ranging from violet and blue, to green and yellow, to orange and red. These are, of course, the colors of the rainbow. Each color represents light of a different wavelength, with the wavelengths becoming longer as the spectrum moves from blue to red.

In addition to the light that you can see with the human eye—this light is in the visible spectrum—there also exists invisible electromagnetic radiation. This invisible radiation is found at both ends of the invisible spectrum. Beyond visible violet, there is invisible ultraviolet. At the other end, beyond visible red, is invisible infrared.

As the infrared spectrum extends beyond the end of the visible spectrum, wavelengths increase. Infrared then merges into what are called *heat waves*. Photographic emulsions are sensitized to record only the infrared spectrum nearest to the visible spectrum; beyond this narrow range, simple radiated heat would completely fog the film.

Infrared film was developed about 80 years ago for scientific purposes. It had many practical applications. In agriculture, for example, crops were photographed from the air with infrared film. All healthy plants recorded as white in the resulting black-and-white photographs, while diseased plants printed black. In this way, farmers were able to easily detect the beginnings of disease and take measures to combat it.

About 40 years ago, fine-art photographers "discovered" infrared film and started working with it in more playful, creative ways. Infrared, however, is an unpredictable film, and, as such, can be quite an expensive toy for the unexperienced. But this chapter delves into the mystery that is infrared and provides the uninitiated with enough techniques that they can use this unique film in cost-effective, innovative ways.

Focusing

Infrared radiation doesn't focus on the same plane as visible light, so you must rotate the lens barrel slightly forward to readjust your focus to the infrared-compensation mark. This is the red dot or the "R" on your lens after you've visibly focused. This will focus just a bit in front of the subject, giving you the increased distance from the lens to the film. For this reason, I try to use an aperture of f/16 or f/22 to give me a longer depth of field and less chance of error. But with some of the new autofocus (AF) lenses, such as most of Nikon's AF lenses, this isn't necessary (the exception: Nikon's 80–200mm F3.5/5.6D lens). Through the use of extra-low-dispersion (ED) glass, these lenses can pull all the wavelengths into focus, including infrared ones.

The only cameras that present a problem in terms of exposing infrared film are moderately priced cameras and old Canon cameras. This is because these cameras use an infrared frame counter. And when the infrared beam inside the camera counts the sprocket holes as the film advances, the film fogs. But new Canon cameras, such as the EOS 1, EOS 1N, and EOS 1N-RS, don't have this feature. So they can expose infrared films without any problems. Keep in mind, though, that even with the new Canon cameras and lenses, you must first focus manually, and then use the red dot or "R" engraved on the lens barrel to refocus for the infrared film.

EXPOSING BLACK-AND-WHITE INFRARED FILM

To get the most dramatic images from your infrared film, you need three optimum conditions: blue skies, ample sunshine, and high temperatures. On infrared film, a blue sky with cotton-candy clouds records as a sea of black ink with tall, white ships afloat. Sunshine creates a halo or aura of reflected infrared radiation around the objects that you photograph. Heat is also recorded as a halo or aura, especially with respect to animate subjects. Human bodies give off a great deal of heat, especially if they are very warm, such as after running or jogging. Infrared film permits you to capture the heat emanating from the body.

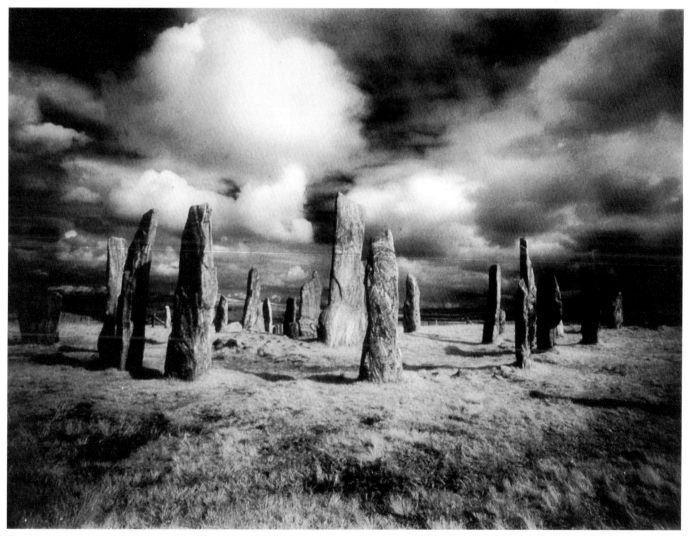

For this photograph of the standing stones, I used an ISO 200 film speed in order to effectively capture the cloud formations.

Using Filters

Because infrared film is also slightly sensitive to blue and violet light, either a #25 red filter or a #29 dark red filter is necessary to absorb blue and violet wavelengths. These filters allow more of the infrared wavelengths to be recorded. Without a red filter, infrared film resembles ordinary, grainy panchromatic film.

A #87 red filter provides maximum filtration, but it is so black-red that it is opaque. And since you can't see through it, you must first focus and compose, and then place the filter over the lens. In comparison tests, there was very little difference between the #25 red filter and the #87 red filter—and certainly not enough to warrant the inconvenience of continually taking the filter off and on.

Infrared film has the ability to cut through aerial haze. When you use this film with a red filter, the combination blocks blue light, and you produce sharp, detailed renditions of distant landscapes. And although you can expose the film on an overcast day, the results won't be as dramatic because the cloud cover blocks a good deal of the infrared radiation.

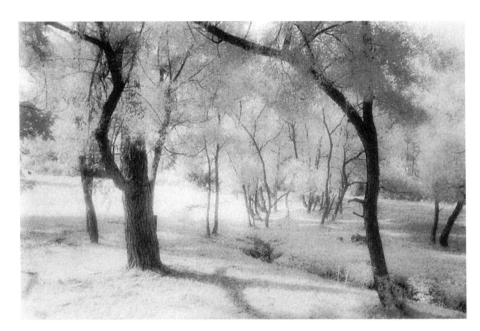

I photographed this landscape with various filters as a comparison test. Here, I used a #25 red filter. The result: good details and a large amount of recorded infrared radiation.

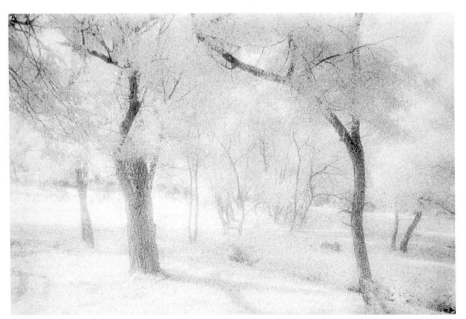

For this shot, I switched to a #87 red filter because it records more of the infrared, even when used with an ISO 400 film. This filter completely blocks blue light waves and enables the film to record only infrared light waves. Many of the details in the leaves are lost because so much infrared radiation is being reflected and recorded on the film. The negative was extremely dense and took a long time to print.

It is also possible to photograph snow scenes with infrared film. And while the resulting pictures won't contain the drama of a picture shot at higher temperatures, they'll capture some of the infrared radiation bouncing off the white snow and portray the shadows of the winter landscape as strangely pronounced shapes. This happens because the shadows are full of blue light, and the red filter you're working with deepens the color blue. You can also emphasize the softness of the snow scene by putting a soft filter over the red filter.

Infrared film is quite sensitive to heat. So don't leave it in a hot car or on the beach in direct sunlight. If you do, the film will fog. Keep your infrared film in the refrigerator, and take it out about two hours before shooting it. And use its heat sensitivity to best advantage! Body heat can be recorded as an aura. You can augment this effect by using a soft filter over the lens, such as Nikon's #1 and #2 soft filters. They have a special coating that thin lines of real silver are embedded in, so a slight softness is imparted to images *without* blurring.

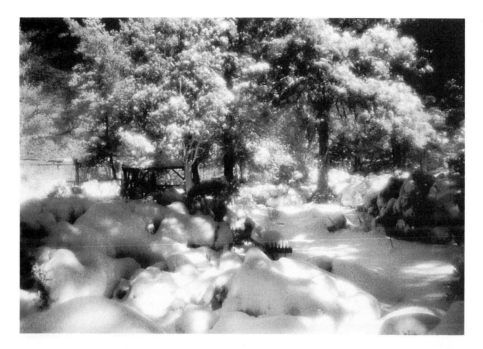

To effectively record this snow scene, I selected a Nikon soft filter #2 and a #25 red filter, and an ISO 200 film speed.

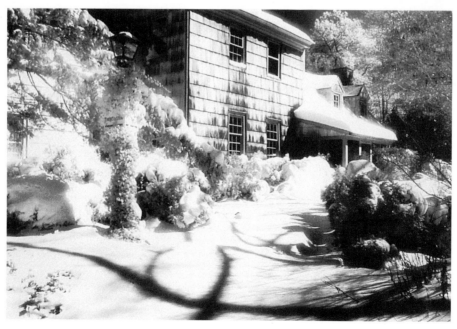

Shooting the same snowy landscape, I decided to use only a #25 red filter. Note the strong shadow on the lawn, which gives the scene an ominous feeling.

Of these two filters, the Nikon #1 softens images less, and it creates a romantic flair for portraiture. It smooths out skin tones, thereby diminishing wrinkles, and makes eyes look dewy. This filter also diffuses landscape images slightly and produces a magical effect. The Nikon #2 filter creates the impression of fog in the landscape and increases the flare around anything reflecting light, especially in subjects with a dark background. Images take on a surreal, dream-like quality. This is a mood enhancer. The feelings that panchromatic film can elicit simply don't compare to those evoked by images shot with infrared film and the #2 soft filter.

When you photograph nudes using infrared, the film adds a beautiful glow to the complexion, as well as smooths out the skin. However, if your models have bluish surface veins, they'll look like black lines in the final prints. And when you photograph a pregnant woman with such veins, they'll be quite prominent. The veins will appear as black lines in the breast and stomach areas where the skin is more translucent and the veins are closer to its surface.

Infrared is a wonderful, versatile film. But even when you think you know how to handle it, every once in a while you'll get an effect you never expected. This element of surprise makes life interesting, and it results in images that are unique and personal. However, if you have a personality that prefers predictable and more constant results, infrared might not be a good film for you to shoot. In addition, you can't use the Zone System with this film because there are just too many variables.

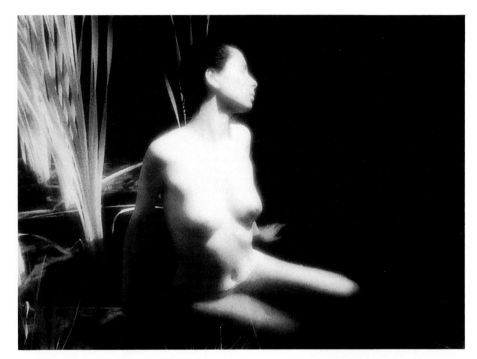

I made this shot of a nude in a pond with a #25 red filter, a soft filter #1, and an ISO 320 film speed. The day was extremely hot (100 degrees), and because the water in the pond was reflecting a clear blue sky, the water appears black. Against this black background, the aura around the body is clearly defined and enhanced by the soft filter.

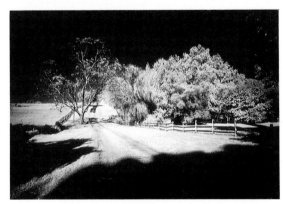

Shooting Konica 120mm black-and-white infrared film, I used a film speed of ISO 50 and a red filter here.

Working with the same film, film-speed rating, and red filter, I decided to add a soft filter #2 for a different effect.

Kodak 35mm Black-and-White Infrared Film

Since Kodak infrared film doesn't have a strong anti-halation backing, it is quite susceptible to lens flare. So when you use this type of film, avoid pointing the camera lens toward the sun. Light can also sneak in between the felt-tipped lips on the metal cassette and fog the film. You should use a lens hood—unless you want to include the flare for effect.

Total darkness is required for opening the black plastic canister in order to load and unload the film before shooting and processing it. If you are in the field, carry a changing bag. This bag acts like a portable darkroom. By placing your camera and film in the bag and slipping your arms and hands through a sleeve device, you can load and unload film in complete darkness.

Once the camera back is closed and out of the changing bag, check the rewind knob to see if the film is rotating after you push and cock the shutter-release button. Because infrared emulsion is coated onto an ester base, the film is quite thin, which makes it difficult for the takeup reel to catch the sprocket holes. So when you first start using it, it is easy not to load it properly. Make sure that the rewind knob is rotating. This indicates that the film is being transported from the cassette across the aperture opening and onto the camera's takeup reel.

If you don't have enough time to load the film in the changing bag, get out of direct sunlight and load the film into the camera as quickly as possible. You'll lose the first six frames to fogging, so shoot them off rapidly and then take your shot. Even though infrared film is expensive and it is a shame to waste up to six frames, this is better than missing a great shot.

It is important to be aware that if your camera automatically reads the film-speed DX coding and the camera is set on "DX," the camera will signal that the infrared film isn't loaded correctly. This might not be the case. Before loading the film, take the dial off the DX setting, and manually adjust your ISO dial to a particular film speed. Since infrared film doesn't have a DX-coding bar, your camera will get confused if the ISO dial is set on DX. Also, if you shoot with a Nikon F3 or F4, both of which have the film window in the back, you don't need to tape it. Light doesn't reach the film.

Caution: Rewind infrared film very slowly, especially if it is cold outside. This prevents static electricity from making black streaks throughout the film, which print as white streaks. Sometimes coating the pressure plate with a drop of Photo-Flo about twice a year helps with this problem. Photo-Flo is a wetting agent used during film processing that reduces the surface tension of water.

Konica 35mm Black-and-White Infrared Film

This type of film is imported only once a year from Japan. So if you want to use it, it is wise to buy at least a block (20 rolls), and then refrigerate it. Exposing this film at an ISO setting of 25, 32, or 50 is optimal. You can use a red or a deep orange filter with this film. Keep in mind that the deep orange filter seems to make negatives clearer and sharper than the red filter, and still records infrared radiation. And because Konica infrared film is more contrasty than Kodak infrared film, I prefer using Rodinal developer with it. I find that this developer gives more even tonal values in the negative.

The medium-format version of this film seems to record more infrared radiation than the 35mm version and imparts a beautiful glow to the skin in portraits and nudes. Because this film has a very tight grain structure, it produces an entirely different look than the Kodak film. I prefer using a film speed of 32 and 50. My choice of developers is Rodinal in a 1:50 ratio (see the charts on page 48 for recommended times and temperatures).

Ilford 35mm Black-and-White Infrared Film

SFX 200, Ilford's newest black-and-white film (which went on the market in September 1996 and comes only in the 35mm format), isn't a true infrared film. But it has an extended red sensitivity into the invisible-light range of approximately 40 nanometers (nm). As such, SFX 200, whose name stands for "special effects," can record infrared radiation.

You can shoot it as a typical continuous-tone film without filters, or as a creative-purpose film with filters. SFX 200 has a medium grain structure with a film-speed rating of ISO 25 to ISO 400 without filters according to which film developer you use, and it can be pushed to ISO 800. Opaque red filters trick the meter, thereby making the exposure time too short. It is better to take a meter reading without the filter over the lens, and then to figure out the filter factor for the correct exposure.

To produce compelling effects or to record as much infrared as possible, you should use a dark red filter that you can readily see through for easy composing and focusing. The deeper the filter color, the more infrared radiation the film will capture. And when you couple a red filter and a soft filter, such as Nikon's soft filter #2, when you shoot, you can obtain ethereal images, similar to those made with high-speed infrared film.

To get creative effects conveniently, using ISO 25 or ISO 50 and a #25 red filter, or ISO 50 or ISO 100 and a #29 deep red filter works best. For any of these

combinations, I recommend developing SFX 200 in Ilford's ID-11 (stock) at 68°F for around 10 minutes. Of course, you might want to adjust this suggested starting time somewhat to fit your own specifications and to achieve the results you desire.

Suppose that you decide to use SFX 200 as a continuous-tone film, either without any filters, or with blue, green, yellow, orange, or red filters for the sole purpose of changing tonal values. In these situations, you should expose the film at ISO 50 or ISO 80, and develop it in Ilford's ID-11 (1:1) at 68°F for about 17 minutes. Keep in mind that because of the film's infrared sensitivity, a red filter changes values a little differently than it does with conventional continuous-tone black-and-white films.

Another option is to push SFX 200 to ISO 800 and develop it in Microphen (stock) at 68°F for around 14 to 15 minutes. Again, this is merely a suggested starting time for development. Ideally, you should run a test roll of SFX 200 at various film-speed settings and with different filters. Then alter your developers and development times according to the look or the negative density you want.

A final point: SFX 200 is coated on a gray acetate base, which gives it a good anti-halation backing. This, in turn, translates into less recorded lens flare. The combination of the film's halation protection and 40nm invisible-light sensitivity makes the film easy to load in subdued illumination.

Clearly, SFX 200 is a handy film for trips when you aren't sure whether you want infrared or continuous-tone negatives. You can make the choice by altering both the film speed and the filters on location, and, of course, changing the developer and the processing time in the darkroom. Just be certain that you carefully mark the cassettes as to how you exposed the rolls of film and how you wish to develop them—before you throw them into your camera bag.

Konica 120mm Black-and-White Infrared Film

Konica also manufactures a 120mm size infrared film. It is a slow film, with a film-speed rating of ISO 32 to ISO 50, and very little grain. The film also records infrared radiation much better and is less contrasty than the Konica 35mm film. The Konica 120mm film is perfect for photographing nudes. The resulting pictures are especially striking: the skin takes on an alabaster look, auras are recorded, and yet the images are quite sharp.

Kodak Versus Konica Black-and-White Infrared Film

Five main differences between Konica and Kodak's infrared films exist. These are:

Formats
Konica infrared film comes in a 120mm medium-format version that records more infrared than the Konica 35mm version, yet still has a tight grain structure. Kodak doesn't make 120mm infrared film.

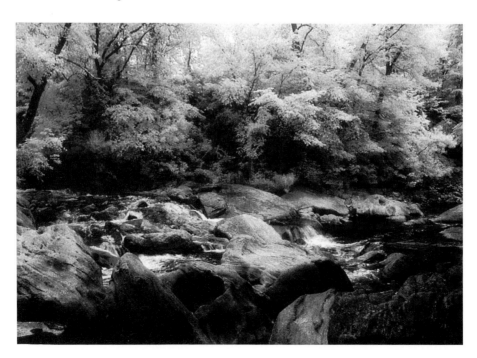

I photographed the same scene with two films in order to assess their differences. For this shot, I used Kodak 35mm film exposed at ISO 200 and a #25 red filter. The densities between the lights and the darks were even and easy to print. The contrast is soft, and the image shows a large grain structure.

The company does, however, make a great 4 × 5 infrared sheet film that has less grain than its 35mm infrared film, but more grain than Konica's 120mm infrared film.

Grain

Konica infrared film has a tight grain structure, whereas Kodak infrared film has a large grain structure. So if you're going to handcolor your images, the Kodak film will be the better choice since the large grain structure lends itself well to this technique.

Speed

Konica infrared film is much slower than Kodak's (hence, its tighter grain). The combination of the Konica film's ISO rating of 25/32 (normal) and a red filter (-$2^1/2$ to 3 stops) almost demands working with a tripod. Kodak film's ISO rating of 200 (normal) is $2^1/3$ stops faster than that of the Konica. So you can work spontaneously and without a tripod.

Imagine, for example, you're using the $f/16$ sunny-day rule. Remember, this rule states that when you shoot any given film at $f/16$ on a sunny day, the shutter speed should be 1/the ISO or the closest shutter speed to the film's ISO. Suppose, for example, that you're working with an ISO 200 film on a sunny day; you'll use a #25 red filter and expose it at $f/16$ for 1/250 sec. But imagine that you're working with Konica ISO 32 film. The sunny $f/16$ rule tells you that the exposure should be $f/16$ for 1/30 sec. But if you're also using a #25 filter, you must decrease the exposure by three stops, to $f/16$ for 1/4 sec., and use a tripod.

If, on the other hand, you're shooting a Kodak 200 film, the sunny $f/16$ rule suggests that you expose at $f/16$ for 1/250 sec. Adding the same filter and subtracting the same three stops translates into a final handholdable exposure of $f/16$ for 1/30 sec.

Sensitivity

Kodak's 35mm infrared film records more infrared radiation than Konica's 35mm infrared film because Konica infrared film is sensitive to a maximum of 750nm. This is just a bit over the 700 mark, which is where visible light stops. Kodak infrared film, on the other hand, is sensitive up to 900nm.

Ilford's new SFX 200 film is just a little less sensitive to infrared light than Konica's infrared film. The Ilford film is sensitive to a maximum of 740nm, versus the 750nm maximum sensitivity of the Konica film. SFX 200 film handles the same way as the Konica film but at higher ISO ratings. Ilford SFX 200 film's best feature is that you can expose it as a continuous-tone film or as a creative infrared film—and you can do both on the same roll of film!

Convenience

Konica infrared film's anti-halation backing makes it less vulnerable to light fogging in the metal canister and lens flare. Because you can load and unload Konica infrared film in low light, you don't need a changing bag in the field. And, Konica infrared film is easier to handle while loading into the camera and onto the reels than Kodak's.

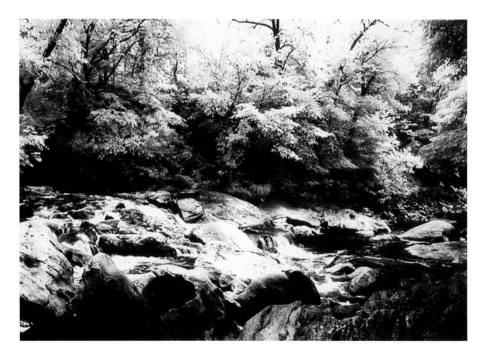

Next, using the same filter, I exposed Konica 35mm at ISO 32. This is a more contrasty film than the Kodak 35mm film and has a fine grain structure.

RUNNING A TEST

You can't see infrared, but by exposing infrared film, you can develop a feel for it. This is why it is important, especially in the beginning, that you run a test film for the different ISO settings for your camera, your metering, your location, and yourself. This will save you a number of headaches, time, money, and film in the future. It will also give you a good standard by which you can evaluate not only the negatives, but also the look and feel of the prints obtained through various film-speed settings.

Exposing a Test Roll of Black-and-White Infrared Film

Shoot a roll of black-and-white 35mm and 120mm infrared film according to the following instructions. This will serve as a reference guide for exposures and enable you to see the different effects you can achieve by altering the film speed. First, choose a bright, hot day. Select a scene that has trees or plant life and, if possible, water, in the form of a pond, lake, or stream. Clouds are also a good touch. And if at all possible, place a person in the scene.

Next, load the film from the canister into the camera in complete darkness. If your camera automatically reads the film's DX coding, you must take the camera off the DX setting and manually adjust it to an ISO number. Place a #25 red filter on the lens. Use the smallest aperture possible; if necessary, mount your camera on a tripod. Set the aperture to at least *f*/8, and preferably to *f*/11 or *f*/22. Then expose three different scenes.

EXPOSING A TEST ROLL OF KODAK 35MM BLACK-AND-WHITE INFRARED FILM

1. Shoot five consecutive frames each of three different scenes, changing the film speed each time (frame #s 1–15).

Frame	1	2	3	4	5	Same scene
ISO	50	100	200	320	400	on all 5 frames

Frame	6	7	8	9	10	Same scene
ISO	50	100	200	320	400	on all 5 frames but different from #s 1–5

Frame	11	12	13	14	15	Same scene on
ISO	50	100	200	320	400	all 5 frames but different from #s 1–5 and #s 6–10

2. Next, shoot off five frames of any scene (frame #s 16–20).

Frame	16	17	18	19	20	Same scene
ISO	50	100	200	320	400	on 5 frames

3. Now go back to the three scenes you originally used (frame #s 1–15), and reshoot them as follows. You'll end up with 15 more frames (#s 21–35).

Frame	21	22	23	24	25	Same scene as
ISO	50	100	200	320	400	in #s 1–5

Frame	26	27	28	29	30	Same scene as
ISO	50	100	200	320	400	in #s 6–10

Frame	31	32	33	34	35	Same scene as
ISO	50	100	200	320	400	in #s 11–15

4. Take the infrared film out of the camera in complete darkness.

5. To process this test roll, cut off the leader and measure out (in the dark) approximately 30 inches of film.

6. Load half of the film on a reel in a processing tank for developing in Rodinal (1:50). Put the other half of the film in a tank for processing in D-76. (Plastic tanks and reels are perfectly fine for developing infrared films.) If you have only one tank, place the other half of the film in the black plastic canister, and tape the lid shut. Develop this half after you run the first half.

7. Process the film according to the directions on the corresponding time and temperature charts (see page 48).

8. Place the processed films in two separate sleeves, and at the top identify the film and film developer used, as well as the time and temperature. Use a Sharpie pen to mark the film speed of each frame on the outside of the negative sleeve.

9. Next, make your contact sheet. Select one set of images, and make a print of each.

10. Finally, write down all the data (film name, ISO film developer, and the time and temperature of developer) on the bottom border of each print.

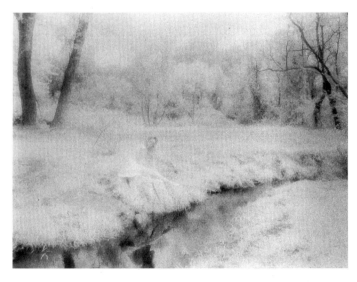

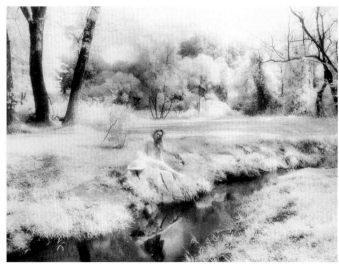

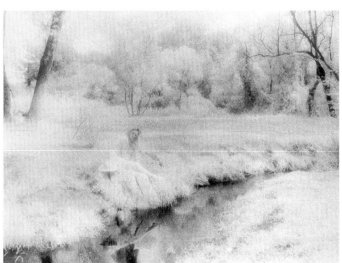

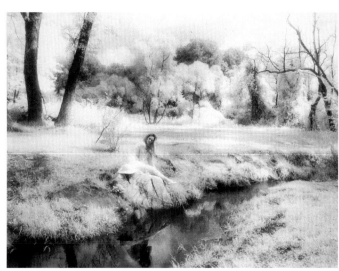

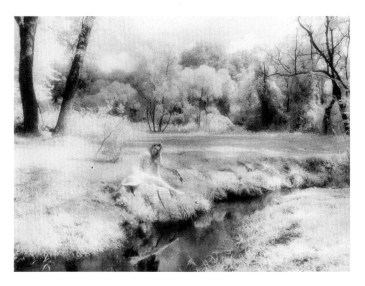

I photographed this landscape scene at different film speeds to show how that variable affects the final image. I used a #25 red filter for all five shots. I made the first shot with an ISO 50 film (top left) and then used progressively faster films: ISO 100 (center left), ISO 200 (bottom left), ISO 320 (top right), and ISO 400 (center right). Note that the slowest film (ISO 50) recorded the most infrared radiation; in fact, the details are lost, and the whole scene is rather nebulous. In addition, the negative is dense and hard to read. Notice the model's face in each frame. The features become more and more distinct from ISO 200 to ISO 320 to ISO 400.

EXPOSING A TEST ROLL OF KONICA 35MM BLACK-AND-WHITE INFRARED FILM

1. Complete the following steps to produce a serviceable test roll of Konica's 24-exposure, black-and-white 35mm infrared film.

Frames	1	2	3	Use a #25 red filter
ISO	25	32	50	

Frames	4	5	6	Same scene as #s 1–3;
ISO	25	32	50	use an orange (G) filter

Frames	7	8	9	Same scene for all 3 frames,
ISO	25	32	50	but different from #s 1–6; use a red filter

Frames	10	11	12	Shoot off 3 frames
				of your choice

Frames	13	14	15	Same scene for all 3 frames,
ISO	25	32	50	but different ISOs; use a red filter

Frames	16	17	18	Same scene as #s 13–15;
ISO	25	32	50	use an orange (G) filter

Frames	19	20	21	Shoot a portrait or a nude;
ISO	25	32	50	use a red filter

Frames	22	23	24	Same scene as #s 19–21;
ISO	25	32	50	use an orange (G) filter

2. Do this test twice: develop one roll in Rodinal and one roll in D-76. Follow the time and temperature charts shown on page 48.

3. Place the film in negative sleeves on which you've clearly marked the developer, time, and temperature used.

4. Make a contact sheet, and then print two sets of images, one showing the effects of the red filter and one showing the effects of the orange filter with the various ISO settings used.

5. Record all the essential information (film, developer, time, temperature, and ISO setting) on the front of each print. Keep these prints for future reference.

EXPOSING A TEST ROLL OF KONICA 120MM BLACK-AND-WHITE INFRARED FILM

1. Expose two rolls of film. On the first roll of film, use the same scenes and a #25 red filter, and expose the frames at ISO ratings of 25 and 50 alternately. For example, shoot frame #1 at ISO 25, and then shoot frame #2 (of the same scene) at ISO 50. Then with an orange filter, shoot frame #3 at ISO 25, and shoot frame #4 (of the same scene as #3) at ISO 50.

Frames	1	2	Same scene on both frames;
ISO	32	50	use a #25 red filter

Frames	3	4	Same scene as in #s 1 and 2;
ISO	32	50	use an orange filter

2. On the second roll of film, shoot the same scene on the same day using the same time frame and both the red and orange filters. *Don't wait a couple of hours before exposing the second roll. The light will change.*

3. Develop one roll in D-76 and the other in Rodinal. Follow the manufacturer's developing directions, and use the time and temperature charts on page 48.

4. Place the film in negative sleeves on the front of which you've recorded all the pertinent data.

5. Make contact sheets, and select the sets of images.

6. Develop one set in Rodinal using both the orange and the red filter at various ISO settings. You want to produce four prints from each roll that you'll use for future reference, for a total of eight prints.

7. Develop another set in D-76, once again using the orange and red filters at different ISO settings, ISO 32 and ISO 50. Keep the resulting eight prints for future reference as well.

Shooting Konica 120mm infrared film at ISO 25 with a red filter produced a very dense negative with a good deal of infrared radiation recorded (left). Switching the film speed to ISO 50 led to a less dense negative because less infrared was recorded; the resulting image is a bit sharper (right).

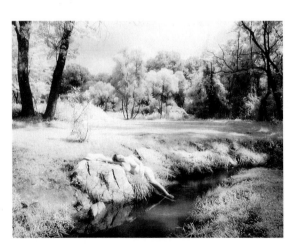
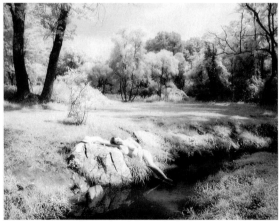

FILM-SPEED SETTINGS AND THEIR EFFECTS

When shooting a single roll of infrared film, you can bracket a scene in order to create various effects. This technique enables you to individually expose frames on the same roll of film, recording more or less infrared on each frame. As a result, you'll obtain a different version of the image on each frame.

Always develop the film the same way, following the time and temperature charts on page 48. You don't have to adjust developing times for different effects; this is done during the exposure, not the processing. This makes the whole procedure that much simpler: you have one less thing to keep track of, and there is one less chance for error (see opposite page for the different effects achieved at different ISO settings on a single roll of film).

You can use many ISO speeds, each producing a different result, but it is important to establish a normal, or base, ISO to deviate from. As a starting point, I suggest ISO 200 for Kodak 35mm infrared film. On a sunny day, this will give you a good tonal range, good details, and a soft grain in the print.

If, however, you're shooting at a base setting of ISO 200 on an extremely bright and hot day, you may need to increase the ISO to 320. If you use a low film-speed setting, such as ISO 100, when you should shoot at a higher one, you'll most likely blow out the frame. In other words, too much infrared will be recorded, and the frame will be dense and black. Sometimes the light will even flare up into the clear borders near the sprocket holes. These flares will look like black flames. When this happens, the frame will be virtually unprintable. There will be no separation in any of the tones, and you'll have a very dense negative.

Different parts of the United States, and of the world, have varying amounts of infrared radiation. Tropical climates have not only more infrared, but also more heat. In Santo Domingo, for example, I used ISO 320 as my base exposure. Because mountainous areas have higher elevations and sometimes more infrared radiation, anything from ISO 200 to ISO 320 is an appropriate setting. For shooting on the plains of Africa, where you have tremendous heat and infrared radiation, I recommend ISO 400 or higher as a base exposure. In cooler climes with little infrared, try starting at ISO 125. (Keep in mind that these suggestions are all based on my normal setting of ISO 200, which is suited for where I live: the eastern United States.)

Shooting at the Altos de Chavon amphitheater in Santo Domingo, I *wasn't able to see* the infrared-radiation light rays that my ISO 200 infrared film was recording. I was simply photographing the composition that the row of seats made, using a #25 red filter.

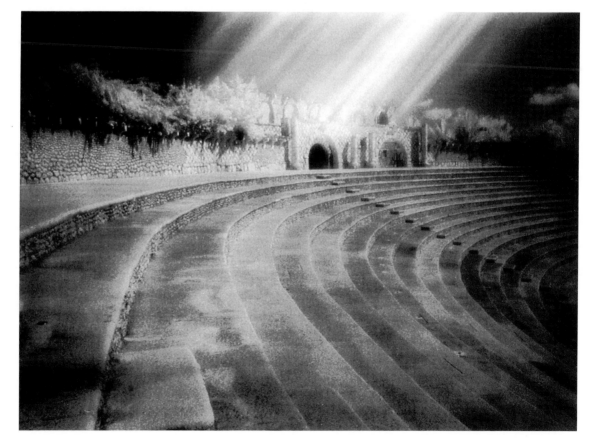

METERING

You can use the camera's meter to obtain different looks. For dramatic effects, meter the highlights; this will give you rich black shadow areas and few if any details. If you meter the shadows, you'll get good details in them, but the highlights won't contain any information. Sometimes metering the dark areas can even blow the frame.

Metering is particularly tricky if the light is bright. To achieve the best possible results, meter the highlights first, meter the shadows next, and then use a setting that is halfway between the two readings. In such a

situation, you can always shoot three differently metered frames, and choose the one you prefer later. If you have matrix metering on your camera, use this feature to arrive at for a more evenly exposed negative (if desired).

If you want to use a handheld meter, you must remember to compensate for the filter factor. For example, with a red filter you need to open your lens three stops. If your meter indicates the exposure to be ƒ/16 for 1/500 sec., you should set the camera on ƒ/16 for 1/60 sec., or ƒ/5.6 at 1/500 sec.

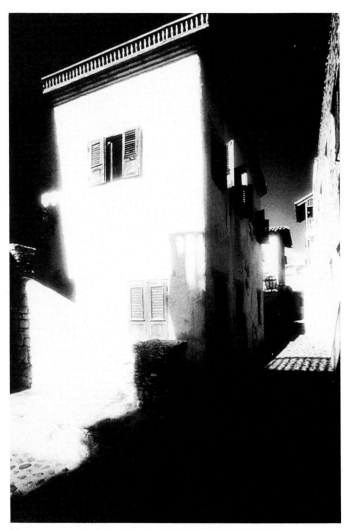

Continuing to photograph the Santo Domingo amphitheater, I metered the scene two ways. First, I took a meter reading of the building facade; here, this comprises the highlights. Details in the stucco are visible, and the shadow areas on the side of the building and the alleyway are blocked up. This created a dramatic image. The exposure was ƒ/16 for 1/250 sec.

Next, I metered off the side of the building in shadow. This resulted in a longer exposure time, thereby recording good details in the shadows but blowing out the highlights. Notice that the stucco on the front of the building contains very little detail. The exposure here was ƒ/16 for 1/30 sec.

FLASH PHOTOGRAPHY

You can use a flash outside at night when shooting at ISO 50, as long as you have your red filter over the lens. If you're photographing people in a crowd and you don't want to conspicuous, put a red cellophane cover over the flash and take the red filter off the lens. This will keep the flash from being bright and intrusive, while still allowing the infrared to be recorded. This is especially true if you're shooting in an area with tungsten bulbs because this type of illumination contains more infrared than others.

To process film that you've shot at ISO 50 with full flash, double your processing time. If you're photographing inside with infrared film and using a flash to augment the light, set the ISO between 50 and 100 according to how much light there is. The less light, the lower the film speed. You'll also have to increase the processing time by about 20 percent. So, for example, if the processing time is usually $11\frac{1}{2}$ minutes, process for 13 minutes and 8 seconds.

FORMULA FOR CALCULATING TIME
$11\frac{1}{2}$ minutes = $11\frac{1}{2} \times 60$ (seconds) = 690 seconds
690 seconds × .20 = 138 seconds more (for your 20 percent)
138 seconds + 690 seconds = 828 seconds
828 seconds **divided by** 60 = 13 minutes and 8 seconds

Filters
These accessories are an absolute must when you shoot black-and-white infrared film. Filters offer photographers yet another means of print control and variation. The filters can create a mood, enhance a person's aura, intensify both visible and invisible light waves, and make it possible to capture motion on a high-speed film.

#25 Red Filter
A #25 red filter is an essential component of your photographic-equipment collection if you want to make best use of your infrared film. This filter blocks the blue light and enables only the infrared wavelengths to get through.

#1 and #2 Soft Filters
These special-effect filters are optional. They augment the halo, or flare, around humans and various objects by reflecting a good deal of infrared radiation and heat. To get the most out of a flare or halo, use a #2 soft filter, an aperture of $f/16$ or $f/22$, and a dark background. You can use any brand of soft filter, but I prefer the Nikon soft filters.

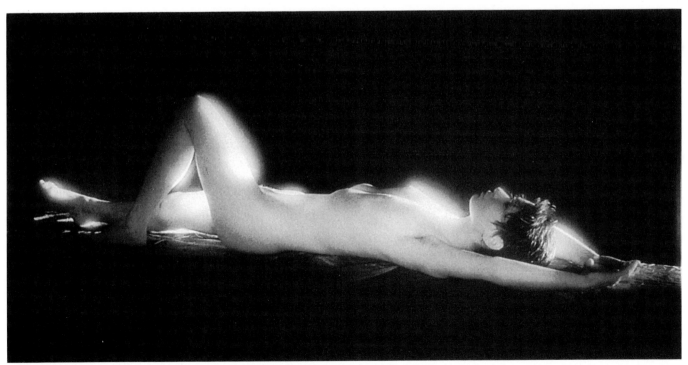

I made this shot of a nude lying on her back in the studio with tungsten lights, an ISO 100 film, a #25 red filter, and a soft filter #2. Tungsten lights contain a great deal of infrared radiation, and the aura was enhanced via the placement of the soft filter over the red filter. The background was a black cloth.

Neutral-Density Filters

These optional filters provide motion and background control. Since the film speed of Kodak's infrared film is usually quite high—ordinarily around ISO 200—you can place one or two neutral-density (ND) filters on top of a #25 red filter. This arrangement will enable you to record blurs or movement, as well as to use a low shutter speed for any reason. ND filters don't change the tones in a negative; they merely reduce the light entering the lens so that a longer shutter speed is required to record the subject. Of course, the use of an ND filter will also permit you to use a large aperture, such as $f/2.8$ or $f/2$, for a controlled-focus background.

Wratten ND filters come in densities of ND.3 to ND.9 and in f-stops that translates as follows:

• ND.3 equals 1 f-stop reduction
• ND.6 equals 2 f-stops reduction
• ND.9 equals 3 f-stops reduction (Wratten #96)

These filters have accumulative densities. In other words, you can stack one ND filter on top of another and then a third ND filter on top of them, in order to effectively produce the desired decrease in light. So if you need five stops less light, you can stack the ND.6 (2 f-stops) and the ND.9 (3 f-stops) and achieve a density of 5 f-stops less light. You simply determine the amount of light reduction you need, and choose the ND filters that will give it to you. By adding my ND.3 and ND.6 filters, I can achieve a three-stop reduction, which is all that I've ever needed.

ND filters come in handy with almost any film, but they are especially helpful if you're shooting in harsh light locations, such as Spain and Greece. And at the seashore, it is almost impossible to either open up your aperture (to $f/2$) in order to throw a background out of focus, or to use a long shutter speed to allow the film to record motion without using ND filters.

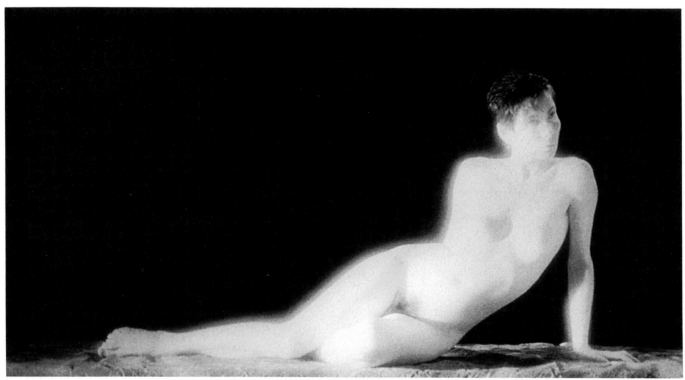

For this image, I photographed my nude model on her side. Once again, I was working in my studio with tungsten illumination, a black background, and a soft filter #2.

PROCESSING BLACK-AND-WHITE INFRARED FILM

You don't need to presoak 35mm infrared film. Before loading infrared film onto the reels, wash your hands well with soap and water. Oils in your skin may cause pitting and will leave fingerprints on the film. Be sure to cover any glowing red lights near the loading table.

I process my film on Paterson plastic reels and tanks. If you have an inexpensive or offbrand tank, be sure to test it first for fogging; fortunately, most plastic tanks are fine. You should, however, check your tank often for cracks. Finally, if you keep the exposed film in the refrigerator, take it out and let it warm up to room temperature, for about an hour, before you process it.

Developing the Film

Developing film is a standard process when it comes to developers, times, and temperatures. But how you agitate the film is an individual technique: everyone seems to have a specific style. Some people have a delicate touch when agitating the film, while others seem to be playing the maracas in a merengue band.

D-76

D-76 gives a dramatic look to the image. I use it when I do architectural work or whenever I want to impart a heavy, dramatic feel to a landscape. The dilution is straight. You should mix your D-76 at least two hours before you plan to use it. It takes a while for the powder to dissolve properly, and those minute particles of chemistry that don't dissolve attach themselves to the film and cause black spots. These spots, in turn, cause white spots on the print, which, of course, you can spot-tone out—but who needs the extra work?

D-76 tends to increase the contrast in the negative and enhances the grain more than Rodinal. You can modify your developing times to get a less contrasty negative. Just test-develop a few rolls while modifying your time and agitation method. Suppose you run your film at 72°F for 9$\frac{1}{2}$ minutes and it looks too contrasty or too dense; the next time try 9 minutes instead. Pronounced graininess and extreme density can occur when the film has been too aggressively rotated during the developing stage. If you encounter this problem, you might need to agitate a bit more gently.

Rodinal

I like developing infrared film in Rodinal because it produces a more open negative with a good rather than excessive amount of contrast. I use Rodinal almost all the time for developing nudes and portraits. I also prefer it for landscapes when I want a soft, romantic look in the images.

Rodinal, a highly concentrated liquid made by Agfa, is convenient to mix and use. The dilution is (1:50), or 10ml Rodinal to 500ml water. Simply attain the water temperature that you desire, and add the chemistry. Once you open the bottle of Rodinal, the developer will discolor somewhat, turning a light brown. But if you store an opened bottle in a cool place, it should last at least three or four months. Then as the Rodinal ages and exhausts, it gets quite dark. If it looks like molasses, throw it away; it is too old and exhausted. If you don't process a lot of film, it is best to buy the Rodinal in small bottles. Once you mix the Rodinal for processing, use it immediately because it exhausts quickly after being mixed. Mix it, use it, and dump it.

After shooting this garden scene on two rolls of film, I decided to process the film in two different developers. I used an ISO 200 film and a red filter. I then developed the film in D-76. The tree in the background is soft, and the dark areas in the foreground are blocked up.

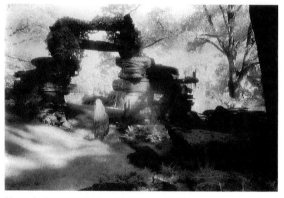

Here, I photographed the garden with the same film and filter, but processed the exposed roll in Rodinal (1:50). The background tree contains much more information, and the shadow area in the front is opened up. The negative has more even tones and was easier to print.

D-19

D-19 gives an image a harsh, special-effects look; very dark, pronounced grain; and hardly any midtones. The resulting image can look like a Kodalith print with grain. Follow the package directions for mixing and time charts.

HC 110, Dilution B

You can use HC 110 for developing infrared film, but it tends to flatten out the tones in the negative and delivers an overall flat look to the print.

DEVELOPING TIMES AND TEMPERATURES FOR KODAK 35MM BLACK-AND-WHITE INFRARED FILMS

	Degrees	Minutes
D-76 (Straight)*	68	11
	70	10
	72	9 1/2
	75	8
Rodinal (1:50)	68	12
	70	11 1/2
	72	11
	74	10 1/2
	76	10
	78	9 1/2
D-19 (Straight)*	68	6
	70	5 1/2
HC 110, Dilution B	68	7
	70	6 1/2

* Mix at least two hours before using so that the chemistry is completely dissolved. (Follow the directions on the package.)

DEVELOPING TIMES AND TEMPERATURES FOR KONICA 35MM BLACK-AND-WHITE INFRARED FILMS*

	Degrees	Minutes
Rodinal (1:50)**	70	9 1/2
	72	9
	74	8 1/2
	76	8
D-76 (Straight)***	68	9
	70	8 1/2
	72	8
	74	7 1/2

* Exposed at ISO 32.
** Presoaking isn't necessary with 35mm film. Follow the mixing formula on page 64.
*** Mix at least 2 hours before using so that the chemistry is completely dissolved. Be aware that D-76 adds more contrast to an already contrasty film. However, if you like the developer, use it, but adjust the agitating technique. Agitate for the first 30 seconds, and then for 5 seconds (three rotations) every minute.

DEVELOPING TIMES AND TEMPERATURES FOR KONICA 120MM BLACK-AND-WHITE INFRARED FILM*

	Degrees	Minutes
Rodinal (1:50)	70	8 1/2
	72	8
	74	7 1/2
D-76 (Straight)**	68	11 1/2
	70	11
	72	10 1/2
	74	10

* Exposed at ISO 32 or ISO 50. Always presoak 120mm film for 2 minutes in water that is the same temperature as the developer. Presoaking causes the emulsion to swell and ensures more uniform development.
** During the developing stage, agitate for the first 30 seconds, and then for 5 seconds every minute.

Keep in mind that these are simply recommended times. Every photographer's techniques regarding exposure, metering, and film processing vary. However, the times listed in the above charts serve as good starting points from which you can make adjustments to fit your individual needs. If, for example, you feel that your negative is too thin (too light), increase the development time accordingly. Conversely, if you feel that your negative is too dense (too dark), decrease the development time.

The Stop Bath

I use plain water for the stop bath. Acidic baths can create little pinholes in the film, which translate into little black dots on your print. And, thanks to Murphy's Law, they always seem to appear on the cheek, the tip of the nose, or in the sky.

The Fixer

Any film fixer will do, but I prefer Kodak's Rapid Fix. Once you use the fixer, store it in a separate jug labeled "Infrared Film Fix." This way, you won't contaminate your other films with infrared radiation. If you've been away from the darkroom for a few weeks, you should always run a test on the fixer to check for fixer exhaustion.

To do this, place the film tip of the leader that was cut off in a couple of ounces of used fixer. Next, time how long it takes to clear the film, and then double it. For example, if the film takes 2 minutes to clear, you should fix the film for 4 minutes. Be sure to do this in the light. If you use Rapid Fix and it takes 3 or more minutes to clear the film, you'll know that the rapid fixer is pretty exhausted. Make a fresh batch.

Remember, you can do this test with any film and fixer. (I don't use Perma-Wash or Hypo-Clear with infrared film because the film's thin ester base doesn't call for any other step or chemical.)

Washing the Film

Wash the film for 15 minutes to get rid of all the chemistry.

Soaking the Film

Mix one drop of Photo-Flo in a graduate of water for 5 reels, and soak the film for a minute. Photo-Flo makes the water "wetter." When you hang the film up to dry, the water runs off smoothly and no water spots are left on the film.

Drying the Film

Hang the film to dry overnight. Because infrared film is thin and doesn't have an anti-halation backing, it tends to dry quickly and curl up on itself. I hang my film with a weighted clip on the end to prevent the film from curling. Be aware: if you dry this film in a film dryer, it will curl severely. And when the film is dry to the touch, you must be careful when cutting it into strips for the negative sleeves because it can get scratched.

Checking the Processed Negatives

When you look at your processed infrared film, you'll find that the negatives are hard to read. Infrared radiation looks very dark or black on the negative. Negatives often appear bulletproof, especially when you try to achieve a high-key, ethereal look in the print. So it is a good idea to do two contact sheets, one to record the darker frames and one for the lighter frames.

In many cases, until you actually make a work print (an enlargement), you can't tell what is on the negative. It is quite possible to have negatives that require one to two minutes—at an aperture of $f/4$—in the enlarger to print. And remember, these negatives won't look like panchromatic negatives.

I exposed two identical contact sheets of landscape images for different amounts of time to produce two noticeably different results. Wanting to read the thinner negatives, which recorded less infrared and were usually exposed at a high ISO rating, I exposed this contact sheet for 12 seconds.

Next, in an effort to read the denser frames, which recorded more infrared and were ordinarily exposed at a low ISO, I exposed the other contact sheet for just 8 seconds.

PRINTING INFRARED NEGATIVES

Infrared negatives are often difficult to read because they tend to be dense. Sometimes it is necessary to make a work print to see exactly what information the negative contains. If the negative is both dense and dark, in order to get a print you might have to use the aperture wide open ($f/2$) on the enlarger for 30 seconds or more. In some situations, you might even have to print a negative for 2 to 3 minutes.

Multigrade papers are a good choice to use for printing infrared negatives. You can add contrast to a flat negative or soften a too-contrasty negative through the use of a filter. Most paper companies are changing over to producing variable-contrast or multigrade papers because of the convenience, the quality, and the economics for both the manufacturer and the consumer.

When you print on graded fiber papers, you can use a double bath for the developers to control the contrast. The first developer is Selectol Soft (1:2), and the second is Dektol (1:2). Selectol Soft is a warm-tone developer that gently develops prints slowly and opens the tonal values in the print evenly.

Dektol is a more aggressive developer that prints faster and gives you more contrast.

The print always goes into the Selectol Soft first and then into the Dektol. As a starting point, give the print 1 minute in Selectol Soft and 1 minute in Dektol. This can vary. For example, if the print needs more snap or contrast, give it $1/2$ minute in Selectol Soft and $1^1/2$ minutes in Dektol. And if the print needs less contrast, perhaps $1^1/2$ minutes in Selectol Soft and $1/2$ minute in Dektol. This is a good contrast control for graded papers.

Many of my infrared prints are handcolored. I choose papers that will accept coloring mainly with pencils and that need no precoating. Two new resin-coated (RC) papers, Kodak's P-Max Art RC and Luminos's RC Rough, are smart choices for handcolorists. Environmentally they don't require as much water to wash them archivally. Many proponents of RC papers claim that they are even more archival because the resin coatings are better and will prevent fixers from getting deep into the fibers of the papers (see page 152).

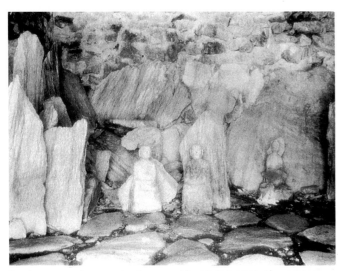

For these two photographs, I exposed Kodak ISO 200 infrared film for 5 seconds. I printed the negatives on Ilford's multigrade, matte-surface paper. The matte surface emphasizes the grain structure in the negative. Here, because of the thin negative, the final image has a pencil-sketch look.

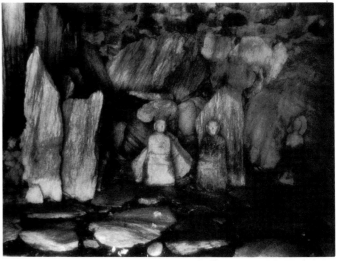

Next, I exposed the dense negative for 10 seconds. The result: a charcoal-like rendering.

I handcolored this print of a dockyard in Bermuda with oil pencils.

For this shot of Tattiana in the forest, I handcolored the print with oil pencils to create an enchanted look.

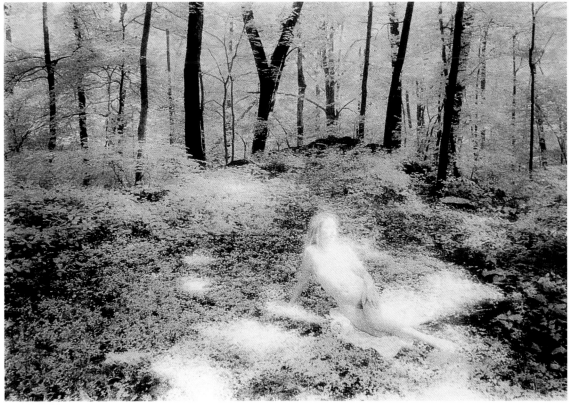

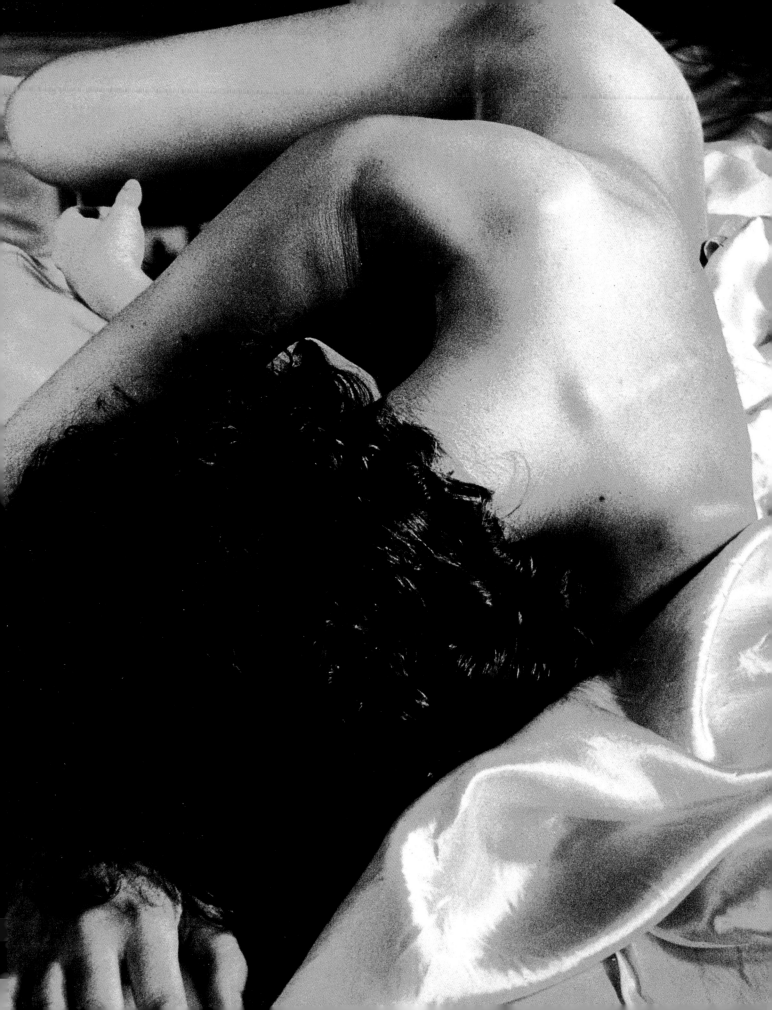

BLEACHING AND TONING

Selectively bleaching and toning a black-and-white print will generate a high-quality image; however, you must start with a quality image. It must exhibit good contrast, deep blacks, clean whites, and a distinct midtone separation. In other words, the "snap" has to be in the print from the beginning.

Bleaching and toning techniques are wild cards. When you play with them, make sure that they aren't taking away from your image, but adding to it. They can also be quite seductive. For example, the beauty of color can overpower the mind, making viewers forget the image content at hand. Bleaching and toning comprise a creative process, one that is similar to painting. To do this successfully, you need to be in the right mood and to have plenty of time. Otherwise, you might get sloppy and mess up a lot of good prints.

Through this fascinating two-part process, you can pull color from a black-and-white photographic paper via the reaction of bleach and selenium on it. The different colors are the product of several variables. These are: the color of the paper base, the kind of emulsion coated onto the paper base, and the types of developers and fixers used.

After printing "Sleeping Nude" on Agfa Portriga Rapid #111 paper, I split-toned the image with Berg's Brown/Copper Toner. I wanted to create a surreal look, as well as to accentuate the light playing on the body and on the sheets.

HANDLING THE PRINT

You have many combinations of papers and developers to choose from. Your choices depend on the colors you want to obtain, as well as the look of the final print you wish to present. For example, a chloride paper developed in Selectol Soft provides warm colors in the process; these include yellows, rich reds, and reddish or rusty browns. A bromide paper developed in Dektol, on the other hand, produces cool colors, such as mauves, dark browns, dark reds, dark reddish browns, and pinks.

Developing the Print

For this process, my paper of choice is a glossy, warm-toned, chloride or chloride/bromide paper, such as Agfa Portriga Rapid #111 paper or Agfa MCC #111 FB paper. When printing, you should print at least one stop darker than usual, so that the print will contain some density. I prefer to develop prints in a combination of two baths, Selectol Soft and Dektol. This enables me to play with the degree of contrast in my finished print.

Let the print develop in Selectol Soft (1:2) anywhere from 1 to 1^1/$_2$ minutes. This gentle developer tends to open up dark areas and to give the image a warm tone. And the more time the print spends in Selectol Soft, the warmer the final image. (Keep in mind that this warm tone plays a role when you bleach a print.)

Pull the print from the first bath when you see a sketchy, almost pencil-like drawing of the image appear. Allow some of the Selectol Soft to drip off before placing the print into the second developer, Dektol (1:2). The Dektol will increase the contrast and fully develop the print.

It isn't necessary to utilize two developing baths. You can use one or the other, or combine the two. However, Selectol Soft gives the image better colors during the toning portion of this process. Finally, if you do use a combination bath, be sure that the time the image spends between both developers totals at least 2 minutes. Otherwise, the paper won't reach its full potential, or density maximum (D-Max). This printing term refers to the density of the silver in a paper, which is what provides contrast between deep blacks and great whites.

Processing the Print

Once you develop the print, the next step is to process the print normally via a fixing agent, or fixer. This substance is also referred to as "hypo" because most fixing agents contain sodium thiosulfate, which was once known as sodium hyposulfite. Ammonium thiosulfate is used in rapid fixers. This compound seems to react better than sodium thiosulfate with the bleach and produces some interesting colors.

Be sure to use only half the recommended amount of hardener. The hardener in a fixer is usually a substance like potassium alum that hardens the emulsion of the print, thereby preventing damage from abrasion. When you use only half the amount of hardener, the print is sufficiently protected, and the emulsion is strong enough for reworking yet vulnerable enough for bleaching and toning.

After fixing the print, place it in a hypo-clearing bath. Hypo-clearing agent contains inorganic salts that remove fixer more rapidly than just washing in tap water. Mix the clearing agent according to the package directions, and then soak the prints in a tray filled with the hypo agent for 3 minutes. Next, wash the prints it for at least an hour. This will cut the wash time in half and clear away the fixer more thoroughly.

At this point, it is time to dry the prints on Fiberglas screening, face down. Keep in mind that Fiberglas doesn't rust. And by placing the prints face down, you avoid the water spots that can leave rings on the fiber papers and mar your images. If, however, you're using RC papers, you can position them face up because the resin coating will allow the water to dry without forming rings or spots.

Bleaching the Print

You don't need to complete this step in the darkroom. Any well-ventilated room with good illumination and a source of running water is sufficient. I find that having my favorite music playing in the background seems to help my "painting."

Mixing the Solutions

Understanding how the bleaching process works is the key to obtaining good results in the final image. Reducers have the same type of chemical action as bleaches. The compound used in this step is Farmer's Reducer. The active ingredient in Farmer's Reducer is potassium ferricyanide. Some chemical dictionaries list this as poisonous, while others don't. Although it doesn't emit cyanide gas during normal use, it does

cause skin irritations. You should wear gloves when you work with it, especially if you have cuts or other abrasions on your hands.

To activate it, you mix together two stock solutions, Solutions A and B, which you keep separate until needed. Keep in mind that when you combine Solution A and Solution B, Farmer's Reducer has a very short life: it lasts only approximately 5 to 10 minutes. By mixing small batches at a time, you can get the most out of your chemistry and work in a relaxed fashion.

Potassium ferricyanide changes the black (metallic silver) areas of a print into a silver salt that dissolves in fixer (hypo). So unless you use a fixer in conjunction with or after the potassium ferricyanide, the altered silver compounds will eventually stain the print. Fixers contain acids, so if any fixer residue is left in the paper, it will eventually cause a yellow stain. Kodak Rapid Fixer is a good choice here (see the chart below). Be aware that the potassium bromide, although not integral to the workings of the bleaching process, prolongs the life of the reducer by 30 percent.

If you keep these two solutions separate in well-stoppered, dark bottles out of heat and bright light, they'll last about six months. Pour them together right before you are ready to use them. Mix only a small amount at one time. Mix Solution B into Solution A until it is the color of lemonade. (If you mix Solution A into Solution B, the potassium ferricyanide might splash into your eyes.) The darker the color, the stronger the solution and the faster it will bleach your print. But with increased speed comes a lack of control. I find it much better to use a weaker reducing solution and have more control over the entire process.

BLEACHING FORMULA FOR PHOTOGRAPHIC PAPERS

Stock Solution A

Water	16 ounces
Hypo (Stock solution of fixer)	4 ounces

Stock Solution B

Water	8 ounces
Potassium ferricyanide	2 ounces
Potassium bromide	1 ounce

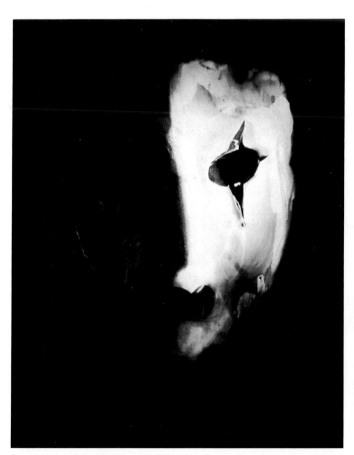

I made this original black-and-white print of one of my images, entitled "Mask," on Agfa Portriga Rapid #111 paper.

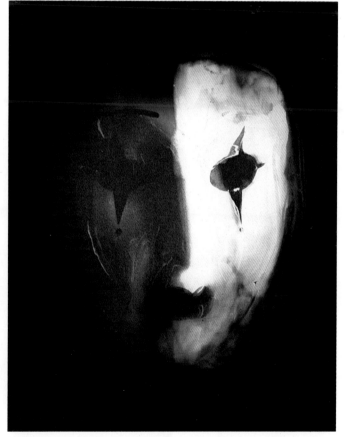

Here, I selectively bleached and painted "Mask" with selenium.

Applying the Bleach

The brushes you use for this step don't have to be expensive. Just buy some Chinese bamboo brushes, sizes 2, 4, and 6. These cost between $1.50 and $3.00 each. A 1-inch size Hake brush, which runs about $6.00, comes in handy for bleaching large prints.

For tiny areas, work with Sceptre brushes, whose price start at $2.50. They range in size from 00 to 6. If, for example, you're bleaching the whites of a person's eyes, a size 00 brush will do. These tools, made by Winsor & Newton, have the advantage of having a ferrule, which is a metal tube that connects the brush and the handle, that resists corrosion when it comes in contact with selenium toner. Once again, be sure to work in a well-ventilated room and to wear surgical gloves, which are available at pharmacies and grocery stores. Selenium is toxic and can be absorbed through the skin.

Soak your print in warm water, with a temperature of about 70°F, for a few minutes. Warm water tends to open up the fibers in the paper faster and more evenly than cool water; the heat also helps produce better colors. Then lay it flat, face up, on a piece of glass, and squeegee it off. Next, mix the Farmer's Reducer. After you dip your brush into the bleach, drag it across the lip of the container or give it a little shake to get rid of the excess bleach. You don't want bleach landing on your print indiscriminately.

As you carry your bleach-filled brush across your print, use a blotter of some sort underneath to avoid mishaps. You can use a folded paper towel or a sponge. Apply the bleach on the area you wish to lighten. Be careful with areas that are already light in tonality; they'll bleach quickly. Bleach areas where you wish to alter the tonality of the image, change a color, or add color. For example, I might decide to bleach a rock and paint it with toner, so that I get a rusty brown color. If you were working on the same print, however, you might choose not to bleach the rock but just to apply selenium, so that it turns mauve or purple.

Don't let the bleach puddle. If this happens, the final print will look muddled. When you want to stop the process, or if you make a mistake, use water to halt the bleaching action. I work with a long hose attached to a faucet. This setup enables me to squirt warm water, between 68°F and 70°F, on a print whenever I wish. Then after rinsing the print, gently squeegee it off and bleach it again. It is better to work in small areas at one time so that you retain control of the process.

Once you've bleached all the desired areas, rinse the print again. This time, however, use hot water with a temperature of 100°F to 120°F, or soak the print for 1 or 2 minutes in hot water. I think that it is easier to rinse a print with hot water from a hose rather than to have a tray of hot water ready. I also find that the water in the tray cools down too quickly. Finally, squeegee the print one more time.

For this shot of a Venice Bridge, I printed the image on Luminos Flexicon Mat Surface fiber paper. I cut the paper in five strips and toned it with Fotospeed odorless sepia toner in five different dilutions. Starting at the bottom, these were 5ml, 15ml, 30ml, 75ml, and 100ml.

Toning the Print

Next, using a fresh brush, begin to paint with straight selenium. Selenium works by combining with the metallic silver in the print to form a compound that is much more stable than silver in its natural form.

Therefore, a print toned in selenium is archival quality. Selenium also protects the silver image from airborne sulfurous gases and other harmful compounds that may adversely affect the print. However, as good as selenium is for your print, it is deleterious to your health. And because the skin readily absorbs this chemical, you should wear gloves when you work with it.

Watch carefully as the selenium comes into contact with the bleached areas of the image. The compound will change from a flaming orange/red, to deep red, to rust, to purple, and to brown quickly. Again, work in small areas, one at a time. Like the reducing action of bleach, the toning action of selenium is arrested by water. Keep in mind, though, that it is costly to paint on too much toner and have to wash away the excess to keep a particular color in an area. It is also unwise to put large quantities of the substance into the environment.

Use plenty of hot water to rinse the selenium toner. This keeps the print warm, thereby speeding up the action of the selenium and giving you intense colors. It is also important to use lots of water in order to dilute the selenium as it goes down the drain.

If you want to obtain purples and mauves, apply selenium in areas that haven't received any bleach. Again, watch the resulting action carefully. As soon as you see the desired color appear, apply water to the print to preserve it. For example, appealing shades of lavender and purple appear where the print or a portion of the print was solarized during the printing process.

You can work with other toners to produce different colors, such as brown toners, sepia toners, blue toners, and poly-toners. Remember, though, that all of these compounds contain sulfides. During the toning process, they emit a gas that is as bad for you as it smells.

Luminos's Fotospeed toners have recently hit the market. They come in green, blue, copper/red, selenium, sepia, and gold. The sepia toner is an odorless toner that produces a color range of yellow/brown to dark brown by mixing different dilutions. It is also formulated to prevent the blue spotting that traces of iron in tap water cause. Best of all, perhaps, is that the bleaching-and-toning process doesn't make your workspace smell like rotten eggs.

When you're finished bleaching and toning, you might think that your print looks flat or that you've overbleached. If this occurs, you can redevelop the whole print or redevelop a portion of it with a brush dipped in a solution of Dektol (1:1) to bring up some contrast. Because of extensive bleaching, the entire image won't be redeveloped; however, enough of the blacks and some of the midtones will reappear. This, in turn, will give the print more contrast.

I made this shot, which I call "Stone Carving," in Santo Domingo. I printed it on Agfa Portriga Rapid #111 paper and selectively bleached the image and then painted it with selenium.

Refixing the Print

When you're satisfied with a print, rinse it off with water and refix it. If you're working with several prints at one time, simply place the prints in a holding bath with running water until you're finished with all of them, and then refix them. Refixing the prints is an essential part of the process: it removes the dissolved silver salts that the bleaching action deposits.

It is important to refix a print even if you've mixed the potassium ferricyanide with hypo. You

After printing "Cliff Lizard" on Agfa Portriga Rapid #111 paper, I selectively bleached and toned it with selenium.

must make sure that all of the altered silver compounds are removed. This guarantees that the print won't be stained later. Use a print-fixing bath of 1:2 with the full amount of hardener instead of the standard 1:1 ratio from a stock solution of fixer. I prefer a 1:2 fixer/water dilution because the ammonium thiosulfate in the rapid fixer bleaches out some of the color from the prints when used full strength. Fix for around 3 minutes.

If you don't use a 1:2 fixer with the full amount of hardener in it, you'll have to put the print in a hardening bath for 2 minutes after fixing it. This bath should consist of one part Kodak Liquid Hardener and 13 parts water (*not* the leftover Part B from Kodak Rapid Fixer). After the hardening bath, hypo-clear the prints for 3 minutes, and then wash them for an hour.

Drying the Print

You should dry prints on a Fiberglas screen, face down. If they curl after drying, lay them on a clean, cool surface, such as glass or metal. Then place a metal print flattener on top of the pile, and add weight to the top. I had a print flattener made out of a 24 × 36-inch piece of stainless steel; it has a lip on two ends for easier lifting. I weigh down the flattener with a pile of books. Leave the prints this way overnight or until they flatten out. Prints tend to curl more in drier climates, so if your prints continually pose this problem, you might need to install a humidifier in your home or darkroom.

For "The Arm," I once again made a black-and-white print on Agfa Portriga Rapid #111 paper and then selectively bleached and painted the image with selenium.

CREATING PSEUDO FLESH TONES

To produce various effects, try bleaching down to a flesh tone on a black-and-white print. Of course, this technique works on any imagery that you wish to add a flesh-like or light-brown tone to. My papers of choice for this process are Portriga Rapid #111 and #118, but Agfa's new multigrade papers, Kodak's Poly-Fiber, and Oriental Seagull work well also.

1. These are the supplies I use for bleaching pseudo-flesh tones in black-and-white prints.

After archivally developing and drying the prints (developing, stop bath, double fixing baths, using Rapid Fixer with only half the hardener, hypo-clearing, and washing for an hour), select the prints you wish to tone, rather than toning the prints during the initial printing procedure. By waiting and selecting the prints to be toned at this point, you avoid wasting a lot of toner on prints that you won't use. Selenium is quite expensive, so it is more economical to purchase the product in gallon-size jugs by special order from your retailer than to purchase small, 8-ounce bottles.

Tone the selected prints in selenium (1:20) for 2 minutes at 70°F. I always print the figure area one to two stops darker than a typical skin tone in a regular black-and-white print. This way, there is some density in the silver print to react with the selenium and later to reduce with the bleach.

After toning the prints, rinse them, put them in a hypo-clearing bath for 3 minutes, and wash for an hour. Dry the prints face down on Fiberglas screening. I mark the prints that I've selenium-toned with a small "s" on the back for future reference.

Toning and bleaching prints on the same day isn't advisable. The emulsion becomes too soft and begins to lift away from the paper backing. Remember, you have only half the usual quantity of hardener. The print is fragile.

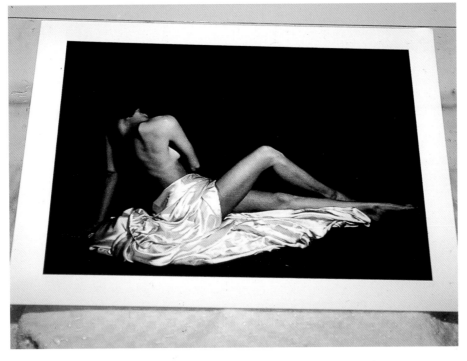

2. I made this black-and-white print using Agfa Portriga Rapid #111 paper and then selenium-toned it.

At a later date, to obtain a pseudo-flesh tone, select one of these prints and soak it for a few minutes in warm water. While the print is soaking, mix the Farmer's Reducer to a fairly weak and therefore manageable strength. Again, it should look like the color of lemonade.

Next, lay the print, face up, flat on a piece of glass and gently squeegee it off. Using a small Sceptre brush, dip into the bleach and begin to reduce the figure area. You don't need to press the point of the brush onto the print. You're merely applying the chemical (bleach) to the paper in this process, so let the chemical do the work.

Work a small section at a time, carefully watching the bleach for reduction. Be sure to stay within the figure area. Use water to stop the action of the bleach. I always keep a blotter material handy (cotton swabs work well) in order to catch the bleach if it begins to spread before I can get the water on it.

The color of the print will change locally where you applied the reducer, becoming brownish or pinkish-beige. However, if you work too fast and reduce the area too much, the print will look bleached down. There is no going back when you bleach down to the print base, so work carefully and slowly, stroke by stroke in a small area.

If the bleach crosses the figure boundary, or if it drops or splashes somewhere you didn't want it to, you have one chance to redeem the print. Mix a solution of Dektol (1:1), and then apply it with a brush or cotton swab to the undesired bleached area. This section will redevelop provided that you haven't bleached down to the paper base. Be aware that this will work only once. If you go back again with the bleach and try to redevelop that particular spot, it will turn blue.

(I've found it almost impossible to do a face because it is so easy to bleach away features, such as eyebrows and lips. And it is very hard to redevelop features without making the face look painted or manipulated. This is the reason why the figure studies that I've selected for this process are faceless. Hair can be tedious, too, but not impossible—as long as you want a blondish hair color.)

After you finish bleaching the figure, rinse thoroughly and re-fix in your usual fixer for 3 minutes. The fixer might slightly reduce the area that has been bleached, so don't take the bleaching too far. Hypo-clear 3 minutes, and wash for an hour. Dry, face down, on Fiberglas screening. In the beginning, you'll lose some prints, but with the right attitude, the work will be fun and the results will be absolutely exciting.

3. Here, I'm starting to selectively apply the bleach solution.

4. At this point in the printing, the flesh tones are beginning to show.

5. The next step is to apply water to stop the action of the bleach.

6. I use a squeegee to get the water off the surface of the print.

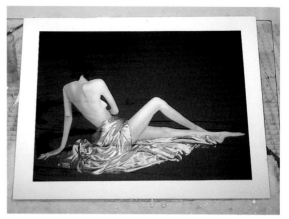

8. At this stage, the bleaching is complete.

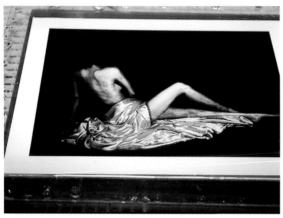

7. This is the half-finished print.

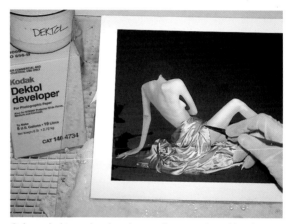

9. I needed to redevelop the small areas where bleach crossed the borders with Dektol.

10. The finished print looks just the way I wanted it to.

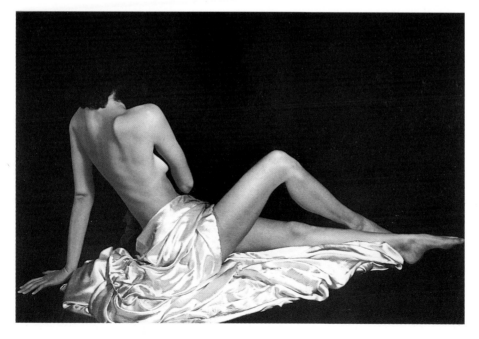

COPPER SPLIT TONING

This technique works well on just about every subject, including nudes and landscapes. Select a contrasty negative, or use a multigrade paper and add contrast with a #3½ or #4 filter. Print your image darker (about one stop more) than ordinarily acceptable in Dektol (1:2) for 2 minutes. For a stop bath, use acetic acid mixed 2 ounces to one gallon of water, and Kodak Rapid Fixer (1:1) with half the hardener.

It is best to use a double fixing bath to ensure that the prints get the full 6 minutes and are properly fixed. Fix your prints for 3 minutes, and place them in a holding bath until you're finished printing. Then refix your prints again in fresh fixer for 3 additional minutes, rotating the prints from bottom to top constantly. Accuracy here is important: if the prints are fixed too long, they won't split.

The next step is to tone the prints in selenium. Dilute the selenium (1:10) with water, and tone them for 30 seconds at 75°F. Transfer the prints to a bath of hypo-clearing agent for 3 minutes, continuously agitating them. Wash toned and hypo-cleared prints for an hour in an archival washer.

Selenium toner is a controlling factor in the copper split process. Be extremely careful to tone the prints one at a time, keeping both the temperature and the length of time constant. This procedure is critical. If the prints aren't washed thoroughly, fixer spots will show up in the last step of the copper split process. This is a waste of time and money, to say nothing of what it does to your temperament. Dry the prints face down on Fiberglas screens overnight.

Whenever you are ready to tone—the next day, the next week, or the next month, place the prints in a tepid water (68°F to 70°F) bath for 5 minutes. The emulsion will swell and soften for even toning. If you use well water, it is wise to soak the prints in distilled water, as well as to mix your Berg's Brown/Copper Toner with distilled water. This will cut down on the possibility of small blue spots on the final print, which are caused by iron contamination.

While the prints are soaking, mix the toner, the Dektol (1:4), the stop bath, and the rapid fix with half the hardener. Always use fresh chemicals. Place the prints, one at a time, into the toner until they turn deep copper. Different papers take different lengths of time to fully copper tone; some take as long as 5 minutes. Keep an eye on each print since they might float up in the center and not tone evenly. Agitate the prints gently every few minutes. When you see that a print is very copper, pull it out and place it in Dektol (1:4). Agitate it gently, and watch it

very closely. The image will begin to change as soon as you put it in the Dektol. When you like what you see, pull out the print, place it in a stop bath, and fix it with Kodak Fixer (the powdered chemistry). Then wash the prints for an hour.

You can use Kodak Rapid Fixer at this stage if you dilute it 1:2. It will, however, lighten the color somewhat. If this is a problem, use the powdered fixer at this stage instead. You must, though, refix the print to get rid of the dissolved silver salts. If you don't, the print will stain later.

Individual papers and paper grades affect the copper split different ways. For example, suppose that you want a dramatic dark copper split with sensuous gray tones. You can use either Ilford RC MG IV or Oriental Seagull, surface G, grades 3 or 4 paper. Luminos RCR grade 3 paper also produces beautiful and dramatic effects, especially when used with a contrasty negative.

Agfa papers provide a soft, pink-gray, watercolor-wash effect, particularly if you develop the initial print in Selectol Soft (straight) and then print it about 2 stops darker than normal. If you want the soft watercolor-wash effect, don't selenium-tone the print.

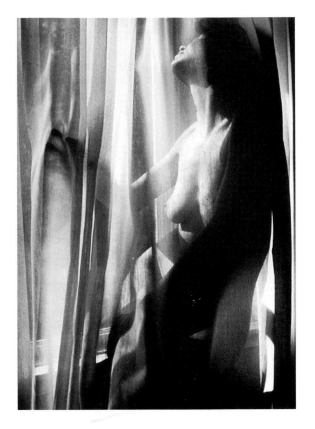

After you process (using Selectol Soft), wash, and dry the prints, redevelop them using Selectol Soft (1:2) during the toning stage. Follow the rest of the procedure described earlier. If the print looks too pink without any white highlights, it is best to process the print and let it dry. Then the next day, after the emulsion has had time to harden—or the next week, or whenever you are in a good mood—soak the print in water and redevelop it carefully, using Dektol (1:4) or Selectol Soft (1:2). Clearing the whites requires only a swishing. Next, put the print in a stop bath, refix (with a powdered fixer) for 2 minutes, and then wash again thoroughly. If you wait to do this the next day, the print's emulsion will have time to dry and harden. In addition, you'll have more control, and you won't lose your print or your patience.

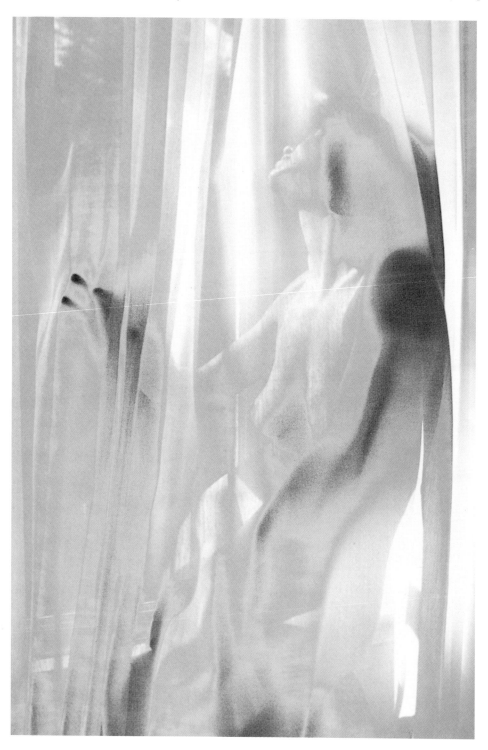

I wanted a variation of this image, entitled "Melancholy" (opposite page). So I used the copper split technique to create a different effect (left).

COLOR POSTERIZATION EFFECTS

Through this process, the tones of an image are separated into distinct, unreal color combinations. You can achieve the following posterization effects with Berg's Brown/Copper Toner. A contrasty infrared negative works very well for this posterization technique. Use Kodak's Rapid Fixer with half the hardener when processing the print. Two excellent paper choices are Luminos RCR grade 3 paper and Luminos fiber grade 3 paper, Classic Pearl warm tone. (I must admit that although other papers might work effectively, both of these Luminos papers produce such fantastic results that I haven't tried any other paper.) Both papers tone well in Berg's Brown/Copper Toner. If this is the effect you want—brown-toned, not posterized—be sure to use a fixer other than Kodak Rapid Fixer when processing your final print. If you use that fixer, the ammonium thiosulate in it will mix with the Berg's toner and automatically posterize. But when you use a nonhardening fixer,

the result will be a beautifully brown-toned print in the tone of your choice.

Next, develop the print in Dektol (1:2), and print the image about one stop darker than normal. After processing the print and washing it thoroughly, dry the print and then tone another day. This time span lets the emulsion harden and enables you to be more selective about the prints you really want to tone.

Then mix the Berg's Brown/Copper Toner, soak your print in a water bath for 3 to 5 minutes, and then place the print in the toner. The print will tone brown and a little coppery in the dark areas and split between the highlights and the dark sections, thereby rendering unusual and surreal posterized effects.

Remember, the controlling agents here are the Rapid Fixer and half the customary amount of the hardener. If you don't use this combination, the print will merely tone brown and then copper without the split or the posterization effect.

SUGGESTED CHEMICAL-MIXING MEASUREMENTS*
Spoon measurements + Water = Working Solution

Total Solution Amounts	Approximately ½ pint		Approximately 1 pint		Approximately 1 quart	
Chemical Dilution	Powder (in ounces)	Water (in ounces)	Powder (in ounces)	Water (in ounces)	Powder (in ounces)	Water (in ounces)
D-76 Straight	1T	7½	2T	15	¼ cup + 1t	32¼
1:1	2t	10	1T	15	2T	29¼
1:2	1t	7½	2t	15	1T + 1t	29¼
1:3	1t	10	2t	20	1T	29¼
Dektol Straight	1T + 2t	8	3T + 1t	15¼	¼ cup + 3T	33¼
1:1	1T	9½	1T + 2t	15¼	3T + 1t	31¾
1:2	2t	9½	1T	14¼	2T + 1t	33¼
1:3	1t	6¼	2t	12¼	1T + 2t	31¼
Selectol Soft Straight	2t	8¼	1T + 1t	16½	2T + 2t	33
1:1	1t	8¼	2t	16½	1T + 1t	33
1:2	1t	12¼	2t	24¼	1T	37
1:3			1t	16½	2t	33
Kodak Fixer Powder Straight	2T + 1t	8	¼ cup + 1T	17¼	½ cup	28¼
Kodak Hypo Clearing Straight	1t	9¾	2t	19½	1T	29¼

* Spoon measurements have worked well for me for the last 10 years: T = tablespoon; t = teaspoon. I prefer to mix chemicals only as I need them. I also make the solutions fresh for each printing session. Please note: the water volumes shown here are rounded to the nearest ¼ ounce.

To produce the color posterization effect on "Grand Canal, Venice," I worked with Berg's Brown/Copper Toner on Luminos Classic Warm Tone paper.

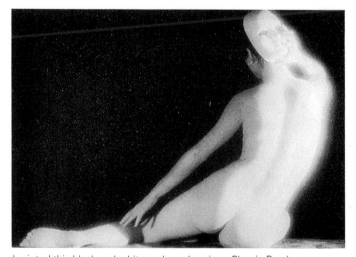

I printed this black-and-white nude on Luminos Classic Pearl paper.

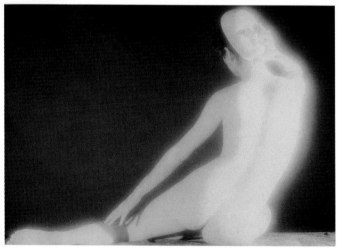

I achieved this posterization effect with Berg's Brown/Copper Toner and fixed the print in Kodak Rapid Fixer with half the standard amount of hardener.

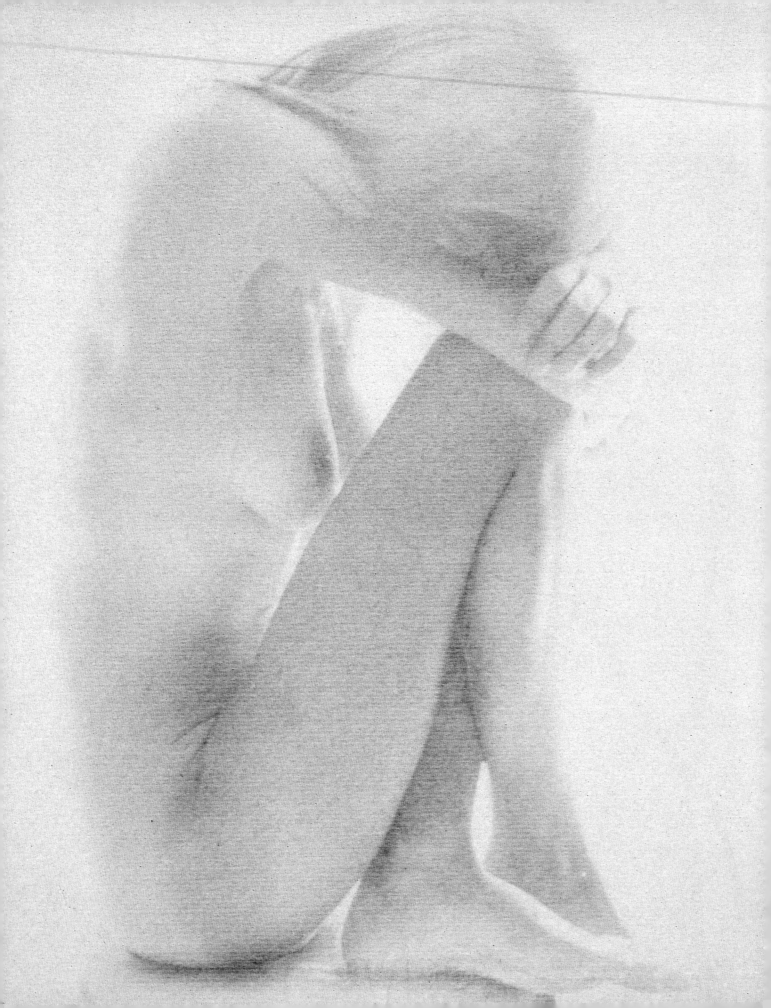

WORKING WITH LIQUID EMULSIONS

A unique way to enhance the emotions captured in an image is to print on artist papers that have been coated with liquid-silver emulsions. The combination of image and texture often magnifies the message that you wish to send. For example, an ancient ruin in Turkey would look better on a rough watercolor paper, such as Fabriano Artistico paper, because the paper can give the stones a tactile quality that a glossy or matte photographic paper can't.

Photographers are no longer limited by photographic papers. Photographers can now make various choices based on the image in question and how they want that image to be seen, much like traditional printmakers. When you consider paper choices, remember that it is easier to coat heavy artist papers, such as 140 lb. and 300 lb. stocks, because of their water strength. A 300 lb. etching or drawing paper that lacks sizing is more absorbent than a 300 lb. watercolor paper that has light-to-heavy sizing. These thick artist papers greatly enhance the image that is printed on them. They are quite strong, don't crinkle or bend, are visibly textured, and are worth the extra expense. Hot-pressed papers, which are hard and smooth, yield a photographic look, while cold-pressed papers, which are rough and textured, produce a painterly feel.

This freedom can help photographers develop and express their artistic personalities. Enjoy what Alfred Stieglitz once referred to as "the working out of the beauty of the picture as you see it, unhampered by conventionality—unhampered by anything—not even the negative."

For this nude study, I used Silverprint diluted 1:2 and Fabriano Artistico hot-pressed paper.

EMULSION TRANSFERS

Two coating emulsions are available in America: Silverprint, produced by Kentmere Ltd. in the United Kingdom, and Liquid Light, made by Rockland Ltd. in the United States. Both Silverprint and Liquid Light contain a small amount of phenol as a preservative, so avoid prolonged skin contact when working with it. Use thin rubber gloves, and apply the emulsions in a well-ventilated room. Both of these emulsions, like photographic papers, are blue-light sensitive.

Although you can apply both emulsions in the darkroom using a red or orange safelight, the coated papers must dry in complete darkness. When you are ready to print on coated papers, it is once again safe to work with the red or orange safelights.

Silverprint has a high gelatin content that makes it viscous, or thick and sticky, enough to be applied to a variety of surfaces; however, if you want to apply it to a porous surface, such as glass or ceramic, a

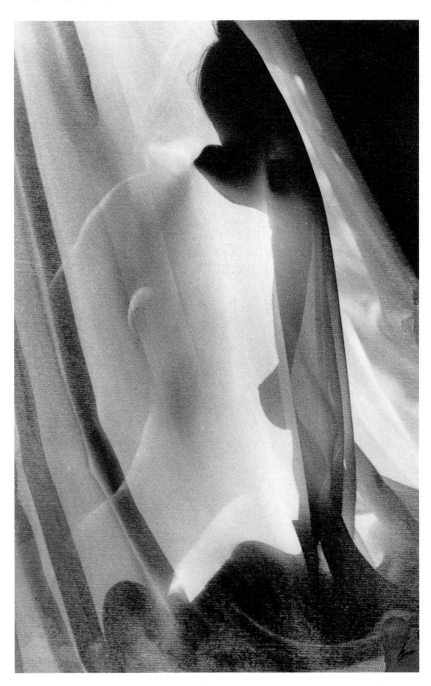

I worked with concentrated Silverprint and Fabriano Artistico hot-pressed paper in order to create this nude silhouette.

pre-coating of polyurethane varnish is recommended. With Liquid Light, you must first scrub a surface with a sodium carbonate (soda ash or washing soda) and then pre-coat it with a special "subbing" material. The subbing process fuses the Liquid Light to the ceramic or glass surface.

Both Silverprint and Liquid Light are solid in their original state and must be liquefied before application. To do this, simply place the closed containers into a hot water bath. Silverprint liquefies between 110°F and 120°F. Higher temperatures run the risk of fogging the contents. Although the instructions that come with Liquid Light state that a water bath of 130°F can be used to liquefy the contents, I find that this temperature fogs the emulsion. I highly recommend not using a temperature over 105°F to liquefy Liquid Light. Both products take about 45 minutes to change from solid to liquid. Gently turn the bottle to test for liquidity; shaking causes air bubbles to form in the emulsion.

Papers coated with liquid-silver emulsions easily fog with light, especially blue light such as the light from a cold-light enlarger. If you expose a piece of coated paper under a cold-light enlarger and you have another print in the developer, the spill light from the enlarger will fog the developing print.

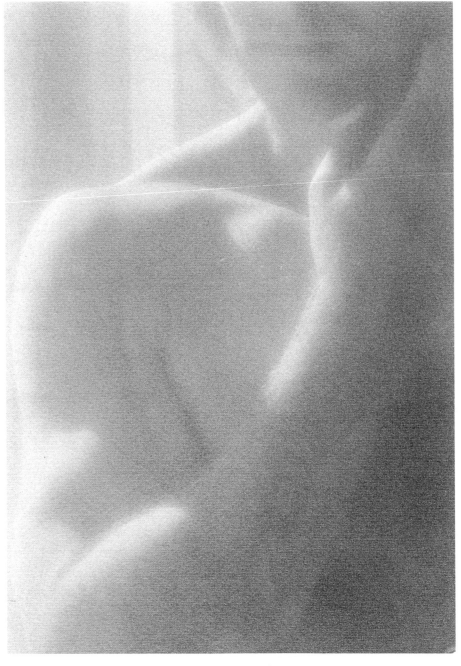

I made this ethereal nude, entitled "Charlie," on Fabriano Classico 5 hot-pressed paper. I coated the paper with Liquid Light diluted 1:1 and developed the print in Selectol Soft.

SILVERPRINT

Silverprint's emulsion is faster and has more contrast than that of Liquid Light. Silverprint is also easier to apply and doesn't fog as quickly from heat while liquefying. In addition, it has a high silver content and can be diluted to different levels of concentration. You can apply it in its concentrated form or at 1:1, 1:2, and 1:3 dilutions.

Silverprint is a straight bromide emulsion and yields results comparable to that of a #2, #2½, or a #3 grade photographic paper, depending on two factors: how you coat the liquid emulsion and how absorbent the receptor is. For example, a very absorbent paper won't produce the density of either a harder paper or of a hard, nonporous receptor.

For this nude, I chose Silverprint diluted 1:1; I then brushed it on cold-pressed paper to produce this gentle effect.

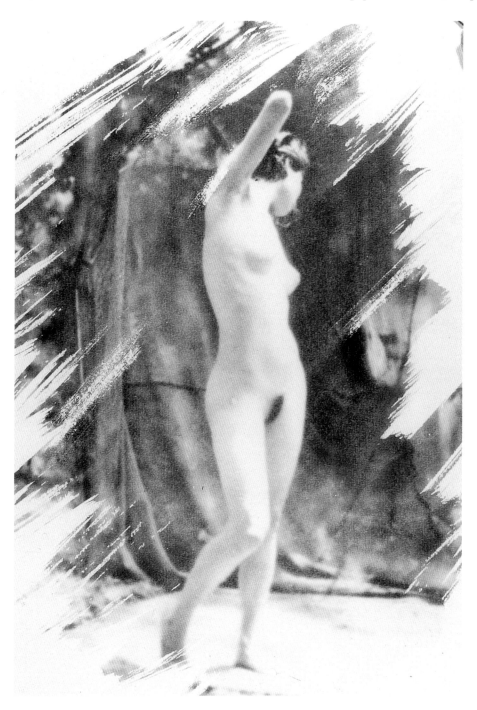

Coating Techniques

Under safelights (amber or red), gently pour some of the Silverprint emulsion into a graduate as if you were pouring a fresh beer into a glass. In other words, run the emulsion down the side of the graduate in order to avoid creating air bubbles. Place this graduate into another graduate containing hot water. This, of course, will keep the emulsion from solidifying while you're working with it. From time to time, soundly tap the graduate to release any air bubbles that might form.

The dilution of the coating is critical. A light (1:1 or 1:2) dilution results in a thin coat of the emulsion on the paper, contains less D-Max, and yields a gentle print with less contrast. Conversely, a thick coat of emulsion, straight or concentrated, provides a thick coat of the emulsion on the paper, contains more D-Max, and yields a hard print with more contrast.

You'll achieve a gentle print by brushing on the emulsion, whether the emulsion is in a diluted form or not. Conversely, you'll obtain a more contrasty print by pouring on the emulsion, once again regardless of the emulsion's physical state. In other words, the coating technique has at least as much of an impact on the final print as the dilution of the concentration of the emulsion.

When coating a print with an undiluted emulsion, I find it is easier to work with a sponge brush. Apply Silverprint with even pressure, and catch the overflow in a tray. Then place the catch tray in a hot water bath in order to keep the emulsion liquid.

Maintaining the emulsion at a consistently warm temperature seems to eliminate excessive bubble formation. Bubbles will leave circular rings on the coated paper, and these rings will naturally flaw the finished print. When putting the emulsion captured in the catch tray back into the graduate, be sure to pour slowly. If bubbles form on the top of the emulsion in the graduate, skim them off. Don't continue to pour more emulsion on top of these bubbles; doing so will only trap more air.

When you coat a print with a diluted emulsion, it is often easier to pour on rather than brush on the Silverprint. Simply position your paper toward the safelight and then pour on the emulsion from the top to the bottom of the paper, moving across and back and forth as you pour. Hold the wet coated paper at an angle toward the safelight to check for dry spots and bubbles. Tap the paper to remove bubbles, and turn the paper upside down and sideways to spread the emulsion. Be sure to tap the paper after each turn. Shake the excess emulsion into the catch tray. The heavier the paper, the more handling it can endure. Heavy paper, such as a 300 lb. paper, has the added advantage of drying flatter than light paper stock.

1. This is my typical setup for pouring Silverprint on paper. I make sure that I have everything I need, including the warm emulsion and a catch tray.

2. When I pour on the Silverprint, I hold the paper at an angle so that I can check for dry spots and bubbles.

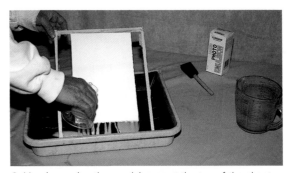

3. I begin pouring the emulsion on at the top of the sheet of paper and then continue down its length.

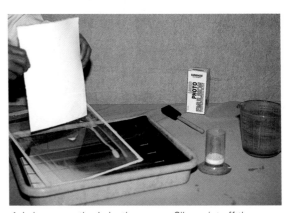

4. I always gently shake the excess Silverprint off the paper; this helps to eliminate bubbles.

Consider the following emulsion densities:

- Straight emulsion: great D-Max (deep blacks) and good details
- 1:1 dilution: good D-Max (less dense blacks) and good details
- 1:2 dilution: softer contrast, gentler, more high key, and fewer details
- 1:3 dilution: grainy, soft, diffused, and impressionistic; little or no contrast; loss of details

Whatever paper you select, it is essential that you mark the uncoated side so that after the emulsion dries, you can tell which side to print on. This is a simple but important tip. Mark a bold "X" in pencil on the back of the artist papers to be coated. If you forget to do this and later when the paper is dry you can't tell which side is coated, hold the coated paper in front of the safelight and turn it slowly. The coated side will have a slight sparkle.

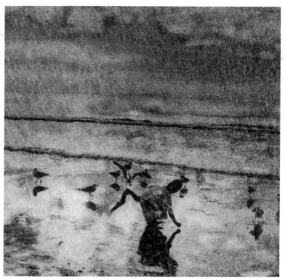

For this interpretation of "Samantha and the Seagulls," I coated Fabriano Artistico Rough paper with a 1:1 dilution of Silverprint.

For this city scene, I poured Silverprint diluted 1:2 on cold-pressed paper; I like the textured effect.

I made several
variations of
"Rubenesque Nude."
Although I used
Fabriano Artistico
hot-pressed paper
and Silverprint for all
four interpretations,
the strength of the
emulsion differed.
For the first print,
I worked with the
concentrated form
of the emulsion on
hot-pressed paper
(top left). The result:
a dark, dramatic
image. For the next
print, I switched
to a 1:1 dilution of
Silverprint, which
produced a lighter
print (top right). For
the third variation,
I opted for a 1:2
dilution of Silverprint
(bottom left);
the result is even
lighter. And for the
last interpretation,
I worked with
Silverprint diluted 1:3
(bottom right). Notice
the pronounced lack
of contrast.

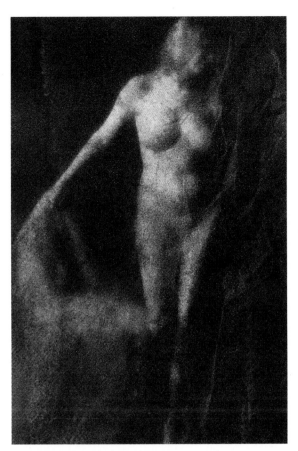
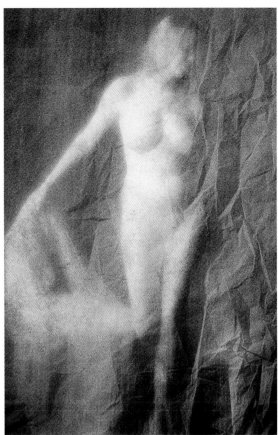
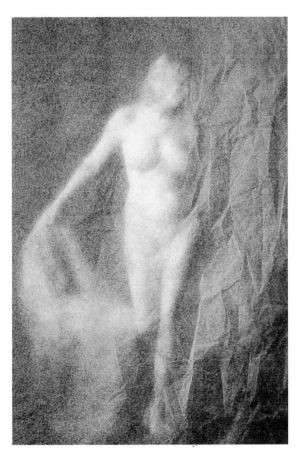
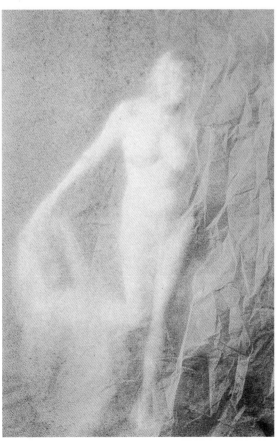

Drying Coated Papers

You can dry coated papers on any flat surface, such as Fiberglas screens. Naturally, you must dry the papers wet side up. You can also hang coated papers on a line to dry; just be sure to lay newspaper underneath to catch any drips. Coated papers that are dried flat tend to curl more than those that are hung to dry. It is possible to dry the prints more quickly if a fan is in the room circulating the air. A hair dryer on the cool setting will also speed the process along.

Remember, if the coated papers curl after print processing, lay them on a cold, glass surface and place a print flattener on top of them. Then weigh them down overnight or for a day or two until they are very flat. Another option is to place them in a Seal Dry Mount Press for a minute or two at a very low temperature. This will flatten the papers without melting the emulsion.

Printing Controls

When coating your own artist papers, you, as the photographer/artist, have all the controls. After you select your paper and decide how much to dilute the emulsion coating, you expose the paper to a negative of your own choosing. Then you determine which developer to use; this, in turn, dictates the tonality and contrast of the final print.

Developers

In terms of developing prints, the first issue you have to consider is heat. Don't place a coated paper in a hot developer (72°F or higher) bath; if you do, the emulsion will melt. Second, keep in mind that you can use developers to control contrast with the Silverprint emulsions. Dektol (1:2) gives the most contrast and rich, deep blacks. Selectol Soft yields a gentler, warm-toned image.

A combination of Selectol Soft and Dektol offers you even further control. Always use Selectol Soft developer first in a two-part developing technique. For example, if a print develops 2/3 of the time in Selectol Soft and then 1/3 of the time in Dektol, you'll achieve a warm-tone print that has good contrast and snap. Conversely, if a print spends 1/3 of the developing time in Selectol Soft and 2/3 of the time in Dektol, it will have good blacks and good contrast; however, it will be more open—have good details in the shadow areas—and will be slightly warmer in tone than a print developed wholly in Dektol.

The Stop Bath

Use a weak stop bath to avoid blistering. If you use a full-strength stop bath, the acid in the stop bath will cause the liquid emulsion to blister. The resulting blisters will eventually pop and ruin the coating by fragmenting it.

To make this print of "Venice Canal," I diluted Silverprint 1:1 and overprinted Fabriano Artistico rough paper in Dektol. I wanted to achieve the deep blacks that this developer is known for.

Fixers

Rapid fixers use ammonium thiosulphate, which can cause a bit of bleaching in the highlights. It is better to use a sodium-thiosulphate-based fixer, such as Kodak's powdered fixer. When working with a powdered fixer, you must fix the print for at least 12 minutes, especially if you're using a heavily coated, 300 lb. paper. You want to make sure that the print is properly fixed. The thick coatings on thick artist papers take longer to fix than the thin coatings on photographic papers.

If you overdevelop a print, you can easily "save" it by having a tray of the "rapid fixer" handy to bleach the image. Rapid fixers are also useful when you want to pull more detail out of a dark background. Simply fix your print on heavy artist papers at least 10 minutes, making sure that it is under the fixer at all times.

Washing

You need to wash prints for at least 30 to 60 minutes, especially if you use a very thick artist paper (140 lb. or higher stock). Wash in a single-slot print washer or in a wash tray, but be careful not to overload the tray with prints. The emulsion is soft and can be damaged by other papers rubbing against it, especially if you're working with coated, heavily textured papers. With 300 lb. papers, I wash a maximum of four prints at a time; with 140 lb. papers, I put a maximum of six prints in a tray at one time. The papers need room to float freely; otherwise they'll stack on top of one another and get stuck together.

If you use an archival print washer, be sure to put a screen or ruler or some such object across the top of the washer, so that the prints stay under the water. You can clip the papers to the divider panel with plastic clothespins to prevent the papers from floating. (Don't use wooden clothespins: they have metal clips that rust and ruin prints.) This is important. Artist papers tend to float, and the portion that does float to the surface won't get properly washed. If you then tone that unwashed portion, the residual fixer will react with the toner and cause unsightly stains. In addition, that section of the print won't be archivally preserved, so it will begin to deteriorate, and eventually the print will be destroyed.

Toning

Since emulsions are a conventional bromo-iodide, much the same as photographic papers, they react to toners the same way. With Berg's Brown/Copper Toner, it is possible to also obtain a split-toning or posterization effect on the coated papers. After washing the prints, lay them face up on Fiberglas screens or hang them to air-dry.

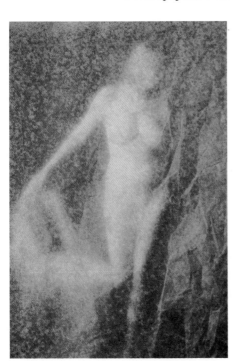

For this version of "Rubenesque Nude," I used Silverprint diluted 1:2, Fabriano Artistico Rough paper, and Berg's Brown/Copper Toner.

I transformed this architectural image by brushing a 1:2 dilution of Silverprint on cold-pressed paper and then sepia-toning the print.

Bleaching

It is possible to bleach for highlights or to reduce fog. However, you must wait until the print dries and the emulsion hardens. If you do this immediately after the first wash, you run the risk of damaging the soft emulsion from too much handling in water and in chemistry. You can, in fact, bleach prints a couple of days or even weeks later. If you inadvertently fog a print or overdevelop a print—in other words, make it too dark—you can use a bleach to lighten the emulsion much as you would an ordinary photographic paper.

You can either use the formula for bleach found on page 64 or mix a small amount of potassium ferricyanide crystals (a little bit goes a long way) with water until the solution is a lemonade-yellow shade. The darker the color of yellow, the faster and stronger the bleach works, and the less control you have. Remember, you can't save a print that you've bleached too far. For this reason, it is better to bleach with a weaker solution and have more control.

You can also apply bleach with a brush for the localized retouching of an image. But be aware that you must then refix and wash the entire print. It is important to refix the prints in order to remove the dissolved silver salts that the bleaching action deposited. Place the entire print in a tray of bleach.

After it is reduced to the desired point, pull the print and wash it off with running water for a few minutes. Then refix the print and wash it for 30 to 60 minutes. If you use a hypo-clearing bath, you can decrease the wash time.

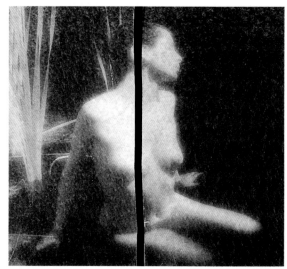

I made this two-part version of "Nude in Pond" with concentrated Silverprint on Fabriano Artistico rough paper. After fogging and overprinting the image, I bleached half of the print to show how bleach reduces fog and print density.

For this variation of "Venice Canal," I worked with Silverprint diluted 1:1; I reduced the print density via Farmer's Reducer, which is a bleach.

Coating Rocks or Wood

Silverprint works well on many different surfaces. It isn't always necessary to coat with a nonporous solution. In many cases, I use Silverprint straight or diluted 1:1 and pour or brush it on rocks and wood surfaces. The emulsion won't be even because some of the solution will soak into the rocks or wood. But this can lead to an interesting effect by letting more of the natural receptor's surface show through and become more of an integral part of the finished piece.

I like the rough, uneven effects you obtain with uncoated surfaces. The following simple procedure comes in handy when you focus on rocks or wood. First, lay the rock or piece of wood under the enlarger. Cover the top of the receptor with the light-tight black bag from an empty photographic-paper pack, and place a piece of white paper on top to focus on. Next, adjust the aperture to $f/11$ or so; you want just enough light to focus with. Turn off the enlarger light, and readjust the aperture to the desired f-stop. Remove the receptor's cover, and make the exposure.

Always have a test rock coated with the Silverprint emulsion for the proper print time. If your rock surface turns all black, you've given it too much light. Remember, Silverprint is fast. I have several test rocks that I can scrub off after the developer bath and use over again and again.

I printed this nude silhouette on a rock surface coated with Silverprint.

For this silhouetted variation of an architectural image, I coated a piece of wood with Silverprint.

TROUBLESHOOTING

Problem: The emulsion melts while processing.

Reason: The developer was too hot.

Solution: Keep all chemical solutions at 68°F.

Problem: Circular spots on the print.

Reason: Air bubbles have been trapped in the emulsion during coating.

Solution: Tap the graduate more often to release the bubbles. Skim the surface of the emulsion with a spoon to remove excess bubbles. Take a glass rod and pop the bubbles in the graduate. To eliminate the bubbles on the wet coating, tap the paper on its side to release them.

Problem: Irregular white spots on the paper.

Reason: The coating wasn't even.

Solution: Try another method of coating the paper, or coat more carefully. Check for any dry spots after you apply the coating.

When I created this version of a nude, I used a 1:4 dilution of Silverprint. This mixture was apparently too weak, producing a very grainy image with a discernible dot pattern.

Problem: Discoloration in the final print.

Reason: You might not have properly fixed the paper.

Solution: It is important to fix the papers at least 10 minutes, and be sure that they are under the fixer solution.

Problem: After you tone your print, you notice discolorations.

Reason: That portion of the paper wasn't properly washed. The fixer is still in the paper and is reacting with the toner.

Solution: Make sure that the entire print is under the water during washing. Heavy artist papers tend to absorb water and float.

Problem: No blacks in the print.

Reason: The develop was exhausted, or there wasn't enough coating on the paper.

Solution: Use fresh developer. Another option is to use the emulsion at a lesser dilution or use it straight. Remember, the more diluted the emulsion coating is, the less contrast the print has.

Coating technique might also be a factor here. Pouring on the emulsion versus brushing it on will give you more density. Some of the rougher papers will get a better coating if the emulsion is poured on. Some very absorbent papers need two coats. If this is the case, don't let the first coat dry completely before applying the second coat. Apply the first coat, wait 15 minutes, and then coat the paper again under a very low safelight.

Problem: Grainy look to the image.

Reason: The liquid emulsion was too diluted, or the paper's surface texture might have been too pebbly.

Solution: Use a more concentrated emulsion coating. If the paper is the problem, select a paper with a smoother surface.

Problem: Lines through the image.

Reason: The paper was coated unevenly. And if you used a sponge brush, you applied too much pressure.

Solution: Coat the paper more carefully. Use gentle, even strokes with the sponge brush in one direction only. Another alternative is to use the pouring method to coat the paper.

LIQUID LIGHT

The consistency of Liquid Light differs from that of Silverprint. It is stickier and solidifies much faster. Liquid Light's D-Max is much lower also. Liquid Light doesn't contain as much silver in the emulsion. Even at full strength, you can't get the contrast from Liquid Light that you can get from Silverprint. In fact, Silverprint diluted 1:2 provides more contrast than undiluted Liquid Light. It is possible to achieve more contrast using Liquid Light by aging papers for three to five days after coating. Of course, you must store the coated papers in a light-tight place.

Liquid Light is also slow. For example, printing a negative on a paper coated with undiluted Silverprint at *f*/4 took 7 seconds. The same negative printed on a paper coated with undiluted Liquid Light at *f*/4 using the same enlarger and the same developer (on the very same day) took 90 seconds. To increase the speed and contrast of Liquid Light, try adding developer to the emulsion as per the instructions.

Keep in mind, however, that this method is risky and can turn the emulsion gray. It is also expensive because you risk losing the sheet of coated artist paper. The primary problem with Liquid Light is its fickle nature; working with it is always a gamble. But when it works, the effects are beautiful.

If you print on freshly coated papers, you'll find that Liquid Light produces a gentle, high-key effect in the finished print. The image looks like a beautiful pencil sketch, which you can then handcolor if desired. However, high-contrast images with deep blacks, like those obtained with Silverprint, aren't possible with Liquid Light—even when the emulsion coating is aged. When coated without aging or the addition of a developer, Liquid Light produces only a soft, high-key look in the final image. Silverprint, on the other hand, has an emulsion concentration that lets you determine the level of D-Max and the detail quality in the finished print.

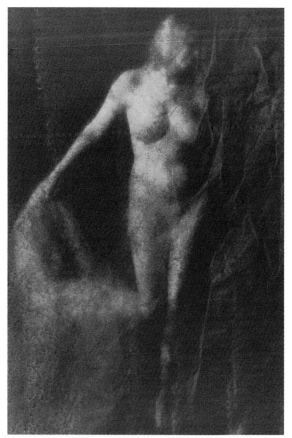

These two prints of "Rubenesque Nude" show the differences between concentrated Silverprint and Liquid Light. I used the same negative, enlarger, and paper, Fabriano Artistico hot-pressed paper. For this version, I used concentrated Silverprint; the print time was 7 seconds at *f*/4.

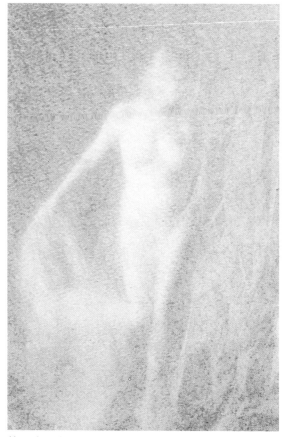

Here, I worked with concentrated Liquid Light, printing for 90 seconds at *f*/4.

Coating Techniques

Brushing on the emulsion gives you a lighter-toned print than pouring on the emulsion does, unless you apply the emulsion twice. Pouring on Liquid Light in either its diluted or undiluted form provides more density and a darker tonality to the finished image than brushing it on.

Drying Coated Papers

Drying coated papers is a relatively simple process that requires only a few steps. Lay the papers on Fiberglas screens, coated side up, or hang them to dry in total darkness. You can use a fan or hair dryer to make the process go faster. If your studio or workspace is very dry, the prints will tend to curl even more readily. As such, you might want to consider investing in a humidifier.

Printing Controls

Just as you do with Silverprint, you have yet another step to complete regarding how you want the final image to look. Developers will both increase or decrease the amount of contrast, as well as alter the tone, making it warm or cold.

Developers

I use only Dektol with Liquid Light in order to increase the density or contrast. Selectol Soft diminishes the contrast to the point where it is just barely visible.

The Stop Bath

Use a weak stop bath, just as you would with Silverprint. in order to prevent blistering.

Fixers

Once again, I treat this part of working with Liquid Light just as I do when using Silverprint. I opt for a powdered fixer, such as Kodak Fixer. I avoid rapid fixers here because the ammonium thiosulfate in them tends to bleach out highlights in the prints.

Washing

The instructions that come with Liquid Light dictate a 10-minute wash; however, if you've used a 300 lb. paper, I suggest washing the print for at least 30 to 60 minutes. Because such heavy papers absorb more fixer, they require more time to completely wash it out.

Toning

You can tone Liquid Light the same way you would Silverprint or photographic papers. But because the

I made this print of a red boat in a canal in Venice with concentrated Liquid Light on Magnani Acqueforti hot-pressed watercolor paper.

prints are so light to begin with, the toning effect isn't as apparent. If a paper fogs during the process, you can place the print in a potassium ferricyanide (bleach) mixture. But Liquid Light doesn't respond to the bleach as well as Silverprint does. It reduces the fogging to a lesser degree than when used on a Silverprint image, but still not completely. In fact, if you place such lightly printed images in bleach, you'll probably lose the images as well as the fogging.

Drying the Print

After washing the print, squeegee only the back of the print and lay it flat, face up, on Fiberglas screens. The surface of a print that undiluted Liquid Light has been poured on tends to be thicker and more rubbery-feeling than that of one coated with Silverprint in the same way. And although Liquid Light provides a thinner coating when brushed rather than poured on, the brushstrokes are visible.

To create this moody print of "St. Mark's Square," I used Liquid Light, diluted 1:1, on Fabriano Classico 5 hot-pressed paper, which I colored with watercolors.

Image Transfers and Emulsion Lifts

Image and emulsion transfers cross the boundaries of painting, printmaking, and photography. When you prematurely peel apart a Polacolor negative from the substrate (the glossy, white photographic paper that the print is usually developed on) and transfer it to a nonphotographic surface, such as artist paper, wood, glass, or fabric, images become tactile, textures are emphasized, colors are muted, and the mood of the print shifts toward something classical, vintage dated, and time honored.

Emulsion lifts, on the other hand, refer to the process of lifting the fully developed image, or emulsion, off the substrate in order to transfer it onto a receptor of your choice. Once transferred, the print becomes an emulsion transfer. You can make the emulsion transfer by lifting the emulsion containing an image of a fully developed Polaroid film: Types 669, Polacolor Pro 100, T-64, 559, 59, or 809. The term "emulsion lift" (versus "emulsion transfer") accurately describes the actual process. Here, you aren't working with the migrating dyes in the negative of an undeveloped Polaroid print but rather the finished, fully developed image.

Some images look better as image transfers than as emulsion lifts and vice versa. The emulsion lift maintains the intensity of colors and the bright photographic quality of the original print. The image transfer creates a separate version of the original print with muted colors and a different feel. When the transfer or lift is dry, you can enhance, intensify, or change the colors with just about any coloring medium you so choose. This is clearly the ultimate manifestation of creative photo printmaking. By moving from image to transfer to handpainted finished print, this process gives new meaning to the phrase "fine-art photography."

I made this smooth, even image transfer depicting an old church door on hot-pressed paper.

MAKING IMAGE TRANSFERS

This process involves two basic steps: the exposure and the transfer. The process is quite simple, and my method of transferring is 98 percent goofproof. It is perfect for photographers who don't have a darkroom, as well as for busy photographers who don't have the time to spend in a darkroom. Furthermore, you can accomplish the whole procedure in the light if you use a slide printer, made either by Daylab or Vivitar. You can also projection-print with a black-and-white or color enlarger when doing the transfer process. There are drawbacks: you must work in the darkroom, and enlargers aren't very portable. But you can dodge and burn selected areas for a better print.

Films

You can use peel-apart Polaroid ER films, such as Types 669, 59, T-64, Pro 100, and 809, to print black-and-white or color slides. Type 669 film is a $3^1/_4 \times 4^1/_4$ format. Type 59 film is a 4×5 format packaged in separately wrapped sheets, while Type 559 is a 4×5 format that comes in a pack of eight sheets. Type 809 film is an 8×10 format that is packaged separately in single sheets. You can also use a black-and-white negative in a slide mount to obtain some rather unusual effects.

Polaroid Polacolor Pro 100 is a great film to use in conjunction with black-and-white slides for a vintage look. This film has an entirely different dye emulsion than the Type 669 film. Polacolor Pro 100 is warm; it has a decidedly golden cast. It conveys a feeling of antiquity and, as such, is ideal when you work with old photographs. (Another option when copying old photographs is to use Polapan, Polaroid's instant black-and-white slide film—see page 114.)

Selecting a Paper

For image transfers, I use Fabriano Artistico hot-pressed paper; I prefer the 140 lb. stock. I find that

I photographed "Row Boat" in Berwick St. James, England. For the image transfer, I selected Polaroid 669 film and reworked it with Marshall oil pencils.

For this image transfer, I used handmade rough paper to show the speckled pattern from a less-than-perfect lift. It worked quite well for this shot of a washtub and teapot, imparting an antique look.

its surface accepts color well and has just the right hardness to ensure a good pull. In addition, this paper is well made and won't yellow with time. Other good paper choices are Arches hot-pressed watercolor paper, Lenox printmaking paper, and Mulberry and tableau papers from Japan (see the List of Suppliers on page 159). It is considerably easier to pull a successful transfer from a smooth-surface (hot-pressed) paper than a textured- or rough-surface (cold-pressed) paper. This is because the surface of a hot-pressed paper is hard and flat. A cold-pressed paper, on the other hand, contains few pits or bumps, so the dyes don't transfer completely. This results in a pitted or speckled effect. However, textured papers can add an interesting tactile feel to the image, which is often worth the extra effort.

There is no real "front" side to Fabriano Artistico or Arches papers (both are tub-sized). The "face-up" side merely refers to the side of the paper that was more gently squeegeed. Some papers are two-sided, and the fronts and backs have different textures. Although it is easy to tell one side from the other when the paper is dry, the soaking process swells the fibers, thereby making the two difficult to differentiate when wet. Be sure to place an "X" or some other distinguishing pencil mark on the side of the paper you don't want to use when the paper is dry. This step will prevent you from printing on the wrong side when the paper is wet.

If the artist paper has a watermark or logo, you should be sure that it is legible. In other words, make the logo side the front and print on it. Be careful to position the image above the watermark, so that the two don't overlap or interfere with each other. The watermark is a sign of distinction, and collectors like to see it because it validates the quality of the paper used. So save your watermark artist papers for special prints. Never use them for a first run.

Artist papers look much better torn to size rather than cut to size. The tear gives the paper an appealing, pseudo-deckle-edge look. The sheet dimensions of Fabriano Artistico paper are 22 × 30 inches. I tear the original sheet in half, then in half again, and then in half again. For the $3\frac{1}{4} \times 4\frac{1}{4}$ and 4 × 5 formats, I tear the paper down to a $5\frac{1}{2} \times 7\frac{1}{2}$-inch size.

I made an image transfer from a portrait shot live on Agfa 1000 slide film.

I created this image transfer from a Polapan (black-and-white) slide of an old photograph of my brother and me.

The Daylab is an enlarger with a color head. It plugs into an electrical socket, needs no batteries, and provides a steady, even light source. Even the filters are built in. You can both enlarge and crop with the Daylab Slide Printer and, unlike the Vivitar model, the Daylab can print three formats with its different bases. There is a base for printing $3^1/_4 \times 4^1/_4$, a base for 4×5, and a base for 8×10. All three bases are interchangeable with the color head. The Daylab system comes with the $3^1/_4 \times 4^1/_4$ base, which prints with Polaroid 669 film. Although you can purchase other bases separately, most photographers start learning the transfer process with the 669 setup.

The Vivitar Slide Printer is inexpensive, easy to use, and portable. However, it runs on batteries and as the batteries begin to exhaust, it takes longer and longer to print. At one time, the manufacturer made an AC adaptor but has discontinued doing so. The Vivitar Slide Printer accepts only the $3^1/_4 \times 4^1/_4$ format film and provides very little latitude in terms of cropping. In addition, you must use filters on top of the slide in order to enhance colors. The Vivitar uses a strobe system for its printing light source, which is excellent.

Arranging Your Workspace

Begin by placing a heating pad next to the enlarger. Next, lay an 11×14-inch piece of smooth-edged glass,

$1/_8$-inch thick, on top of the heating pad. This is your "worktable." Then place another smooth-edged piece of glass, 10×12 inches in size and $5/_{16}$-inch thick, on a folded towel directly behind the heating-pad setup. This arrangement makes picking up the glass easier, as well as protects the glass from getting chipped and cracked. Be sure to keep your brayer, scissors, and a small hand towel nearby. Then tear a large sheet of paper into small pieces, and stack them near your workstation.

Next, you need three trays of water. You'll use one tray of hot water, about 100°F, for soaking your artist paper. (An 8×10-inch tray is fine for Type 669 and Type 59 transfers, but you might want to use an 11×14-inch tray so that you'll have a little more space to work in. For Type 809 film, you need an 11×14-inch or 16×20-inch tray, depending on how large the paper you're transferring the image to is.) Alongside or inside this soak tray, place a piece of glass on a slant and a squeegee. The second tray holds a mixture of cool water, $1^1/_2$ inches deep, and $1/_3$ cup of distilled white vinegar. You'll use this tray for bleaching or reducing the transfer. Finally, fill the third tray with cool, running water in order to wash out the transfer after you've bleached it with the vinegar solution. I have a water hose in a large tray that is propped up on one side, so the water runs in and out very gently.

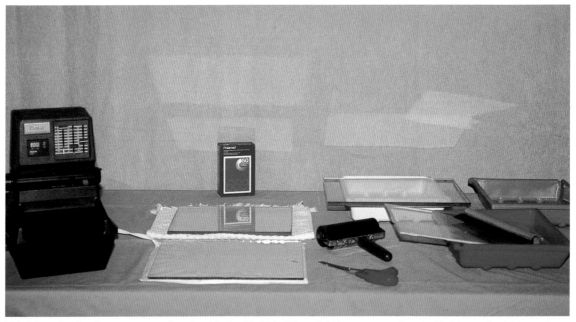

This is how I ordinarily set up my workstation. My Daylab Slide Printer (left) is next to my "worktable" (center), which consists of a piece of glass resting on a heating pad. I also have my brayer, scissors, and three trays filled with water ready (right).

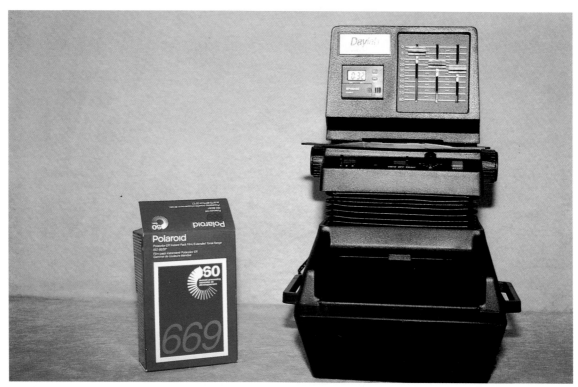

This Daylab color head is sitting on a 3$\frac{1}{4}$ × 4$\frac{1}{4}$ base alongside a box of Polaroid 669 film.

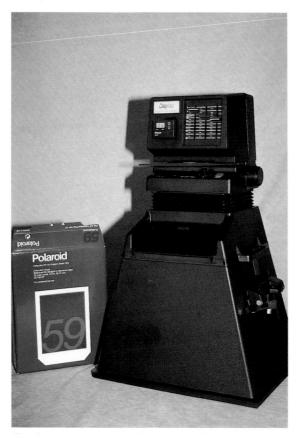

This Daylab color head is sitting on a 4 × 5 base next to a box of Polaroid 59 film.

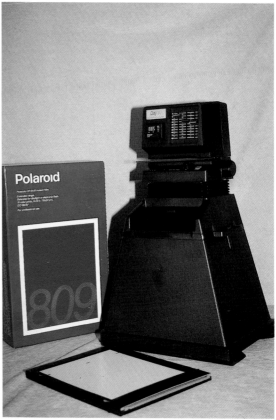

This Daylab color head is sitting on an 8 × 10 base; nearby is a box of Polaroid 809 film and an 8 × 10 film holder.

Loading the Slide Printer

Initially, you should select a slide that is open overall. The dark areas of a slide are the ones that will give you more trouble when you lift the negative from the paper during the transfer; therefore, you should choose a slide that doesn't have too many dark values. Place the slide in the printer. If you're using a Daylab, you must reverse the slide left to right. Otherwise, because the Daylab exposes the ER film through the back of the film, the image will be the reverse of the original slide. So whatever you see on the right side of the screen when focusing will be on the left side of the transfer print. In some cases, this won't matter. But, when the image contains letters and/or numbers, it matters a great deal. You must reverse the slide so that the figures will right themselves in the transfer.

When using the Vivitar, you don't need to reverse the slide when loading it into the printer. Simply place the slide in the slot right side up; in other words, the way you see it from the top is the way it will appear in the transfer. The focus is preset. Next, load the slide printer with film. After loading Type 669 film into the slide printer's film chamber, remove the dark paper with arrows. This is your dark slide for the negative pack. Use both hands, and pull it out firmly and slowly. Be careful not to pull the white tabs when completing this step; this renders the entire pack useless.

This Daylab base contains Polaroid 669 film.

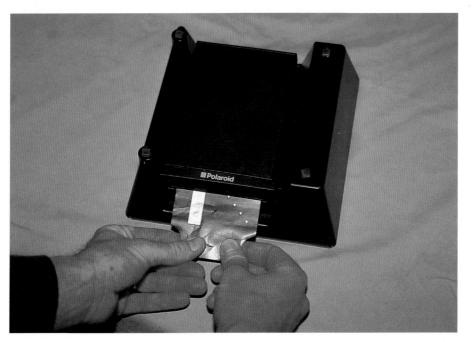

Here, I pull the dark slide from a Polaroid 669 film pack that was loaded in a $3^{1}/_{4} \times 4^{1}/_{4}$ Daylab base.

Before You Expose

Before you make an exposure, work out the proper exposure times and filtration. The first time you print a slide, select "N," or the normal setting for exposure, and zero out the filtration. Let the print develop for the full 60 seconds, and then peel it apart for inspection. At this point, you can judge if the print needs an exposure or filtration adjustment. You can also simply opt to add more color if you wish.

Determining Exposure

On the Daylab Slide Printer, the "0" setting denotes "normal." Each line or dot on the exposure dial is 1/3 of a stop; therefore, going from 1/3 to 2/3 to 3/3 is one stop. If the print is light, subtract time from the exposure dial. If the print is dark, add time to the exposure dial. Make yourself a reminder card, and tack it somewhere next to the Daylab. Remember, more light produces a light print, while less light results in a dark print.

If the slide you're working with is dense or if you've sandwiched two slides, you might need two stops more light than usual. It is important to note that if you're sandwiching two slides, the slide on the bottom will be more predominantly printed when using a Daylab printer. In this case, set the exposure dial with the (+) sign at the top (which is one full stop more

light than normal), and hit the "Start" button twice before pulling out the film. Because the Daylab gives only one more stop of light, you must push the button again for a second stop of light if you need more exposure. So by hitting the button two consecutive times, you expose the sheet of film two times.

You can vary this procedure to suit your needs. You can print in increments of 1/3 stop and can do so in any combination. For example, if two full stops provide too much light for the exposure and one full stop isn't quite enough, you can expose the film at one full stop and then expose again at +1/3 or +2/3 of a stop.

The exposure-control level on the Vivitar Slide Printer operates under the same principal as the exposure dial on the Daylab. The machine is calibrated with 1/3-stop gradations, and you can expose the same slide on the same sheet of film two or three times if necessary. If the slide is "normal," use the long slash or notch in the middle of the setting (this denotes "N"). If the slide is light, drop one or two notches, each of which represents 1/3 of a stop. This will give the slide less exposure time and create a darker final print. Conversely, if the print is too dark, move the setting one or two notches above normal. This will give the slide more exposure time, and you'll achieve a lighter print.

For this variation of "The Shell," I sandwiched two slides and reworked the combined image with Marshall oil pencils.

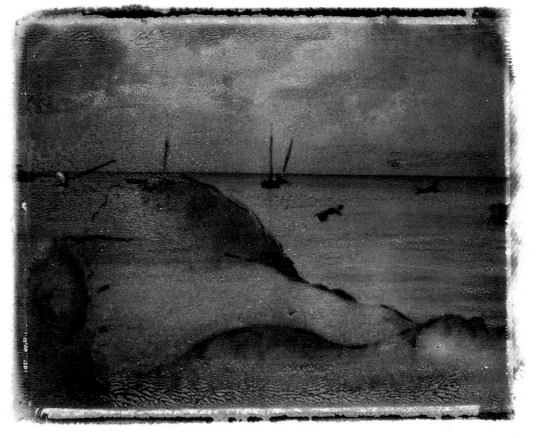

Filtration

On the Daylab Slide Printer the filters are built in. The Daylab system uses three sliding color bars: cyan, magenta, and yellow. Each color bar is capable of providing 80 color-compensating units of that particular color. These colors can be added separately or together, equally or unequally, to provide a variety of in-between colors. To increase a specific color, simply add that color to the filtration or decrease its complement.

The Daylab manual comes with a clear, easy-to-use chart for adding or subtracting a color. For example, if you want less green, you either add magenta or subtract cyan and yellow. Conversely, if you want more green, add cyan and yellow or subtract magenta. Remember, though, the more filtration you add, the longer your exposure times will be. So it is more advantageous to make color changes by taking out filtration whenever possible.

When you work with the Vivitar Slide Printer, you must place the filter on top of the slide. Color-compensating (CC) filters come in handy here; these filters are used primarily in color printing to gain control over the color during the printing phase. They come in six colors: red, green, blue, cyan, magenta, and yellow; their densities range from 0.025 or 0.05 up to 0.50. The filters are identified with a CC in front of their density number and color designation. For example, a CC20R filter is a color-compensating filter with a density of 20 and the color red.

These filters work very well with the Vivitar. The CC20R provides excellent flesh tones and enhances the colors within the red to red/brown arena. A CC20B (blue) filter removes the golden cast from slides. If you purchase 3 × 3-inch CC filters in gel form, you can cut them up and put them in a slide mount. Another option is to combine two or three filters of the same color in one slide mount in order to achieve their cumulative density. For example, two CC20R filters lead to the same result as a CC40R filter.

You can also experiment with color-correction filters. These are ordinarily used in black-and-white photography to render the colors in a scene different shades of gray according to their relative brightness. The 81A amber gel filter is actually a color-correction filter; however, you can use it to warm up the color in an image printed from a slide on your Vivitar Slide Printer.

Running Through the Checklist

Before you begin working with a slide printer, you should ask yourself the following questions:

- Check the exposure dial. Is it set correctly? (see page 91).
- Check the filtration. Is it set where you want it?
- Check the focus. Is the slide clear and properly aligned?
- Check the print/view dial. The Daylab Slide Printer has two light sources: one for viewing and one for printing. Is the dial set to "Print"?
- Check the dark slide. Have you pulled it out?

If everything is set, gently push the "Start" button.

1. This closeup shows the Daylab Slide Printer's filtration dials.

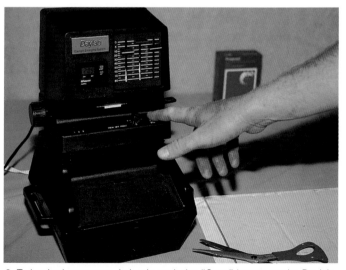

2. To begin the process, I simply push the "Start" button on the Daylab Slide Printer.

Exposing the Film

When using the Daylab, after you've gently pressed the "Start" button, place your artist paper in the hot-water tray for 30 seconds. Be sure to flip the paper over a couple of times. Next, lay the paper down on a piece of glass, and firmly squeegee off the excess water. Then lift the paper, and squeegee off the glass. Flip the paper over again, place the paper back on the glass, and softly squeegee the paper's other side. The last side that you squeegee off will receive the negative, and you don't want to ruffle the paper fibers. Move the artist paper, and lay it face up on the warmed glass that rests on top of the heating pad.

Go back to the Daylab Slide Printer. Push in the dark slide, and then pull out your film. When using Type 669 film, first pull the white tab, and then pull the black tab. When pulling the black tab, do so with one long, strong, smooth, downward movement. If you stop at any point while pulling out the black tab,

you'll squeeze the emulsion pack unevenly and ruin the print. Remember, the developing process doesn't begin until you pull the film through the rollers and break the emulsion backing.

In the Vivitar system, there is no dark slide to pull or push back, and no focusing to do. Simply push the "Print" button; the Vivitar Slide Printer uses a strobe light to make the exposure. So all you have to do is prepare your paper first, push the button, and make the pull.

You can also shoot live by exposing film directly in the field or studio; if you want to, you can then make transfers on the spot. For Type 559 or Type 59 film, simply load a Polaroid 545 filmback onto the back of a large-format camera. You can use Type 669 film in a Polaroid 231 camera (unfortunately, Polaroid no longer manufactures these cameras, but you can frequently find one at flea markets; you can also call Graphic Camera in California—see the List of Suppliers on page 159).

3. Squeegeeing off the artist paper eliminates excess water.

4. This detail shot of the film-exposure process provides a close look at the Polaroid film tabs.

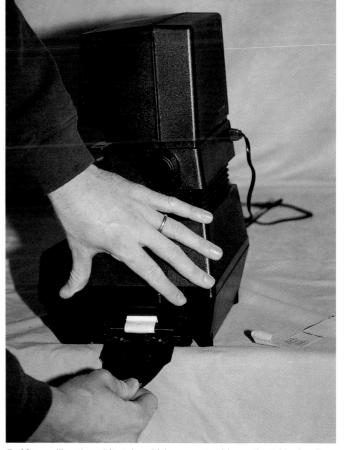
5. After pulling the white tab, which was set aside on the table, I pull the black tab with arrows.

Peeling the Negative

After exposing the film, whether you do this via the slide printer or directly, don't wait for the print to fully develop. As soon as you draw the emulsion pod through the rollers, the dyes begin to migrate to the substrate. The yellow layer migrates first, then the magenta, and then the cyan. If you wait too long, all the dyes migrate to the substrate, leaving no dyes in the negative with which to make a transfer.

If you have sensitive skin, you should wear surgical gloves when you peel the negative. The paste is caustic and can give you an alkali burn. This isn't as serious as it sounds, but the paste will dry and crack your skin. Otherwise, if you get some on your skin, wash it off immediately in water.

Hold the print in your nondominant hand so that you can turn the film and cut both ends off without touching the film sandwich in the center. With your dominant hand, immediately cut off the black tab with the yellow arrows, turn the print, and cut off the emulsion-paste end. This step allows for a much neater transfer. If you touch the center of the film while cutting, you'll make a yellow spot on the transfer.

Peel the negative away from the substrate in a smooth, continuous motion. Hold the thin, white tissue edge with your thumb against the substrate so that it doesn't come loose and smear the negative. If you hesitate during the peel, the negative will have ridges, as will your transfer. This step should take about 10 to 13 seconds, so be mentally ready.

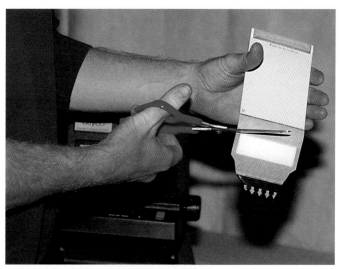

6. Next, I cut off the tab end of the filmpack.

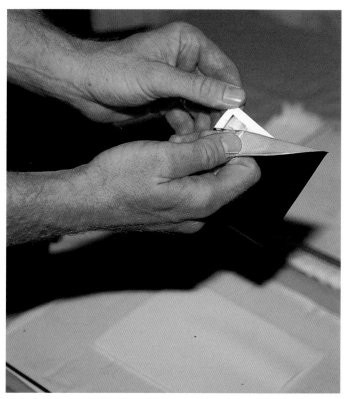

8. As I peel the negative from the substrate, I hold back the tissue paper.

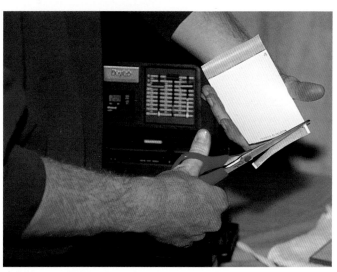

7. I then cut off the emulsion paste end of the film.

This is what the substrate looks like after a 12-second pull (left). Only the yellow has migrated. But in the image transfer from the 12-second pull, the magenta dye has moved into the print (right).

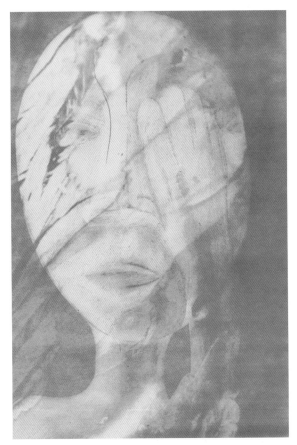
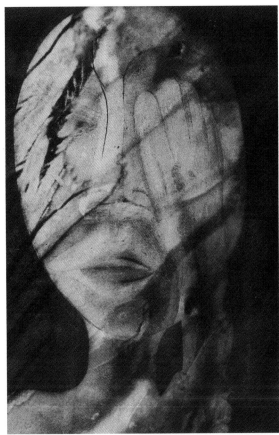

This picture shows what the substrate looks like after a 30-second pull (left). Both the yellow and the magenta have migrated. The image transfer resulting from the 30-second pull reveals a lack of magenta in the print (right).

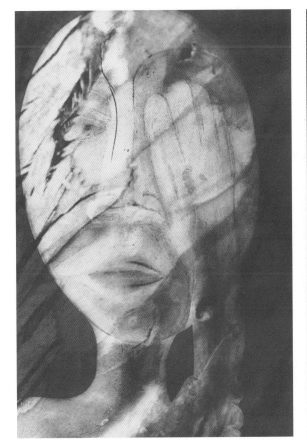
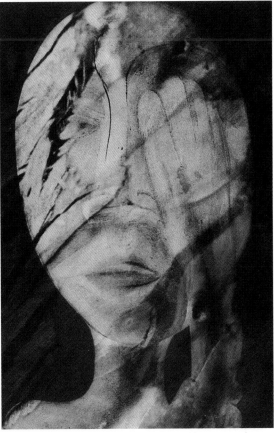

PROJECTION PRINTING

You can projection print with a black-and-white or color enlarger using Type 809 (8 × 10 format) or Type 59 (4 × 5 format) film and avoid using the slide printers completely when doing the transfer process. If you want to projection print onto Type 669 film (3¹/₄ × 4¹/₄), you can do so by positioning a Daylab Slide Printer base under the enlarger. This setup enables you to dodge and burn. However, I find that the Daylab does an excellent job of printing on the 669 film, so I don't bother to dodge or burn on such a small format. The secret to making a successful transfer is heat and pressure. Of course, patience is a must.

Projection Printing Using Polacolor ER 809 Film

For this procedure, you need an 8 × 10 film holder, an 8 × 10 processor, and an enlarger. After selecting a slide, place it in the negative carrier. You don't need to take the slide out of the mount. Turn the enlarger on, crop, and focus on a white sheet of paper that you've positioned over the top of the dark slide on your film holder. Next, set the aperture and time. The density of the slide to be printed will determine the aperture to be used in the enlarger.

Keep in mind that when you print a positive (slide), more light yields a lighter print, and less light yields a darker print. A typical slide might require an exposure time of around 7 seconds at f/16. If the slide is quite dense or if you're sandwiching two slides, start with f/5.6 for about 30 to 60 seconds. A good starting time for a thin or light slide is f/22 for approximately 7 seconds.

In general, I zero out the filtration for the first print and add color as I think I need to. Add filters for printing with the black-and-white enlarger, or if using a color head, you need only to dial in the filtration. If your black-and-white enlarger has a cold light, you might have to add a CC20Y filter under the lens to compensate for the blue color of the light. Turn out all the lights, including the safelights. Remember, you're working with film, not paper. Pull out the dark slide, make the exposure, burn or dodge as needed, and then replace the dark slide. Turn on the lights.

Next, wet your artist receiving paper and have it waiting on a piece of glass. Then having made the exposure, take the film holder over to the processor, and set it up for processing according to the instructions that came with your equipment. Push the "Start" button on the processor. When the filmpack (the negative and the carrier paper) comes out, immediately cut the black-paper tab at the top of the negative sandwich apart and peel the negative away from the carrier print paper. This should take about 12 seconds. At this point, you are ready to make the transfer.

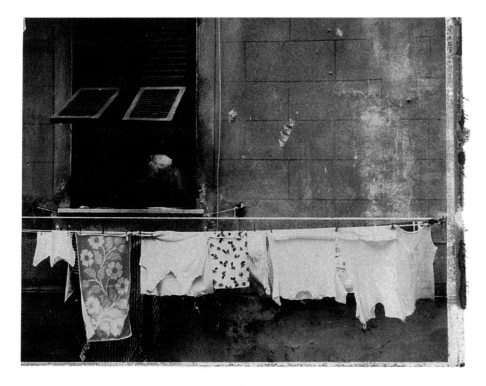

I originally shot "Cinque Terra" in Italy. I made the image transfer with Polaroid 809 film on Fabriano Artistico hot-pressed paper.

1. Here, you see both the negative and substrate of Polaroid 809 film, an 8 × 10 film processor, and an 8 × 10 film holder.

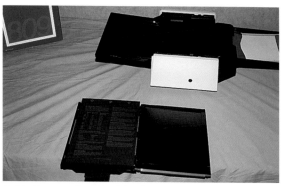

2. My first step is to load the Polaroid 809 negative in the 8 × 10 film holder.

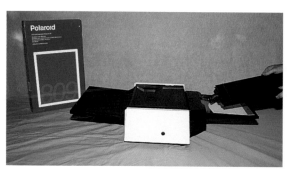

3. Next, I load the film holder with the exposed negative on top of the Polaroid 809 substrate paper in the 8 × 10 film processor.

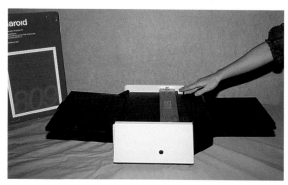

4. After loading the processor with the film holder and substrate paper, I push the "Start" button on the processor.

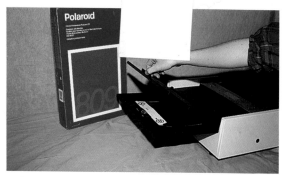

5. Once the processing is completed, I retrieve the negative and substrate paper.

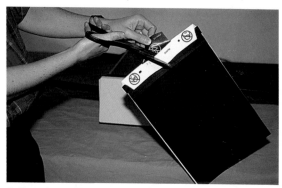

6. Next, I cut off the tab of the Polaroid 809 film sandwich in order to peel apart the negative.

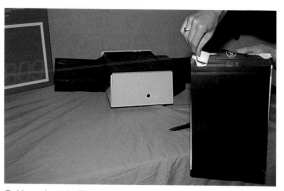

7. Here, I peel off the cut tab.

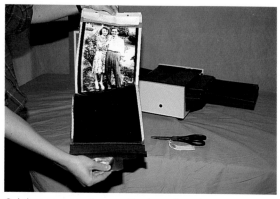

8. I then separate the negative from the substrate paper.

Using the Daylab 8 × 10 Base

As mentioned earlier, the Daylab Slide Printer has an 8 × 10 base for printing with 8 × 10 film. If you have this base, you don't need an enlarger to do 8 × 10 printing. But you still need the 8 × 10 film holder and processor.

For the 8 × 10 format only, set the printing dial located on the left side of the Daylab (the one with the "1," "2," and "3" settings) on "2." (The rest of the time, this should be set on "1.") Follow the negative-loading instructions that come with the 8 × 10 film holder. Set the loaded film holder into the Daylab 8 × 10 base. Next, turn the Daylab "View" light on, and compose and focus your image. The new 8 × 10 film holders have a dark slide with a white top surface, which simplifies focusing. If you have an older film holder with a black-top dark slide, you must insert a sheet of white paper on the top to focus on. Don't paint the dark slide white: the paint will chip and peel when you insert and remove the dark slide, and will inevitably get on the film.

Then adjust the time-exposure dial according to the slide's density. A good starting point for a typical slide is +2/3 stop. Remember, you can expose the film more than one time. But be aware that too much exposure time will cause a color shift. And even though Type 809 film and Type 669 film have the same film-speed rating (ISO), you'll need more time to make the print with 809 film because there is more distance between the lens and the film plane.

After you run through the checklist, pull the dark slide out—but not all the way—and make your exposure. Push the dark slide in, and take the film holder out of the base. Next, go over to the processor, load the carrier paper and film holder according to the directions. Prepare your paper: wet it, squeeze out the excess water, lay it on warm glass, and then push the "Start" button on the processor. The negative and carrier paper are run through the rollers and are ejected as a sandwich.

Be careful handling the 8 × 10 sandwich. If you bend the negative, an air pocket can form and separate the negative and substrate down the middle. This, in turn, will cause a glitch and a loss of information during the transfer.

Projection Printing Using Polacolor ER 59 and ER 559 Film

When you work with these two films, you need a Polaroid back. The Type 59 sheet film requires the #545 Polaroid filmback; each piece of film is separate. The Type 559 film, which comes in an eight-exposure package, calls for the #550 Polaroid filmback. You'll have to fashion an easel of sorts to hold the filmback. You can accomplish this by taking a thick piece of cardboard and cutting out an opening large enough in which to insert the filmback. Another option is to simply set the filmback on an empty 8 × 10 photographic-paper box. Tape it down on the easel.

You don't need to create an "easel" with the 4 × 5 film format when using the Daylab 4 × 5 base. With the Daylab base, you simply place the #545 film holder in a track inside the base and then lock it into position. Next, insert the white-plastic dark slide, focus, and follow the instructions above for projection printing. The only difference here is that you can't dodge or burn when using the Daylab base; however, it is more stable when locked into the base because it can't move.

The Daylab 4 × 5 base comes with a white-plastic dark slide that you focus on. You can insert this slide into the 545 film holder by setting the handle on "L," for "Load." You can easily make one out of white cardboard, cutting it so that it fits inside the film holder; use a piece of #59 film for the measurements. Once you focus, set the handle on "P," for "Process," and pull out the dark slide.

Next, setting the handle back on "L," load in the sheet of 4 × 5 film until you hear the click. Be sure that the words "This side toward lens" are facing the light source. If you're using the #545 film holder under an enlarger, be careful not to move the easel and turn off all the lights before pulling out the paper dark slide until it stops to make your exposure.

A good starting exposure for 4 × 5 film is $f/22$ for about 5 seconds. Naturally, you have to adjust the time according to the density of the slide. Process according to your equipment instructions. The transfer begins once you pull the film through the rollers, so take your time and do so only when you are ready to peel the negative from the substrate.

MAKING THE TRANSFER

Place the negative on the wetted artist paper, wet side down. Don't move it once it comes in contact with the paper; simply pat it gently with your fingertips. Using a soft brayer, very gently brayer the negative back and forth, adding pressure as you go. When increasing the pressure, don't push the brayer harder along the paper. Instead, press down, thereby adding pressure from above. Be careful not to brayer the tab side of the negative (the end of the negative that isn't adhered to the paper). If you do, this side will roll up with the brayer and peel the negative off before the transfer is complete. Brayer the negative about six times, alternating the direction. If you're working with 8 × 10 film, make about 10 passes with the brayer. Again, gradually use more pressure with each pass.

After you've brayered the negative and paper together, place the heavy piece of smooth-edged glass on top of the "sandwich." Wait 2 minutes. This is just enough time for the dyes to transfer completely, but not enough time for the negative to stick to the paper. If you're working with 8 × 10 film, weigh down the sandwich for 4 minutes with a heavy piece of smooth-edged glass.

Lift the glass, and look for a rectangular border of condensation around the print. If you see one, this is a sign that you've successfully steamed the dyes into the artist paper. If you don't have a heating pad, place the heavy piece of glass on top of the transfer sandwich and place a gallon jug filled with hot water on top of that, and then wait 2 minutes, or 4 minutes for an 8 × 10. The pressure and heat will facilitate the transfer. This method doesn't work as well as the heating-pad method, but it does work.

Before you peel the negative, make another pass with the brayer in both directions to ensure good contact between the negative and the paper. Begin at a corner, and pull slowly and carefully on a diagonal. If an area starts to lift away from the paper, lay the negative back down and brayer again, and then resume the peel from a different corner. If the area continues to lift, brayer one more time, place the entire sandwich into a pan of cool water, and very slowly peel off the negative under water (see Troubleshooting on page 101).

At this point, you've successfully completed an image transfer. Now, you must decide if the color is correct, if the print is too light or too dark, and if it needs to be selectively or wholly reduced. Keep in mind that the colors in the print will be darker when dry. Also remember that the colors will be muted in comparison to those in a glossy color print.

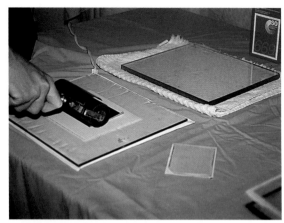

1. First, I brayer the negative to the artist paper.

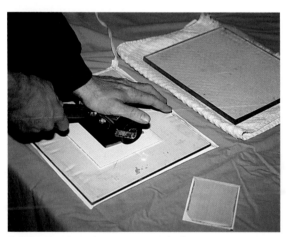

2. I then increase the pressure on the brayer.

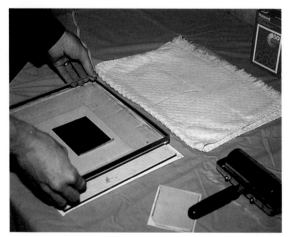

3. At this point, I am ready to place heavy glass on top of the negative-and-artist-paper sandwich.

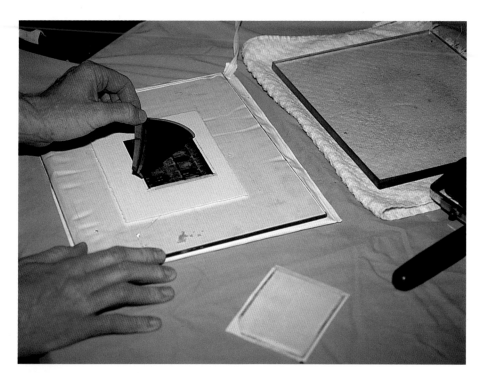

4. Here, I peel the
negative from
the artist paper.

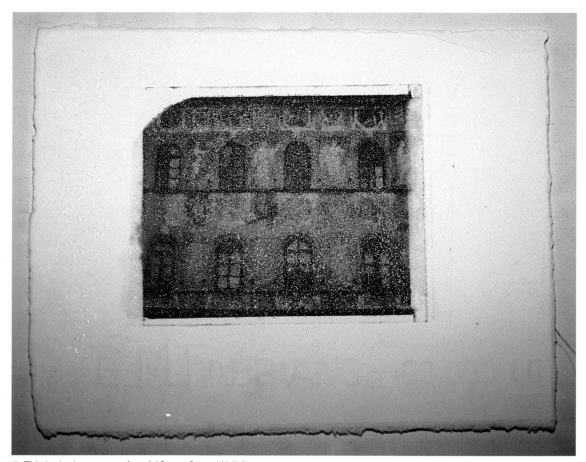

5. This is the image transfer of "Santa Croce Wall."

Reducing the Print

If you have a print that is flat in contrast or is too dark, you can place the whole image into an 8 × 10 tray filled with a vinegar (¹/₃ cup) and water (1¹/₂ inches) mixture. Then watch what happens. When the print reaches the desired contrast or lightness, take it out and place it into a pan filling with cool, running water. Never let the running water hit the surface of the image directly. Wash the print for 5 minutes, and then squeegee around the image. Don't squeegee the image itself. Next, lay the print on a Fiberglas-screen rack, face up, until it dries. (This step takes about 5 hours for a 140 lb. paper.) Check the transfer during the first hour of drying to see if you need to blot excess water containing color from the dyes, which can puddle around the border of the transfer. Blot the print with a hand towel, paper towel, or tissue. This will give you a cleaner finished print.

The vinegar bath is also quite effective at removing any residual emulsion paste that might be on the surface of the print. Sometimes this paste adds another dimension to the print, and sometimes it doesn't. Dip the print into the vinegar bath, and then gently rinse it under running water to wash off the residue.

If you want to selectively bleach an area, use a soft sable brush, #2 or #4. While the print is submerged in the vinegar bath, softly sweep the areas that you wish to lighten with the tip of the brush. The gentle friction created by the brushstrokes actually floats off the top layer of emulsion containing the dye. Be sure that the selected areas are in the solution during this step; otherwise too much of the emulsion will be removed. But don't let the print remain in the vinegar solution too long, more than 2 minutes or so. If you do, the dyes will fade, and the dried image will have a whitish look. Keep in mind, too, that the higher the concentration of vinegar, the quicker the print will reduce—and the less control you'll have over the process.

1. This reducing, or bleaching, bath consists of distilled white vinegar and water.

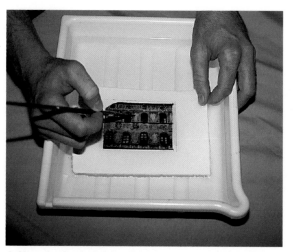

2. Here, I selectively bleach the image transfer using a brush.

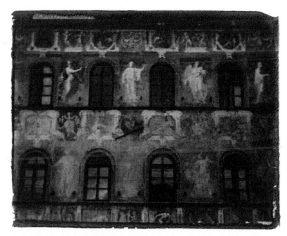

3. Because the dried transfer is dark and flat, it needs contrast and lightening.

4. This is the reduced transfer after I selectively bleached the figures painted on the wall in the vinegar-and-water bath and lightened the tones overall.

IMAGE TRANSFERS WITH POLACOLOR PRO 100

Because Polacolor Pro 100 is a 90-second film (versus Type 669, which is a 60-second film), you need to slightly alter the image-transfer procedure. Here, you must wait at least 30 seconds before pulling the negative away. If you don't, you'll get a very yellow transfer.

Next, pull the negative away in a smooth, very rapid movement. Do this literally as fast as you can in order to avoid crinkle lines across the negative and, thus, the transfer. When making the transfer, pull the negative immediately after brayering it onto the transfer medium. Don't wait 2 minutes.

If your images are a bit too yellow for your taste, you can lessen the effect via the following steps:

- Add a CC10C (cyan) filter to the color filtration
- Soak the transfer in the vinegar bath

- While soaking the transfer, take a soft brush and remove the yellow emulsion with light strokes.

After you reduce an image, put it in a very cold water bath in order to set the dyes and firm up the gelatin surface. Be sure to do this before you place the image into the running-water rinse bath.

Polacolor Pro 100 is sensitive to water, and especially to water that is very high in mineral content or chlorine. As such, you should buy and work with distilled water and forget the additives when using this kind of film. Otherwise, if your water source is chlorinated or high in minerals, you must make the water in the soak tray either acidic or alkaline by adding $1/2$ cup lemon juice or vinegar or 1 tablespoon of baking soda, respectively.

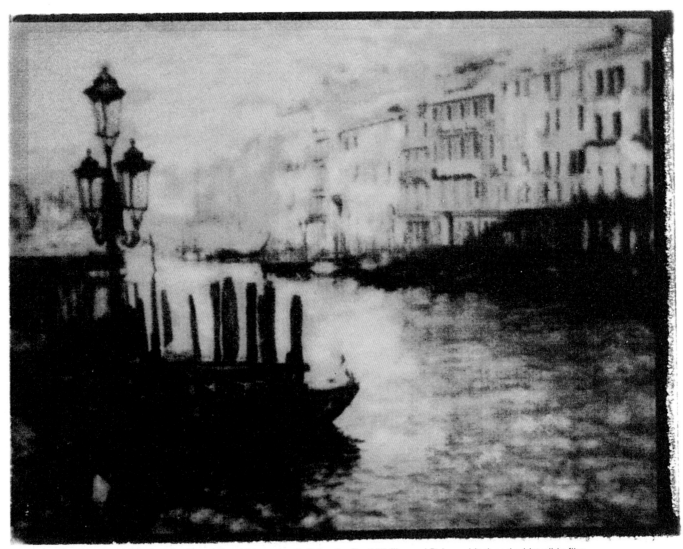

For the image transfer of "Venice, the Grand Canal," I used both Polacolor Pro 100 film and Polapan black-and-white slide film.

TROUBLESHOOTING

Problem: Your negative isn't making a good transfer and seems to lift off the paper as you peel.

Reason: When prematurely separating the negative from the substrate, you waited too long (more than 12 seconds), so the magenta dyes started to migrate. Another possibility is that the heating pad was on too high, so the warm glass was actually hot glass. As a result, the dyes dried out too fast; by the end of the 2 minutes, the negative dried onto the paper.

Solution: Brayer the print again. Place a heavy piece of smooth-edged glass on top of the negative/paper sandwich to weigh it down. Then wait an extra minute, and try peeling the negative again under cool water.

Problem: Certain areas of the transfer are lifting off the paper during the negative peel.

Reason: You didn't soak the paper for 30 seconds, you didn't wait the full 2 minutes for the dyes to transfer out, or you didn't expose the image enough in the printer.

Solution: Peel the negative slowly. Sometimes the lift will lay back down by itself. If this doesn't happen, use an X-Acto knife to cut and separate the problem area as you pull. Be sure to soak the paper for 30 seconds, and lightly squeegee off the front side. Wait the entire 2 minutes for the dyes to transfer. If you need more exposure, try a 1/3 stop or 2/3 stop exposure increase.

Problem: The print has small spots where the emulsion didn't adhere.

Reason: You used a paper with uneven sizing, or the paper was too rough in texture for a complete transfer.

Solution: Try a better grade of watercolor paper with moderate to heavy sizing, or try a hot-pressed paper instead of a textured paper. You can also touch up the spots with soft pastel pencils, such as Conté à Paris. You can also use a watercolor wash or Marshall oil pencils. Remember to spray the print if you've used coloring. When selecting a slide for printing, keep in mind, too, that the dark areas in a slide are the most troublesome.

Problem: There is a dark, mushy-textured coating on the print.

Reason: You soaked the paper too long, you applied too much pressure when brayering the negative, or you didn't give the image enough light during the exposure.

Solution: Try soaking the paper for a shorter length of time, apply less pressure, or add more light.

Problem: There are white dots on the print.

Reason: Either the paper is too textured for a complete transfer, or it has a sizing defect. It is also possible that you didn't apply enough pressure when brayering, or that the paper doesn't contain enough moisture. Did you soak the paper long enough? Did you squeegee too much water out of it? Was the glass work surface too hot, thereby robbing your paper of moisture?

Solution: Use hot-pressed, smooth paper for best results. Try another brand of paper. Dip the glass in cool water or take it off the heating pad for a few minutes.

Problem: There is a smudged look to the print.

Reason: You moved the negative after it made contact with the receptor paper, or you applied too much pressure while brayering.

Solution: Remember to increase the pressure from above. Also, don't push the brayer forward; this will cause the negative to slip and blur.

Problem: The transfer is very faint.

Reason: Too much time elapsed between the pull and the positioning of the negative on the paper.

Solution: The negative should come in contact with the paper no later than 13 seconds after the pull. Remember, as soon as you draw the emulsion pod through the rollers, the dyes begin to migrate to the substrate. So if you wait too long, there won't be any dyes in the negative with which to make a transfer. Check the substrate (the throwaway positive). If it has good color, this means that all the dyes are in it, and not in the negative.

Problem: The transfer has dried and the image lacks contrast but you want to reduce it.

Reason: The image received too little exposure in the Daylab, you used the wrong filtration or too much filtration, or the film was old.

Solution: Place the print back into the vinegar bath. The transfer isn't too fragile now, so you can easily use a brush to bleach selected areas. This bath will also remove the green haze that occurs when you use old or outdated film. Make sure that you buy fresh film. Always rinse the print in a running cold-water bath for 5 minutes after reducing.

MAKING EMULSION LIFTS

You can accomplish emulsion lifts with various Polaroid films: 669, 559, 59, Polacolor Pro 100, 809, and T-64. The actual emulsion lift takes place in a tray of hot water. As the gelatin emulsion is lifted off its paper backing, you can transfer it to another receptor. By letting it move on the new receptor, you can create or enhance an image that has a "flow," or fluidity of movement. Although the emulsion-lift procedure is, technically, quite simple, you must give a great deal of thought to the selection of both the image and the paper (or some other receiving medium) in order to achieve the best results. For example, images containing architectural elements look great on either a rough artist paper or a piece of wood; these two receiving mediums can actually add texture to a stucco wall or grain to an old wood barn.

Carefully pairing an image and a receptor is essential. You don't want to end up with a nude with pigskin or a dilapidated barn door with a smooth, polished surface. The process should suit the image, and the image should be enhanced through its use.

Selecting a Paper

My artist paper of choice for emulsion lifts is a 300 lb. rough watercolor paper, such as Fabriano Artistico. Papers in this weight range have enough backbone or strength to remain firm in the water. This is an important consideration. It is difficult to work with a slippery emulsion and a flaccid paper at the same time. Many handmade papers and Oriental papers go limp when wet.

If you would prefer to use a softer, more pliable paper, use a plastic support sheet under the paper when placing it into the cool-water tray. A heavy piece of acetate works, as do two pieces of Contac paper sandwiched together or a piece of Plexiglas. If you're working with a clear Contac-paper support, be sure to mark an "X" on one side with a Sharpie pen. If you don't, the Contac paper will "disappear" when you place it in the water, and you'll have to search to find it.

Another approach for working with a soft, delicate artist paper is to wet it briefly and then lay it on a piece of glass. Next, squeegee off the water, collect the emulsion on the acetate or Contac-paper support, and transfer the emulsion to the prepared wetted paper. Brayer the back of the acetate or Contac onto the wetted paper. As you peel the plastic sheet away, the emulsion will stick to the paper. If you need to move or adjust something, place small portions of the transfer in water or use a soft brush saturated with water. If the emulsion image needs to be reversed before going onto the receptor paper, you can use the same technique: place the emulsion onto the plastic first and then transfer it onto the receptor paper.

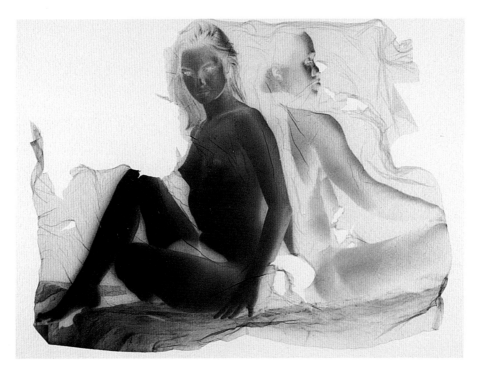

I made this "Positive/Negative Nudes" emulsion transfer from a black-and-white negative used in a Daylab Slide Printer.

For an emulsion transfer of "Sam at the Ocean," I chose Fabriano Artistico cold-pressed paper and reworked it with watercolors.

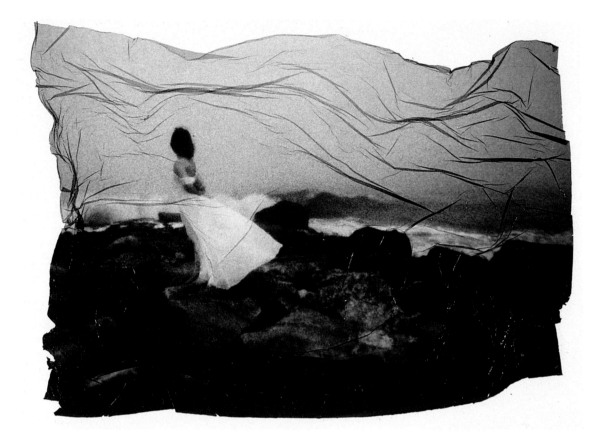

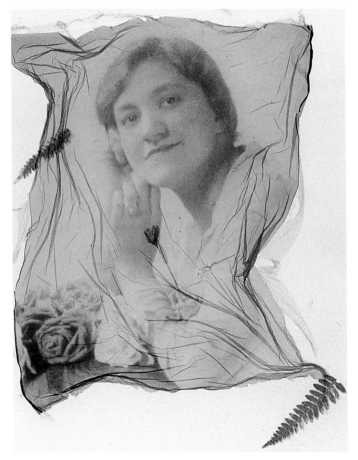

This is an emulsion transfer done on Larroque Fleurs paper. I made it from a Polapan black-and-white slide of an old photograph. The original image was a picture of my husband's grandmother at age 16.

Achieving Effective Emulsion Lifts

In order to produce a fully saturated emulsion lift—one with abundant color—expose and process the film for the proper print time, thereby letting the print develop fully. The sheet of exposed and processed film must be completely dry, not just dry to the touch, before you begin the emulsion-lift process. You can, of course, force-dry your film by using a blowdryer, blowing warm air on both the front and back sides of the print for 4 to 5 minutes. Another option is to let the image dry naturally for 12 to 24 hours. But, either way, the sheet of film must be bone dry before you start.

I've found it very helpful to warm up the print for 1 or 2 minutes under the heat of a blowdryer before beginning the lift procedure. This makes the lift easier and helps prevent the jelly-like substance that is between the substrate and the gelatin emulsion from being released.

The next step is important. You must seal the back of the print, either with spray paint or, via an easier method, with Contac paper. (You can usually find some inexpensive, and ugly, rolls of Contac paper in sale bins at drugstores and hardware stores.) Lay the back of the print onto the sticky side of the Contac paper, and then smooth it out. Don't worry about occasional air bubbles. This step prevents the back coating from dissolving and making the water an opaque white. Using an X-Acto knife, cut away the white border trimming the Contac paper as well.

While sealing the backs of the prints with Contac paper, boil a pot of water. Be aware that the water must reach a temperature of 150 to 160 degrees, or the lift procedure won't work. Use a thermometer to check the water's temperature. In general, a rolling boil indicates that the water is sufficiently hot.

Next, lay the Contac-sealed, warm, dry print in a tray and pour the hot water on top of it. Make sure that the print stays under the water at all times. You can place something on top of the print to weigh it down, so long as the weight isn't sharp or too heavy. A long-handled bristle brush, for example, works well. Don't poke at the print because as the emulsion softens, it can easily tear and get damaged.

After allowing the print to soak for 4 minutes, take a square or flat $1/4$-to-$1/2$-inch bristle brush, and pull/push the emulsion edges toward the center of the print. Continue lifting all around the perimeter, working only the edges free. Next, use a pair of tongs to pick up the print by its paper backing (remember, the water is hot!), and submerge it in a tray of cool water.

Once the print is in the cool-water tray, you can peel off the emulsion with your fingers. Peel slowly and carefully, and do everything under the water. Right before the emulsion starts to float entirely free, slip the receiving artist paper between the free-floating emulsion and the old substrate that it was originally anchored to.

Grab the free-floating emulsion with your thumbs, and hold it down on the artist paper. As the rest of the emulsion works free of its original substrate, allow the water to float it up and position it. Work slowly and gently with the water's action by easing the artist paper in and out of the water. But let the water move the print. Always try to keep two points of the emulsion anchored with your thumbs, and never let the emulsion go without anchoring at least one point. If this happens, the emulsion will roll into a sticky, gummy, hopeless mass of goo.

All adjusting and positioning of the image onto the artist paper must take place in the cool-water bath. If you try to work with the emulsion out of the water, it will tear. Though you must be careful: the longer the image is in the water, the more it will begin to stretch—and not always proportionally! You have about 5 minutes once the image hits the cool-water bath to perform the lift and anchor the emulsion onto the artist paper (or whatever receiving medium you're using) before any stretching occurs. Most people find this to be a comfortable length of time in which to work.

Once the image is on the receptor surface and you like its positioning, gently pat it down with your fingertips. Be extremely gentle. Too much pressure will stretch the emulsion. Let the excess water drip off. You can squeeze around the image or blot the surface water around the image, but don't blot or squeeze the emulsion lift itself.

Next, allow the emulsion lift to dry naturally by laying it on Fiberglas screening. You can't force-dry the finished product because it will dry too quickly and crack. When the emulsion lift is dry, you can enhance the color, if desired, with Shiva oil paint sticks, Marshall oils or oil pencils, watercolors, watercolor pencils, pastels, or pastel pencils.

When the emulsion transfer is thoroughly dried, protect it with an acrylic spray, such as those made by Krylon Crystal Clear and Sureguard's Pro-Tecta-Cote. This step is important whether or not you've touched up the image with color because the spray will keep the emulsion from cracking or peeling; it will also protect the colors from fading.

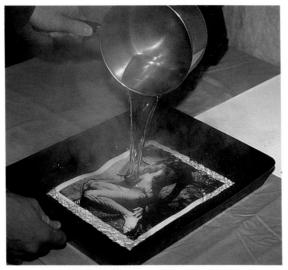

1. The procedure for making emulsion transfers involves several steps. Here, I'm pouring 160-degree water on top of a fully developed print.

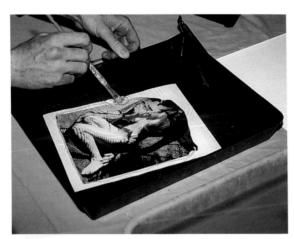

2. Next, I brush the edges of the loosened emulsion toward the middle of the print.

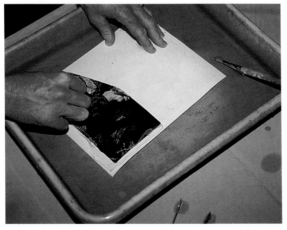

3. I peel the emulsion containing the image away from the substrate.

4. I then slide the emulsion lift onto a piece of 300 lb., cold-pressed watercolor paper.

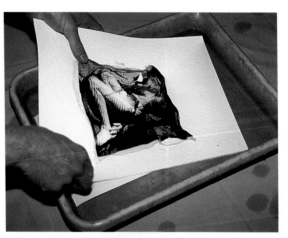

5. I use water while working with the print.

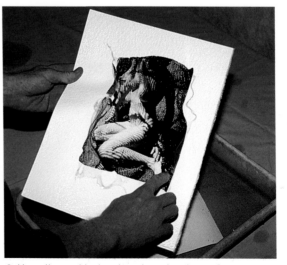

6. Here, I'm positioning the print using the water.

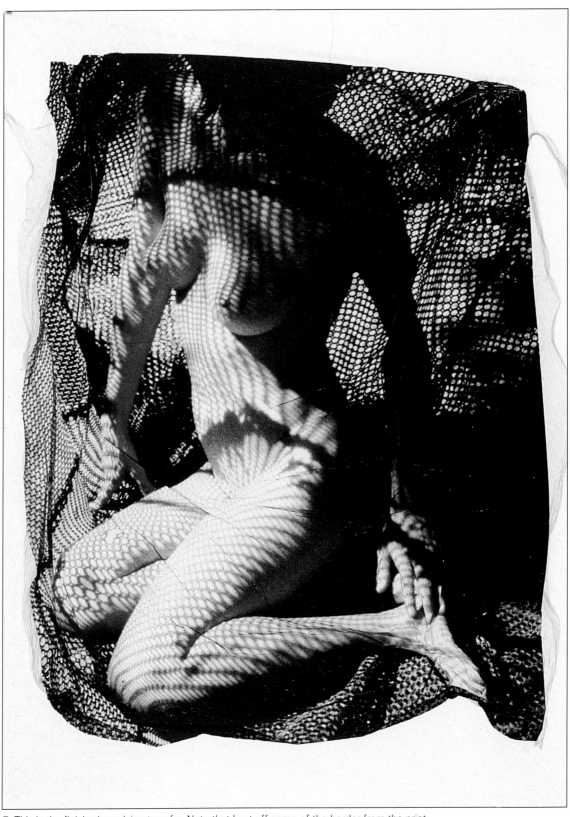

7. This is the finished emulsion transfer. Note that I cut off some of the border from the print.

TROUBLESHOOTING

Problem: You get a bubbly, jelly-like substance under the emulsion lift.

Reason: The print wasn't completely dry.

Solution: After you position the emulsion on the paper, take a brayer and gently roll it out. This is tricky: sometimes the emulsion sticks to the brayer and rolls up. But if you can get rid of the jelly-like material with the brayer, you can wash it off. Then place the emulsion transfer back under the water, and make any necessary adjustments.

Problem: The image tears easily.

Reason: The parts of an image that tear easily are the areas that aren't dense, such as a white dress or a white sky. The more color a picture area has, the denser it is, and the less susceptible it is to tearing.

Solution: Handle light areas in the print very carefully.

Problem: The emulsion won't lift.

Reason: The water wasn't hot enough.

Solution: Make sure that the water reaches a minimum temperature of 155 to 160 degrees.

Problem: The image is distorted.

Reason: The emulsion was in the water too long, and it started to stretch.

Solution: Work a bit faster.

Problem: The emulsion transfer is flaking off the paper that it was transferred onto.

Reason: You didn't spray the image after it dried thoroughly, which takes about a week. The smoother the paper or receptor is and the more flexible the receptor is, the more easily the transfer will flake off.

Solution: Always protect the emulsion transfer with an acrylic spray, even if you didn't add coloring.

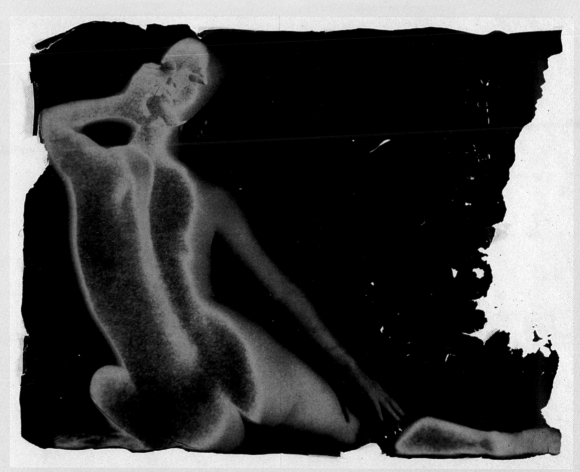

I transferred this emulsion lift of "Nude with Mask" onto 140 lb. Fabriano Artistico hot-pressed watercolor paper. I didn't spray the emulsion transfer for permanence, so the chipping off of the emulsion started about a month later.

MAKING TRANSFERS ON DIFFERENT SURFACES

One of the unique characteristics of the image-transfer process is the option to transfer an image onto a material not ordinarily seen in the photographic arena. An image transferred onto glass becomes a transparency, an image transferred onto wood becomes fresco-like, and an image transferred onto a rock becomes a pictograph. All of these alternative approaches are intriguing.

Glass

Glass is actually a better receptor for emulsion transfers than for image transfers. Making an emulsion transfer on glass is simple. You proceed as if you're working with paper. Just slip the emulsion onto the glass while it is under water. Image transfers on glass, however, are risky at best and require a little prep work. You must first etch the glass with Armour Etch, which is a glass-etching cream. Follow the directions carefully. Wear heavy rubber gloves and protective eyeglasses, and work in a well-ventilated area. This acid can be quite dangerous. Using a sponge, brush the cream onto the glass and then wait 5 minutes. In the meantime, put 4 tablespoons of baking soda into a pan of water; you'll use this mixture to stop the etching action of the cream. Then use plenty of water to rinse the glass clean.

Silk

Silk produces interesting image transfers because it is transparent to a certain degree. This characteristic enables you to choose a colored underlay (mat board or paper) to impart a different color to the image or to enhance the colors that already exist. White Habotai China silk is best for this process. It comes in many sizes, is inexpensive and is readily available through Jerry's Catalog (see the List of Suppliers on page 159).

To make a silk image transfer, quickly dip the fabric into hot water and lay it down on a piece of warmed glass. Next, take a brayer and roll out the air bubbles before placing the negative on the silk. Although the fabric is translucent when wet, it is opaque when dry.

When making emulsion transfers on silk or other textiles, you must be patient and use caution when working. Tape the silk or other fabric onto a piece of Plexiglas. Next, slide the emulsion lift over onto the silk while it is in the cold-water tray. Positioning the emulsion as you would if you were using paper, work with the action of the water. Then let the emulsion transfer dry on the taped-down fabric. Because fabric is pliable, it bends, and the emulsion will crack and flake off. If you use cloth of any kind, be sure to tape it, sew it, or attach it some other way onto a support.

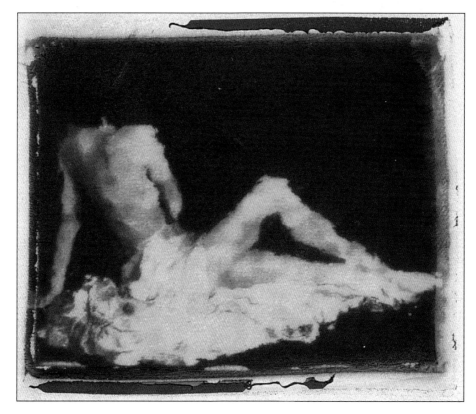

When planning to make this image transfer of "Lisa," I decided to work with silk.

Wood

When making an image transfer on wood, soak the receiving side of the wood in a pan of hot water for about 30 seconds. After you squeegee off the excess water, apply the negative and brayer the sandwich. Next, place the side of the wood with the negative face down on the heated glass. Set a gallon-sized jug filled with water on top to weigh down the sandwich.

Wait 2 minutes, and then peel the negative off the wood very slowly.

To make an emulsion transfer on wood, you simply follow the same procedure that you use for paper. The only problem you'll encounter is that wood floats. So having an extra pair of hands to hold the wood under the water during the transfer would be helpful.

I made this emulsion transfer of "Red Alley," which I initially shot in Burano, Italy, on wood.

THE TWO-FOR-ONE BONUS

You can use the substrates, or positive throwaways, that are generated during the image-transfer process to make emulsion lifts. Once you make sure that the throwaways are dry, you can apply a Contac-paper backing and toss them in the "surf." True, they won't have much color. But this is where Conte pastel pencils, watercolor pencils, and Marshall oils and oil pencils, and Shiva oil sticks come into play. Watercolors will work well, too, if you mix them with a little gum arabic.

You have three options here. After handcoloring the emulsion transfer, let it dry. Then spray it with a protecting sealer, such as Krylon's Crystal Clear or Sureguard's Pro-Tecta-Cote. An alternative is to color the throwaways first with graphic-artist pens, like the

Mars Graphic 3000 or those made by Staedtler or Flair. When the throwaways are dry, do the emulsion lift and transfer them to a receptor of your choice. Then protect them with an acrylic spray.

The third two-for-one bonus option involves waiting 15 to 20 seconds before prematurely pulling the negative away from the substrate when doing an image transfer. This will ensure that there is enough "color" on the substrate for an emulsion lift, and that there are enough dyes remaining in the negative to migrate to the receiving artist paper. The colors, of course, won't be optimal, but again, you can add color. You can actually get two prints from one sheet of film this way: an image transfer and an emulsion transfer!

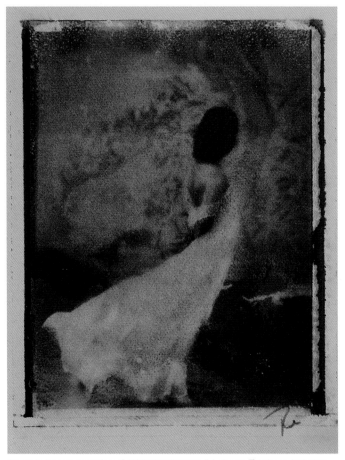

For this image transfer of "Windwalker #2," I chose Fabriano Artistico hot-pressed paper. I reworked the image slightly with Conté pastel pencils.

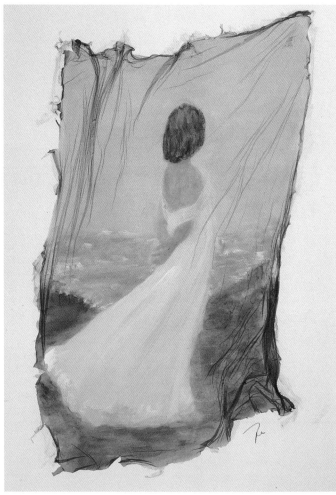

I lifted this gelatin image and turned it into an emulsion transfer on Fabriano Artistico cold-pressed watercolor paper.

This two-for-one image is the positive substrate from a 17-second pull. The golden tones fit the subject, which is Venice.

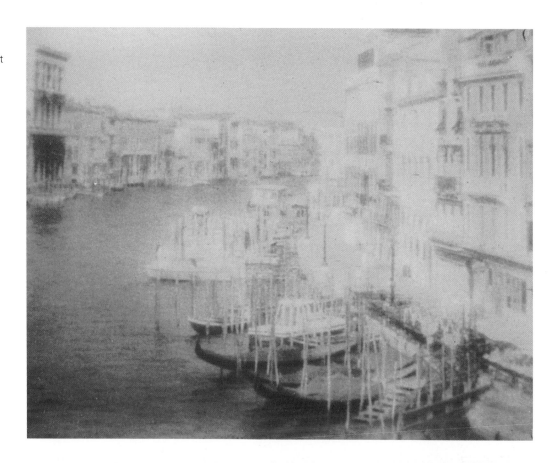

I made this image transfer using the negative pulled from the substrate shown above. It was a 17-second pull so that both an image and an emulsion transfer could be made.

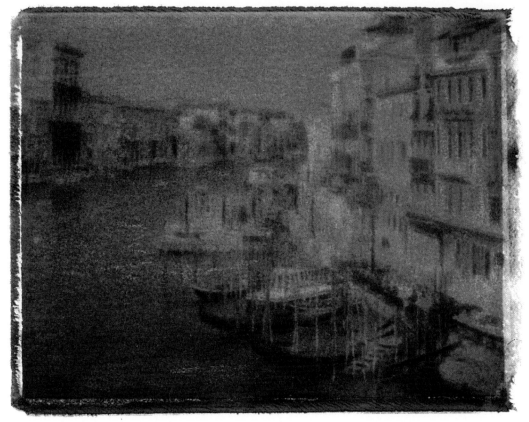

Polaroid Instant Slide Films

Polaroid manufactures two instant slide films: Polapan and Polachrome. Polapan is a 35mm black-and-white, panchromatic film that produces positive, continuous-tone slides. The film, which is packaged in 12- and 35-exposure cartridges, comes with the chemistry pack needed to process it in the Polaroid Auto-Processor. The recommended exposures are ISO 125/22 for daylight, and ISO 80/20 for 3200K tungsten light.

Polapan is a great film to use either in the field or on the copystand. Polapan responds to filters in the same manner as black-and-white negative films. Furthermore, you can exaggerate its grain by developing it longer than the standard time of a minute.

Polachrome, on the other hand, is a 35mm color slide film rated at ISO 40/17. It comes in cartridges of 12 and 36 exposures. The color is balanced for daylight and electronic flash. Polachrome is an excellent film for projection, but not for transfers because of the way the film is made. Its single light-sensitive layer isn't apparent when projected but is obvious in viewing when held up to the light. It is quite difficult to make transfers from Polachrome slides.

When I came across this old photograph of me in the first grade, I decided to manipulate it. So I shot it on a copystand using Polapan, a Polaroid instant black-and-white slide film, at ISO 60.

POLAPAN

This film is processed and ready to mount 5 minutes after you unload it from the camera. It has a fine grain emulsion with good middle-tone separation. However, Polapan does have about 1 1/3 stops less ability to record shadow detail than conventional transparency film. But I find that by adjusting the film speed to ISO 60 rather than ISO 125, I obtain more pleasing slides without any blockups in the shadow areas.

When exposing this film, use an adjusted film speed of ISO 50 or ISO 60. To achieve warm-toned, open slides, you can use an 81A light amber filter. The resulting slides will have a warm rather than cold black-and-white tonality. And the combination of various colored filters with a Nikon soft filter #1 or #2 will impart a hauntingly romantic, "infrared" quality to your images. They'll appear soft and high key, which means that they'll contain high values from gray to white, but no blacks.

Snow scenes will contain more open tones and take on a soft, wispy feel if you shoot Polapan with an 81A light amber filter coupled with a Nikon soft filter #1 or #2. Again, the filtration gives an almost infrared look to the final images. For dramatic snow scenes, use an orange filter over the lens. This will deepen the color of the tree trunks (which tend to be blue/black/gray in winter), emphasize form and contrast, and deepen the color of the sky.

Vibrant hues characterize the summer landscape when you use Polapan with a G(X1) filter, which is green. This type of filter separates all shades of green, renders the slide open, and increases the definition of the landscape by eliminating blocked-up areas. Clearly, this is a superior film to use when you want to give your own spin to what you see through the viewfinder. Polapan is also an excellent teaching tool for instructors. But the biggest advantage, of course, is that it is instant. After exposing a roll, you have only to wait 1 minute and you have finished slides.

The Polaroid Instant Slide Processor is inexpensive, small, lightweight, and portable. When you purchase the film, the packages come with the chemistry pack for the development of the film. So, in essence, you're paying for the film and the processing at the same time. You don't need to let your not owning a processor stop you from trying Polapan: many photographic stores allow you to use their processor if you buy the film from them.

A note of caution: When you pull this film out from its canister, it sometimes looks green. Don't worry. This "off color" dissipates immediately when the air hits it; it is simply a chemical residue. The film is quite fragile at this point and will scratch very easily. After examining the film, I rewind it back into the canister and let it sit overnight or for about 8 hours. This enables the film emulsion to harden.

For this wood scene, I shot Polapan at ISO 50 with an 81A filter combined with a Nikon soft filter #1.

I photographed this snow scene on Polapan at an ISO rating of 50. I used both an 81A filter and a Nikon soft filter #1.

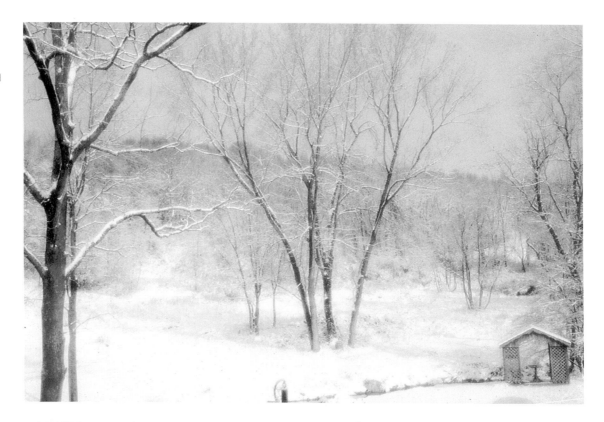

To record this version of the snow scene, I shot Polapan at the same film speed, ISO 50, but switched to an orange filter.

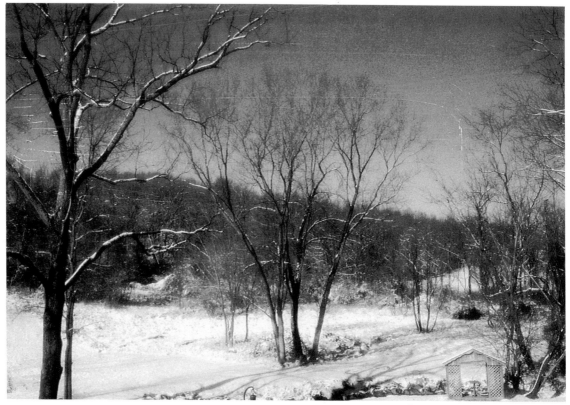

1. I photographed this series of images using the same film, Polapan, set at the same film speed, ISO 60. I did, however, change or add filters. Here, I didn't use any filtration.

4. For this variation, I used an 81A filter.

2. For the next shot in the sequence, I mounted a Nikon soft filter #1 on my lens.

5. Next, I combined an 81A filter and a Nikon soft filter #1.

3. I then switched to a Nikon soft filter #2.

6. Leaving the 81A filter on the lens, I replaced the Nikon soft filter #1 with a soft filter #2.

7. I made this shot using only an orange filter.

10. For this rendition, I used a red filter.

8. This image is the result of combining an orange filter and a Nikon soft filter #1.

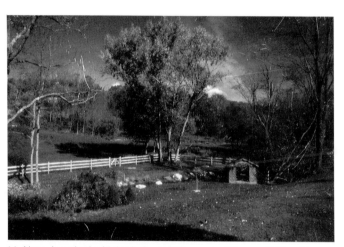

11. Next, I worked with both the red filter and a Nikon soft filter #1.

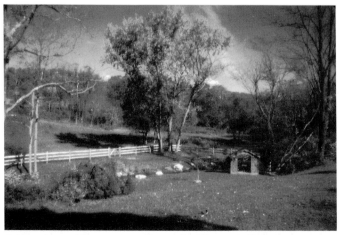

9. Here, I opted for an orange filter and a Nikon soft filter #2.

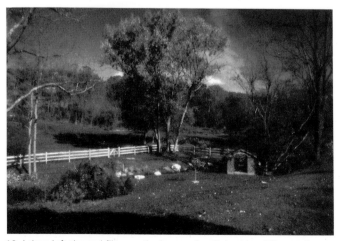

12. I then left the red filter on the lens and switched to a Nikon soft filter #2.

Using a Copystand

Polapan is a good choice for doing copy work on a copystand. This film works well with both tungsten and daylight bulbs. With 3200K tungsten-balanced bulbs, such as ECA and ECT, use ISO 60. With 4800K BCA or 3400K daylight-balanced bulbs, use ISO 100. (For more information on copystand work, see page 156.)

When working with Polapan to copy old photographs on a copystand, use ECA bulbs, a film speed of ISO 60, and an 81A filter over the lens. This light amber filter warms up the tones in the slide, changing blacks to warm browns. This effect readily lends itself to the desired old-world or vintage look. A yellow filter tends to lighten the yellow stains on old photographs as well, thereby producing a pseudo-increase in contrast. Thus, the slide looks sharper than the photograph.

Making Transfers

Polapan slides make excellent transfers. Because they are black and white, you can dial in the color you want. You can create a noticeable yellow, red, or copper tone. The final coloration depends on the filtration combinations you devise.

Using Filters

For old copied photographs, try dialing in around cyan 10, magenta 45, and yellow 20. This particularly successful combination gives the pictures a rich, red sepia or copper tone, suggesting yesteryear. Be aware that this is a starting filtration formula; you might need to alter it for your slide and film. For example, if you want more of a yellow sepia tone, add more yellow and less magenta, perhaps 25 yellow and 30 magenta. And if the print needs a little contrast, add about 10 cyan.

Another way to obtain an authentic vintage effect is to project your Polapan black-and-white slides onto Polacolor Pro 100 film instead of Type 669 film. Polacolor Pro 100 transfers have a slightly warm or yellow tint that lends itself readily to the vintage look. But if you don't want these warm tones, simply add 20 cyan into the filtration of the Daylab. If you're working with a Vivitar Slide Printer, use a CC20 blue filter with the slide. This cyan filtration will counterbalance the yellow tones.

For this image of my husband's grandmother, "Nanny Button," I copied the old photograph on a copystand with Polapan. I used a film speed of ISO 60 and an 81A filter. Note the warm effect.

I copied this picture of my parents, which was taken in 1942, on a copystand (without retouching it first). I used Polapan at ISO 60.

POLACHROME

Conventional color films have three separate emulsions to record the red, green, and blue portions of the visible spectrum. Polachrome has color layers—cyan, magenta, and yellow—on the back of the acetate. The image is hard to see without being projected.

Polachrome's grain is comparable to that of an ISO 400 film, but when you project Polachrome, its grain isn't visible. Remember, though, that when this film is underexposed, its grain increases. In a contrasty situation—one with bright sunlight and dark shadows—this film doesn't render pleasing slides.

You must be careful when you develop Polachrome because temperature is the key. For the best results, process the film at 70°F for 60 seconds. If the temperature is less than 70°F, process the film for 2 minutes. Never process the film at a temperature of less than 68°F; if you do, the colors in the resulting Polachrome images will be blue-toned.

Using Filters

If you keep your subjects in the shade, the resulting slides will be more even in contrast; the color of the images, however, will be bluish. To remedy this, use a Wratten 81D filter. When shooting Polachrome in the field or on the copystand, I prefer a film speed of ISO 25 or ISO 32, both of which slightly overexpose the film. When you combine either of these film speeds with a combination of soft filters, you obtain an impressionistic look.

1. I photographed this scene several times, using Polachrome at different film-speed settings. I shot this variation at ISO 12.

3. Here, I used Polachrome, an ISO 16 film-speed rating, and a Nikon soft filter #1. This combination produced a very soft, creative effect.

2. Next, I increased the film speed to ISO 16.

4. I made this shot with Polachrome rated at ISO 20.

5. For this image, I shot Polachrome at ISO 20 and put a Nikon soft filter #1 on my lens. The result: an impressionistic look.

8. I then adjusted the film-speed dial to ISO 40. But I found that this setting didn't work well: this recommended ISO resulted in an image that was too dark and contrasty.

6. Using progressively slower film-speed ratings with the Polachrome, I set the dial to ISO 25.

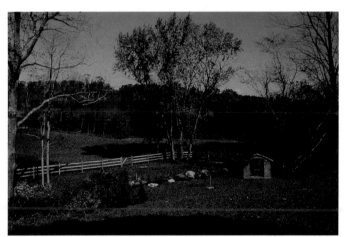

9. Here, I switched the film speed to ISO 50.

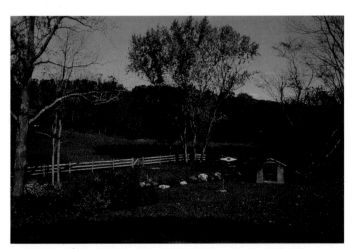

7. For this version of the scene, I shot the Polachrome at ISO 32.

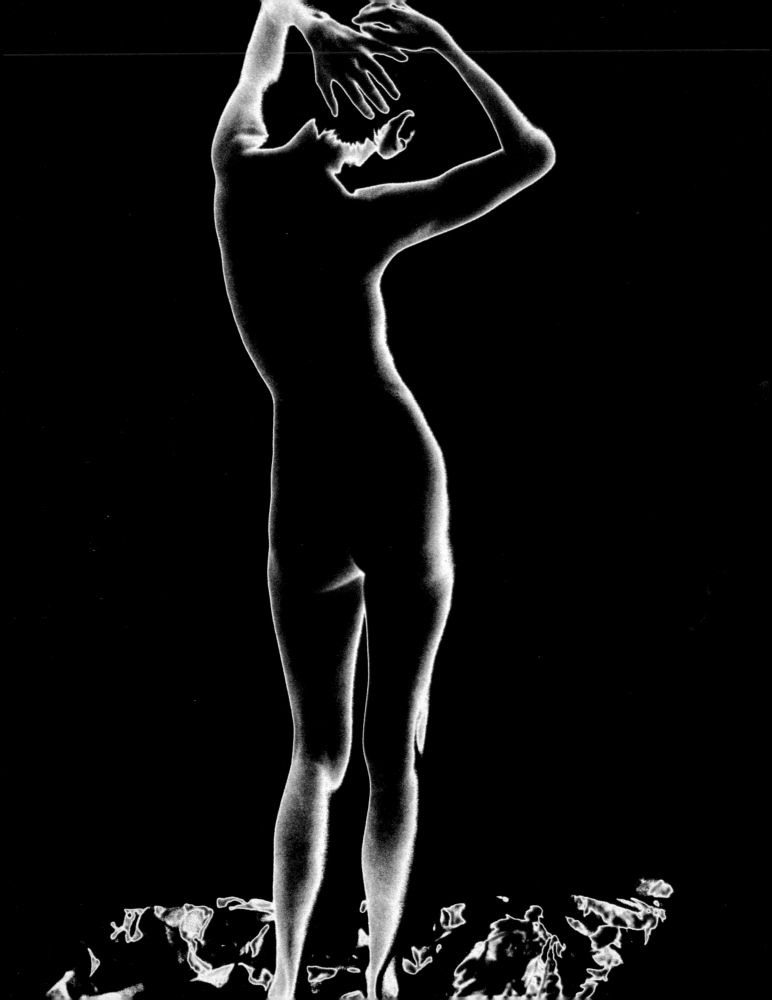

Chapter 7

SOLARIZATION

Solarization is a process that enables photographers to play with the yin and yang of reality. Photography, more than any other field of endeavor, shows people that very little in life is black and white. There are just too many gray zones!

As with most things in this world, photography is made up of negatives and positives. And sometimes negatives become positives while at other times positives become negatives—literally, figuratively, and absolutely. The print becomes a visual game of hide and seek. Now you see it, now you don't, now you see it differently. You can make images look inside out or partially inside out. Shapes seem to fade into and out of view . . . at the same time.

Pseudo-solarization, also known as the Sabattier effect, is the total reversal of an image on film. About 100 years ago, Dr. Armand Sabattier discovered that he could achieve a pseudo-solarization reversal effect by re-exposing film or paper to light while it was in the developer. This effect differs from true solarization in that white bromide lines form between the light and dark areas of the "solarized" image. These Mackie lines are a direct result of the Sabattier effect; they don't occur in instances of true solarization.

Solarization occurs on the film in a camera because of long overexposure. However, today's films have such extensive exposure latitudes that true solarization is rarely achieved any longer. So, since real solarization, for all intents and purposes, is no longer attainable, the Sabattier effect has become synonymous with solarization among photographers.

I made this image from a Konica infrared negative. I contact printed and solarized "Standing Nude" on Ilford MG IV glossy RC paper. Using a 75-watt bulb, I re-exposed the image for 2 seconds; this took place 30 seconds into the developing time.

SOLARIZING A PRINT

Photographic paper is coated with a light-sensitive emulsion whose active ingredients are silver atoms in combination with bromide and/or chloride atoms. Bromide renders cold-tone prints, while chloride provides warm-tone prints. A bromide/chloride paper produces basically middle-tone prints, but either the chloride or the bromide will dominate. In the enlarger, light passes through a negative according to its various densities. As the light strikes the photographic paper, it breaks down the silver crystals in the emulsion.

When you place exposed photographic paper into the developer, chemical action converts the broken crystals of silver into solid metallic silver. As the print is processed, the silver crystals that didn't receive any light are washed out in the fixer.

If while in the developing stage the print is re-exposed to light before it has been fixed, the silver crystals that light didn't strike during the first exposure under the enlarger will now be broken with the second exposure to light. They're then converted into solid metallic silver during the remaining time in the developer. And the areas of the print that had already been exposed to light in the enlarger and converted to metallic silver in the developer during the first few

seconds of the developing stage begin to reverse. So, the positive becomes negative, and vice versa.

Although there is no way to predict exactly how an image will react to its second exposure to light, two guidelines hold true. First, the longer the image's initial exposure in the enlarger, the more "positive" the image will remain after the second exposure. The opposite is also true: The shorter the image's initial exposure in the enlarger, the more "negative" the image will become after the second exposure.

The degree to which a print is solarized largely depends on the wattage of your light bulb and the point at which you interrupt the developing stage with the second exposure. Clearly, these variables guarantee that many very different prints can be derived from a single negative.

As mentioned earlier, Mackie lines develop between the light and the dark areas of the print. High-contrast negatives yield prints with pronounced Mackie lines. These lines not only give form and definition to existing shapes within the print, but also add another dimension to the image as a whole. This is more proof that photography is never as simple as black and white.

After printing the corresponding contrasty negative on Ilford glossy MG IV RC paper, I developed "The Zoo Keeper" in Solarol developer.

Selecting a Negative

Select a negative that has good contrast. For the solarization process, the more contrast an image has, the better it shows the desired effect. Infrared negatives work very well. They result in compelling Mackie-line configurations and interesting reversals.

Selecting a Paper

Glossy, multigrade RC paper results in the most dramatic solarization. The glossy coating reflects the light of the second exposure twice as much as a semi-matte or matte paper, thereby increasing the contrast in and drama of the solarized prints. Always use a #5 filter with multigrade papers; this filtration increases image contrast. I've found that Luminos's papers—RCR, Flexicon VC, and pastel papers—all work exceptionally well when it comes to solarization. In addition, the RCR and pastel papers enable you to add color directly to the print with color pencils without the necessity of precoating.

Developers

Developers serve as an important control during the solarization process. Remember, you re-expose the prints to light a second time while they are in the developer. As such, the wattage of the light, the length of exposure, and the type of developer combine to determine the result. If, for example, the print is in fresh Dektol, it will develop too quickly and turn black before you can stop the developing action. If the print is in a weaker solution of Dektol, you might be able to stop the developing process in time; however, this is still risky, and you'll probably lose a lot of prints.

A better approach is to use Solarol. This is a slow developer made for re-exposing prints to light and thereby enhancing the Sabattier effect; you can let the print reach full D-Max before placing it in the stop bath. So you'll get a rich black-and-white (not gray) solarized print.

Solarol

This developer is made by the Acufine Company for the sole purpose of solarizing a print. As a result, when you re-expose a print developing in Solarol, you get guaranteed solarization. And because the print remains in the developer for the full print time, it yields rich blacks and good whites. Solarol also produces great Mackie lines. You can solarize both film and paper with Solarol with enormous control of the process and repeatable results. Plus, the product has a long shelf life.

Although you can solarize a print in a typical developer like Dektol, the solarization process will be tricky and the results unpredictable. You can waste a great deal of time and paper before you pull a good solarized print—if ever. (But if Dektol is your developer of choice, use a weak dilution of it for the best results, or use it at the end of a printing session when it is almost exhausted.) Solarol is easier to work with and is more cost effective.

Working with the Print

The first step in the development process calls for you to put a #5 filter under the lens of the enlarger. Then make a test print. After determining the proper print time, you need to subtract 10 percent of that time and print another sheet for solarizing. For example, if the test print takes 15 seconds to print and $1\frac{1}{2}$ minutes to develop, you'll expose the negative for $13\frac{1}{2}$ seconds (15 seconds minus 10 percent, or $1\frac{1}{2}$ seconds). Remember, the shorter the initial exposure under the enlarger, the more "negative" the image will become with the second exposure!

Next, place the paper into the developer (preferably Solarol). Make sure that the developer solution is still, not sloshing around. If the chemistry is moving from side to side, ripples will appear on the solarized print. (Of course, this effect isn't bad—if you want an underwater look.) You also don't want to agitate the liquid or create bubbles. Any bubbles on the surface of the developer will leave circular marks on the print.

Consider the following points when you try to determine the length of time required for the initial exposure (in the enlarger). If you decrease the correct print time by 25 to 50 percent, the solarized print will contain fewer details (less information in the print) and be more "negative" (reversed). With this shortened initial exposure, image contrast is reduced, so you lose some of the Mackie lines. Remember, these lines are most striking when there is dramatic contrast between dark and light areas in an image.

The length of time that you permit the print to develop before re-exposing it to light has a profound impact on the solarization process. The strongest solarization occurs $\frac{1}{3}$ of the way into the print time. For example, if the proper print time is 90 seconds, you'll re-expose the print at 30 seconds into the developing process. The longer the print is allowed to develop before re-exposure, the more pronounced the Mackie lines will be. And the less time the print is allowed to develop, the less distinct the Mackie lines will be.

Combining the length of time allotted for initial exposure under the enlarger and the amount of time the print develops before re-exposure can lead to even more subtle control of the solarization process. Less light in the enlarger provides fewer details in the print, as well as greater areas of unexposed emulsion for the solarizing effect of the second exposure. You can capitalize on this by decreasing the amount of time the print remains in the developer before you re-expose it.

After you wait the recommended 1/3 of the print time, be sure to give the developing print a second exposure of light. Ideally, this light source should be over the tray. (I use a 75-watt light bulb with a pull string.) Turn the light on and off as quickly as possible. I find that it is easier on your eyes if you keep them closed during the flash.

Controls

Although I prefer working with 75-watt light bulbs for re-exposure, you can use bulbs ranging in strength from 10 to 100 watts during the solarization process. Naturally, each wattage produces a different effect in the final prints. The lower the wattage, the gentler

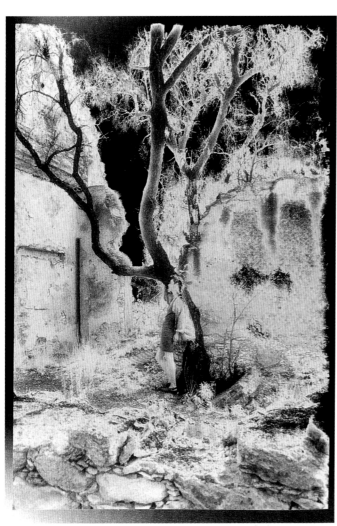

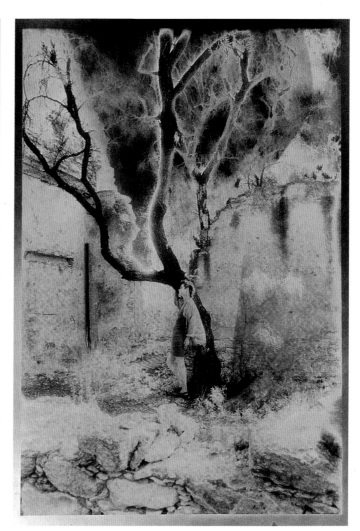

I made quite a few versions of "Girl Under a Tree in Pozos," which I'd photographed in Mexico. Each print depicts a different look because of the various paper-exposure, re-exposure, and coloring choices I made. I developed all of the prints in Solarol, a solarizing developer, for the full developing time of 90 seconds. For this print, I selected Luminos RCR paper and re-exposed with a 75-watt bulb at 30 seconds into the developing time (at 1/3 of the full developing time) for a duration of 2 seconds. This gave the image a rich black tone, a more "positive" look, and good Mackie lines.

I used Luminos RCR paper and a 75-watt bulb once again, but this time I re-exposed the print at 30 seconds into the developing time for only a 1/2 second duration. Here, I used Solarol. The resulting print has a softer, less dramatic look.

the reversal, the subtler the tones in the print, and the longer you need to re-expose the print to light.

A short, bright flash of light gives more contrast in the finished print than a long, dim one. A 2-second re-exposure produces deeper blacks and more dramatic solarization than a split-second exposure with the same wattage. Taken together, the length of exposure and the wattage create a third variable. For example, if you use a 40-watt bulb for a 2-second exposure, you'll get a gentler solarization than you would if you were to use a 100-watt bulb for the same amount of time. With the weaker light bulb, dark areas will turn mid-gray. With the 100-watt bulb, these parts of the image will turn dark black, for a contrasty, dramatic solarization.

Make sure that nothing casts a shadow over the chemistry when you re-expose the print to light. Sometimes if the print moves to the corner of the tray when the light is turned on, the side of the tray will block some of the light. As a result, that portion of the print won't solarize. Now let the print fully develop in order to obtain the paper's full D-Max. You'll see the reversal of the tones and the Mackie lines form.

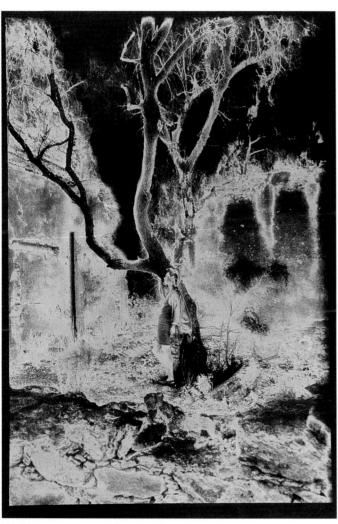 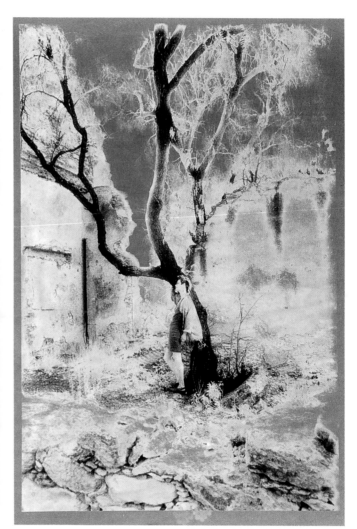

Working with Luminos Flexicon VC paper, I re-exposed a print of "Girl Under a Tree in Pozos" at 30 seconds into the developing time for a duration of 2 seconds with a 75-watt bulb. The result: good details, a more "positive" look, and great Mackie lines.

Still using Luminos Flexicon VC paper, I then re-exposed another print at 15 seconds into the developing time for a duration of 2 seconds with a 75-watt bulb. This combination led to fewer details and a more "negative" look.

SOLARIZING A PRINT

For this version of "Girl Under a Tree in Pozos," I decided to switch to Luminos pastel red paper (top left). The other variables remained the same: I re-exposed the print using a 75-watt bulb at 15 seconds into the developing time for a duration of 2 seconds. This combination turned the paper a rich, deep red color. For yet another interpretation I worked with Luminos pastel red paper again, re-exposing this print at 15 seconds into the developing time with a 75-watt bulb (top right). However, the length of the re-exposure was only 1/2 second. Note the bright red color of the paper.

Next, I decided to try Luminos pastel antique ivory paper (bottom left). At 15 seconds into the developing time, I re-exposed the print of "Girl Under a Tree in Pozos" for 2 seconds. I then made this print on Luminos pastel blue paper and re-exposed at 15 seconds into the developing time for a duration of 1/2 second (bottom right).

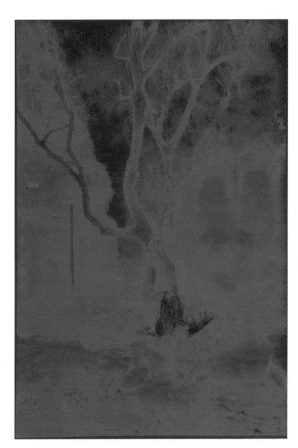
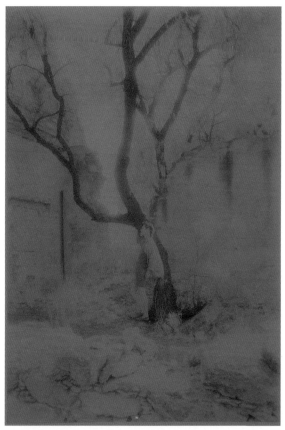
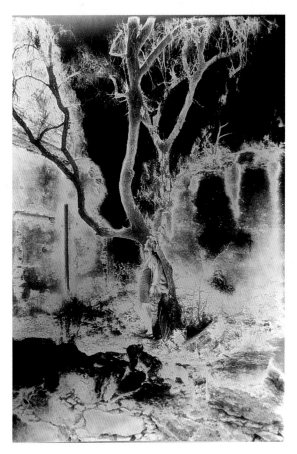
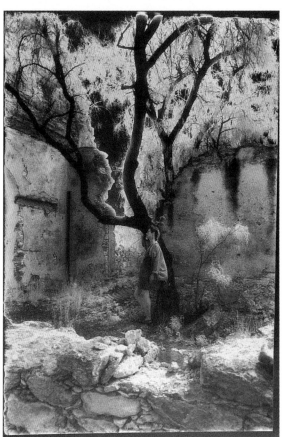

Printing Variations

One alternative when printing is to use a slide, either black and white or color, instead of a black-and-white negative. A slide will print a negative image onto the paper that when solarized will partially reverse. (Yes, this is strange.) Make the print with the slide in a negative carrier; you don't have to take the slide out of its mount. If you're making the print on RC paper, wash the print for 5 minutes and then dry it with a blowdryer.

Next, contact print the dried RC print onto another sheet of paper. Any RC or fiber paper will work. Just be certain that this piece of paper doesn't have a logo or watermark on the back because it will print through the paper. If you want to handcolor the finished print, be sure to use a paper that accepts coloring. You might want to try Ilford Multigrade Mat-surface paper; Kodak Poly Art paper; or Luminos RCR paper (RC paper, rough surface), Antique Ivory RC paper, Charcoal paper, or Mer paper.

To make the contact print, lay an unprocessed sheet of photographic paper on the contact printer with the emulsion side up and the processed print on the top, image side down. In other words, the papers will be positioned emulsion to emulsion, with the paper containing the image on the top. Next, open the enlarger lens, and do a test print with increments of 5 or 10 seconds depending on the density of the print you're working with. The darker the printed image, the more time you'll need to make the contact print. Develop your test contact print, and evaluate it to determine the correct exposure time. Then go at it again, this time re-exposing the print to light when it is in the developer.

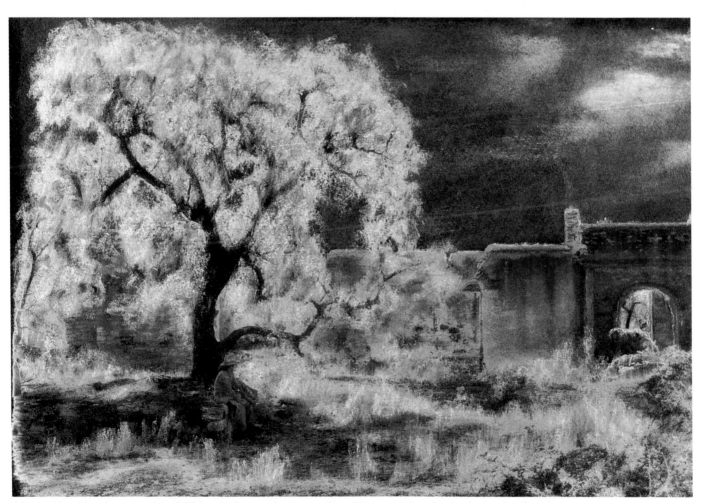

After making this print on Luminos RCR (grade 2) paper, I re-exposed it at 30 seconds into the developing time for a 2-second duration, and handcolored it with Conté pastel pencils.

After treating several prints of "Roman Soldier and Horse" with Solarol, I reworked them. This print was made from a colored slide on Ilford Glossy MG IV RC paper using a #5 filter and then solarized.

I then made a contact print of the image on Ilford Multigrade Mat-surface paper and solarized it.

Next, I handcolored the solarized print with both oils and dry watercolor pencils.

Printing a Solarized Negative or Slide onto Film

The advantage of solarizing film is that the process provides you with a solarized negative to print from. Because the solarization is on film instead of on paper, it will reproduce itself consistently and exactly on any paper you select. On the other hand, solarization directly on photographic paper yields a unique image. Both methods have their advantages and disadvantages.

Kodak Professional Black-and-White Duplicating Film SO 339

This film produces a negative from a negative. Kodak SO 339 comes in 4 × 5 and 8 × 10 formats. As the "SO" designation suggests, you must special order it from Kodak, but it takes only a few days to get it. You can develop the film in Dektol 1:1 or Solarol, and because it is blue-light sensitive, you can use it with a #1A red safelight in the darkroom.

When you use this professional duplicating film with a negative in the enlarger, you obtain a negative image on the film. And when you use a slide (or positive) to print, you get a positive image on the film. The disadvantage of using professional duplicating film is the cost: it is much more expensive than fine-grain positive film.

Kodak Fine Grain Positive Film 7302

This film provides a positive image from a negative. It comes in 8 × 10, 10 × 12, and 11 × 14 formats. You can develop it in Dektol 1:2 or Solarol, and, like professional duplicating film, you can use it under a #1A red safelight in the darkroom.

When you work with fine-grain positive film, such as Kodak 7302 film, with a negative in the enlarger, you get a positive image on film. If you want, you can then contact print this onto another piece of film in order to obtain a negative. The advantage here is that when you print from the small negative in the enlarger to make the positive image on film, you can dodge and burn to create a perfect positive image—just as if you were making a print on paper. Then after you process and dry the sheet film, you can contact print it onto another piece of film and achieve a perfect negative for future use. The disadvantage of this film is, of course, the extra steps in producing a negative.

If want to solarize the positive on film, you'll solarize the film the same way you solarize using paper. You can then contact print the solarized film onto paper; it reproduces perfectly every time. And as the print develops, you can solarize again if you so desire. The possibilities are endless.

A great way to create unusual images is to take your 35mm negatives out of the negative sleeves and place them, emulsion to emulsion, on top of a sheet of 8 × 10 film. Expose the negatives under the enlarger in a contact printer, just as if you were making a contact sheet. If you're using fine-grain positive film, you'll have 36 frames of positive images that you can solarize and use to print individually. If you're use professional duplicating film, you'll have 36 frames of negatives that you can solarize and use to print individually with constant, predictable results, unless of course you interrupt again to solarize. There is virtually no end to this madness.

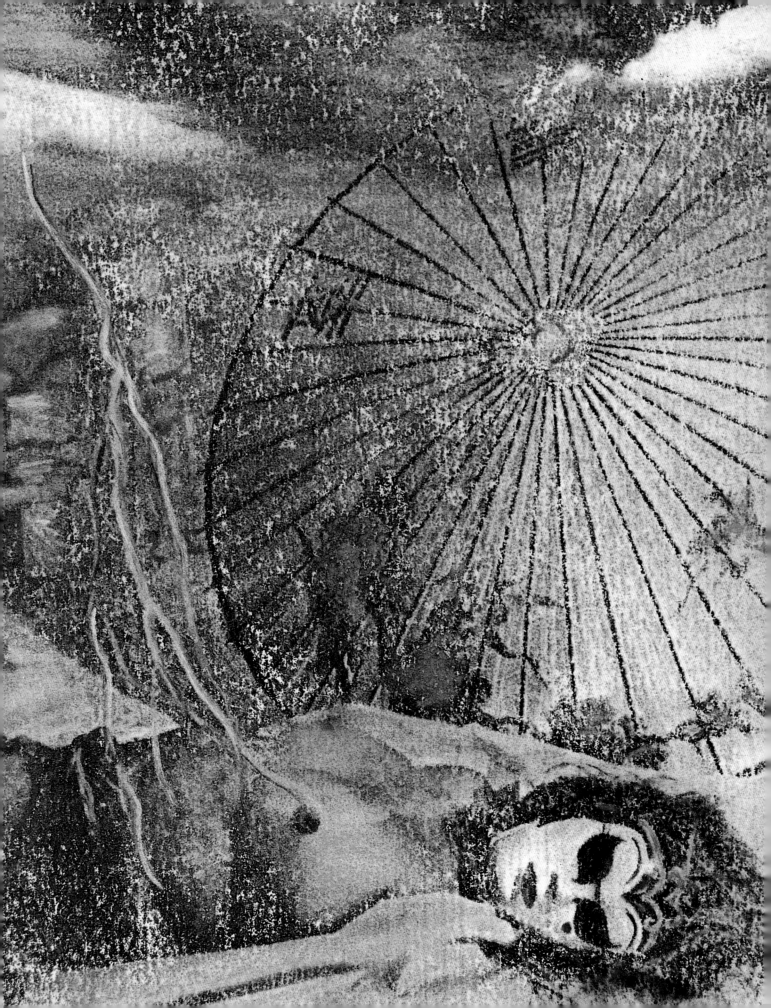

PHOTO
TRANSFERS

Photo transfers spirit photographers into the world of alchemy. Magically, without the darkroom, without expensive equipment, without photographic papers, photographers can produce images that are both unusual and unique. Almost any image can make a good transfer: nudes, landscapes, portraits, and architectural shots. The secret is to keep the image simple. If is too cluttered, it will be difficult to do a transfer that will give you all the information the print contains. Look for good separation in the grays, or the middle values.

In my experience, photo transfers involve a simple, three-step process based on my own photographs. First, I make a print on any photographic paper, although I've found that RC paper makes the process fast and easy. Next, I photocopy the print using a copy machine. Finally, I transfer the photocopy to artist paper.

To get started, you need to gather a few materials. The supplies needed for photo transfers are minimal: artist papers, black-and-white prints (that you've developed yourself or sent out to a lab), a clipboard, masking tape, lacquer thinner, a bit of patience, and access to a photocopier. All of these elements come together with the same thunderbolt effect of having turned lead into gold. Here, however, carbon is elevated to the status of art. This accomplishment is no less mystifying, even in this day and age.

I handcolored this detail of a photo transfer of "The Orient," a collaged image, with pastels and dry watercolor pencils.

SELECTING A PRINT

As with any photographic procedure, careful image selection is essential. If you have access to a darkroom and can make your own black-and-white prints, I recommend using RC paper. It is inexpensive and convenient. If you choose black-and-white prints that a lab has developed, keep in mind that not all images will look good as transfers. As a guideline, select a print with an uncluttered look. However, if you feel like experimenting, you can work with collage prints.

It is important to remember that your print will reverse on the transfer. In some cases, this isn't a critical issue. But if the composition is unbalanced or if the image contains words or numbers, the reversal might turn into a catastrophe. When printing for myself, I generally flip the negative when making my initial print. The print will then "right" itself during the transfer process. I look for negatives with a simple composition, and I dodge and burn accordingly.

Black-and-white copier-made prints from color photographs don't always work very well because they tend to block up or to lose information with certain dark colors. However, you can have your color photographs copied on a Canon Laser Copier (200 or 400) and directly transfer that color photocopy onto artist paper. You can also take the color photocopy to a black-and-white copy machine and make black-and-white copier prints. These prints transfer better than their color counterparts, and the inks are much more archival than color dyes.

The colors on the Canon Laser Copier 200 are outstanding. But be aware that when you transfer a color copier print from a Canon Laser Copier, some of the colors won't fully transfer. When this happens, you can enhance or rework them with pencils, oils, and pastels after the transfer to artist paper.

The Canon Laser Copier also produces beautiful color copy prints from slides. So if you have an image on a slide that you want to see on artist paper, have it copied on the Canon Color Copier in color first to get your copier print. You can then go from there to a black-and-white copy machine to make reproductions.

The supplies needed for photo transfers include lacquer thinner, rubber gloves, a baren (the one shown is made by Speedball and has a Teflon base), masking tape, scissors, acetone, a rag, and a clipboard.

SELECTING AN ARTIST PAPER

When selecting the artist paper to be used during the transfer, keep in mind the mood and the feelings you want to convey. Some beautiful watercolor and etching papers are available (see the List of Suppliers on page 159). It is always best to experiment: transfer one image onto several papers to understand what different papers can do to enhance an image.

Rives BFK paper is a printmaking and drawing paper that leads to good, consistent results. Its smooth finish transfers details well. This paper also comes in a buff color that is suitable for nudes and portraits. Rives Lightweight paper is another printmaking and drawing paper, but its surface is a little more supple and produces intricate details from photocopies. Because this paper is so thin, the transfer sometimes bleeds through to the other side, but not with the same amount of information. The flip side tends to be more mysterious and haunting.

Both Fabriano Artistico and Arches hot-pressed watercolor papers are somewhat pricey. But they are worth the extra expense if you intend to use watercolors on the transferred prints. The surface textures of these papers lend themselves to providing good detail and great results.

Arches 88 paper is a waterleaf paper that offers excellent results. Because there is no sizing at all in the paper, the dissolved inks and toner are absorbed easily; this, in turn, gives prints great details. Little dissolving fluid is needed.

Strathmore 403 pastel paper has a barrier coating that prevents the acids in oil paint from being absorbed into the fibers of the paper. As such, it is a good choice for transfers if you wish to rework or color the final image with oil paints. This paper comes in soft colors and has a nice surface. The only drawback is that the largest size it is available in is 11×14 inches.

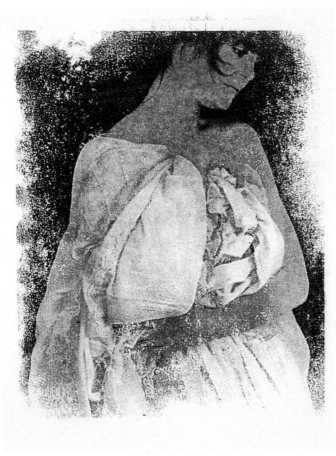

I made this black-and-white photo transfer of "Lisa" on Rives Lightweight paper.

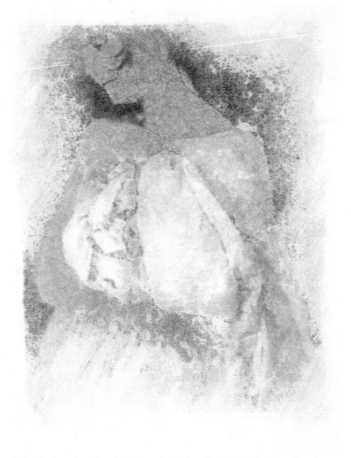

This black-and-white photo transfer is the flip side of the transfer shown opposite; the image bled through the Rives Lightweight paper I was using. I then decided to handcolor this "Lisa" with Marshall oil pencils.

THE COPIER PRINT

You can determine the size of the photo transfer, or the sizes of the various parts of the photo transfer, at the copy machine. Simply adjust the enlarging/decreasing percentage button as desired. Be sure to copy dark enough to transfer information, but not so dark as to block out the details present in the print. You do, however, want rich blacks, not dark grays. You need information—details—in the dark areas and a little tone in the white parts. If the white sections are blank, there is nothing to transfer.

Make sure that the copier print isn't too contrasty. Pretend that you're judging a black-and-white photographic print when looking at your copier print. You might have to use another machine if you can't achieve a rich black. In order to make a transfer, there has to be something (ink or toner) on the copier paper to transfer.

Collaging can be done before or after you make the copier print. If you want to transfer more than one image or parts of different images onto one sheet, cut out the part or parts you want to use and begin to transfer. Take a piece of copier paper that contains pure black ink (no image), and use the black ink as a blending tool. Next, position the black-inked copier

paper on top of the artist paper, and rub the lacquer thinner on the back to dissolve the ink where you want to blend images. You can also apply color later by hand to pull the image wholly together or to create a particular mood.

Occasionally, the partially dissolved inks on the copier print produce a unique-looking print that is preferable to the transfer itself on artist paper. Because this has happened to me many times, I now purchase Perma-Life, an archival copier paper made by Howard Bond and available from Light Impressions in Rochester, New York (see the List of Suppliers on page 159). This 20 lb. paper is pH balanced and doesn't become brittle with age. You can use it in any copier machine, including the Canon Laser Copier. During the transfer process, Perma-Life paper releases the inks far better than the inexpensive copier paper used in most machines.

When transferring images, you should avoid cold-pressed and rough artist papers. They are so textured that the inks won't go into the pits on their surfaces. As a result, the images break up and aren't readable. You'll have more success with hot-pressed papers. Although they have a hard surface, they are absorbent.

I produced this good photocopy of my photograph entitled "Mythology #3" on a copy machine. This shows how dark a photocopy should be for transferring; the photocopy should contain full information.

MAKING THE TRANSFER

Black-and-white photo transfers are very permanent print due to their carbon-based ink (toner). In a nutshell, the photo-transfer process itself is actually the dissolving of the carbon-based inks in the copier print onto artist paper. Copy machines have different percentages of carbon in the inks that they use. So it is a good idea to call the manufacturer of the ink or the toner in order to find out the percentage of carbon it uses if you're planning to do a lot of transfers. Remember, the higher the percentage of carbon, the more archival the final transfer will be.

Two warnings: Never do a photo transfer inside a closed room, and don't smoke during the procedure! In fact, you should do this outdoors. Wait for a warm, breezy day, and wear gloves to protect your skin. If you find that the odors irritate you or give you headaches, you should also wear a respirator.

To begin, tear your selected artist paper into the size you want, and tape it to a piece of plywood or a clipboard. Lay the copier print face down on top of the artist paper. Use masking tape or clips to secure the print to the artist paper at the top.

If you're working with a black-and-white photocopy, saturate a small cloth with lacquer thinner and wet the entire back of the photocopy by rubbing it lightly in a circular motion. You can apply more pressure as needed. Check the transfer's progress by lifting the untapped portion of the photocopy. Apply more pressure and more thinner if the ink isn't dissolving and transferring. When you're satisfied with the transfer, lift the copier print off the artist paper and pin the transfer to a piece of cardboard to air and to dry. This should take about 20 to 30 minutes. If you're doing this on a very hot day, the heat will affect the partially dissolved inks from the photocopy; they'll form strings of toner if you lift the print too quickly. So in this situation, you should raise the print a little more slowly than you otherwise would to check your progress.

If your copier paper is archival and the inks have dissolved off during the transfer process so as to make the photocopy the preferred image, you have an archival piece on which to add color. Such images take coloring beautifully with pastel pencils.

1. I place the photocopy of a photograph, "Mythology #3," face down on the artist paper and secure it with tape.

2. Wearing gloves, I gently rub lacquer thinner with a rag on the back of the photocopy.

3. Next, I apply even pressure via a brayer to make sure that the ink on the photocopy is dissolving and transferring.

4. This is the photocopy image bleeding through the back of the photocopy paper, indicating that the transfer is finished.

The steps involved in making color transfers with color copier prints from a Canon Laser Copier machine are pretty much the same. Here, however, you use acetone as the dissolving fluid. Once again, you should work outside on a breezy day, wear gloves and a respirator, and refrain from smoking. And keep in mind that acetone takes off fingernail polish and dissolves acrylic fingernails.

5. Here, I'm inspecting the transfer's progress.

Coloring Techniques

To color photo transfers, you should first take stock of the artist paper that you used in the transfer process. Most papers accept all pencils—oil, watercolor, and pastel—as well as graphic inks. However, if you choose pastels, be sure to spray the final print with a workable fixative first and then an acrylic spray, either glossy or matte, to keep the color from smearing. On heavy (300 lb. stock), hot-pressed, watercolor papers, you can apply wet watercolor paints.

If permanence is an issue, you shouldn't use oil-based colors—oil pastels, oil sticks, or oil paint—on papers without a ground or without priming the papers beforehand. Both of these create a barrier between the paper and the pigment. Oils have acids that will eventually weaken the fibers in the paper, even those in archival pH-balanced papers.

6. Pleased with the transfer, I lift the photocopy off the artist paper.

7. This is the transferred image from the photocopy on artist paper. I decided to handcolor it with Marshall oil pencils.

8. The final step was to handcolor the used photocopy print on Perma-Life paper, containing partially dissolved inks. I used Conté pastel pencils here.

TROUBLESHOOTING

Problem: The copy doesn't transfer.

Reason: The copy machine can't provide a deep enough black, or the artist paper can't fully release the inks.

Solution: You have several options. First, check to see if the copy machine uses a carbon-based toner. Try Perma-Life archival paper in the machine; this will facilitate the release of the inks from the copier print onto your artist papers. You can also try another copy machine. Also, make sure that there is enough ink on the copier print to dissolve and transfer the image onto another paper. You need a rich black on the copier print, not a dark gray color.

If the artist paper you're working with is too textured, it won't produce a good transfer. The inks can't get down into the little depressions in the paper. Apply more pressure by rubbing harder with the cloth; you can also try using a burnisher, the back of a large spoon, or a baren. This printmaking tool, which is a plastic or Fiberglas disc with a handle, evenly distributes pressure for improved pigment transfers. Another option is to apply a light coating of a dissolving fluid to the artist paper before laying the copier print on the top. Then proceed as usual. A third possibility is to run the sandwich (of the photocopier print and artist paper wetted with a dissolving fluid) through a printing press.

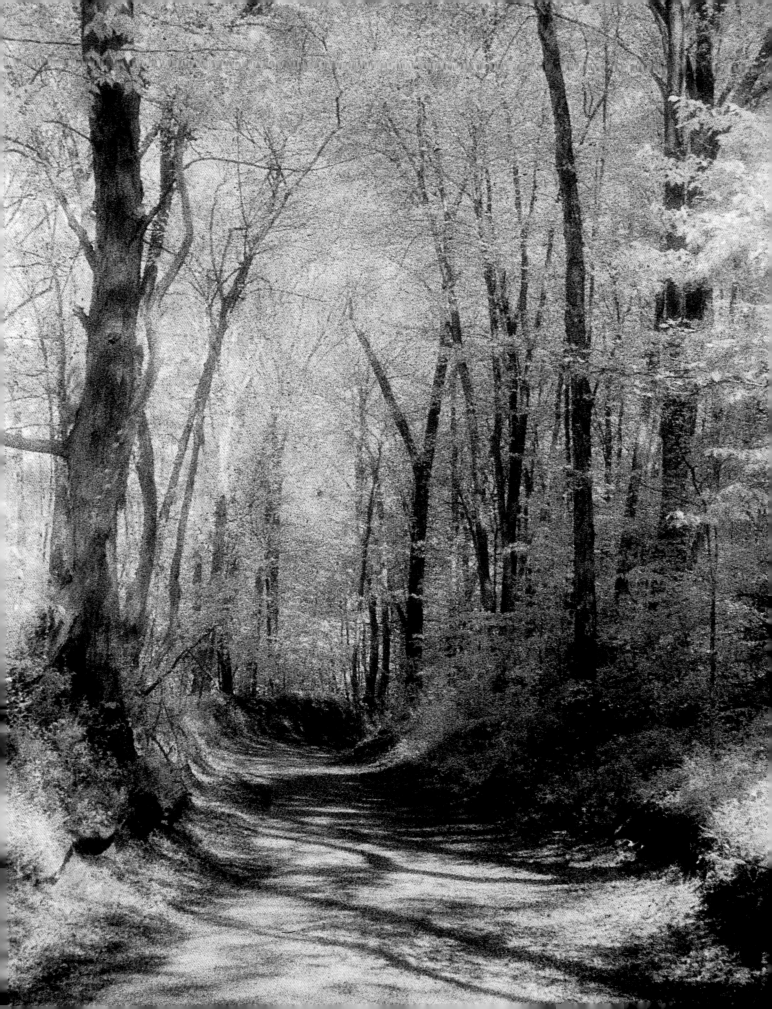

Handcoloring Photographs

Artists evoke emotions with both color and composition. Imagery and form take on nuances of meaning because of shadow and hue. For this reason, handcoloring, as a manipulative photographic technique, gives artists poetic license, or the freedom to control the image and create the mood.

Handcoloring can enhance a photograph by imparting an emotional quality that might otherwise be lacking in the straight print. Photographers can also use this technique to magnify or downplay qualities already present in the print. However, handcoloring can't turn a bad print into a good one; it can't make up for a lack of tonal values or poor composition. Handcoloring is meant to be a supplemental tool because it is only capable of adding dimension to the image at hand.

For many photographers, handcoloring is a "fingerprint" of sorts, an indicator of style, and a way to tap into the subconsciousness of artistic expression. In a very real sense, handcoloring gives photographers an opportunity both to "retake" a photograph emotionally and to put those feelings on paper. The importance of color can't be disputed. Its use can make or break an image.

To handcolor this detail of "Matthews Lane" on Forte Bromofort paper, I used pastels and Marshall oil pencils.

SELECTING A PHOTOGRAPHIC PAPER

The first order of business when assessing a new black-and-white photographic paper is to fix it out, archivally wash it, and look at its color. Fixing out the unexposed paper involves putting it in a fixer bath and fixing out the silver without an image. You should be able to hold the paper in the light and see its base color. (If you don't fix out the paper, it will turn black in the light because it will still be light-sensitive.)

Then place the paper next to other fixed-out papers to see if its base color is white, off-white, cream, yellow, or pink. This is the color you'll see in the highlights of a finished print. And if you use a bleaching technique, the base color will help you determine what colors might be pulled from the paper.

Next, analyze the paper's surface. Is it a pearl, matte, semi-matte, glossy, luster, silk, or rough surface? Different coloring mediums are best suited to certain surfaces. For example, if you're working with a heavily pitted or canvas-like surface, like that of Luminos Tapestry paper, hard color pencils, such as Marshall oil and watercolor pencils, will leave marks on the surface. In addition, the color won't reach into the little wells, thereby giving an "I've unsuccessfully attempted to color this picture" look to the image. For this type of surface, soft pastel pencils, like those Conté a Paris makes, work best (see page 154).

RC (resin-coated) papers aren't made only on glossy stock anymore. They come in a myriad of tactile surfaces, ranging from canvas to suede-like. Furthermore, manufacturers now claim that RC papers are just as archival as fiber-based papers. And because their surfaces are coated with resin, applying water to them won't swell the emulsion or ruin the print. This feature enables you to use water-based coloring agents on the paper. And there is an added bonus. If you don't like the finished print, you can take it to the sink, wash it off, let it dry for 5 minutes, and start over. This should eliminate all qualms you might have about experimenting with a color or trying something new and different color-wise. You have nothing to lose in terms of money or paper, and if you consider the time and effort involved as a learning experience, you'll have actually gained a few things in the process.

Almost all glossy papers must be pre-coated before they can receive color. If you apply a pre-coat and later take the color out, the pre-coat will be removed as well, leaving a smudge that is quite difficult to cover up.

For this reason, I prefer to use textured, semi-matte, and matte papers that don't require pre-coating.

Toners

You should try different toners on the paper. Work with the toners you use the most often, and then experiment with some you aren't too familiar with. I make a test print using Poly-toner, selenium, Kodak's brown toner, and Berg's Brown/Copper toner. First, I cut an 8 × 10 print into quarters, tone each section with a different toner, and then reassemble the image on a corkboard for future reference. This step, in conjunction with the two preceding steps, provides a good working sense of the paper.

Developers

Your developer affords you an opportunity for even greater control of the feel of the finished print. Use Selectol Soft and Dektol together for a two-step developing process that will control contrast, open up a difficult print, and impart more information to the dark, otherwise blocked-up areas of the print. This means less dodging, less work time, and more aesthetic freedom.

Although you can effectively control contrast in a multigrade paper through the use of filters, the paper might not have the surface texture or the color that you desire for a particular image. This two-step developing process method enables you to be more creative with your paper selection. It also has the added advantage of softening lines or wrinkles in faces and smoothing out skin tones in the final print. If you're using a multigrade paper, a good choice of developer is DV10. Made by Fotospeed and distributed by Luminos, DV10 produces tack-sharp images and excellent midtone separations.

Begin by placing an exposed sheet of photographic paper in Selectol Soft for 1 minute. Drain the print for a few seconds, and place it in Dektol for 1 minute. To achieve a softer print with less contrast when working within a 2-minute developing time frame, you need to increase the time the print is in the Selectol Soft bath and to shorten the amount of time that it spends in the Dektol. If, however, you want more contrast, place the print briefly into Selectol Soft. When you see a pencil-like sketch of the image appear, slip the print into the Dektol for the balance of the 2-minute development time.

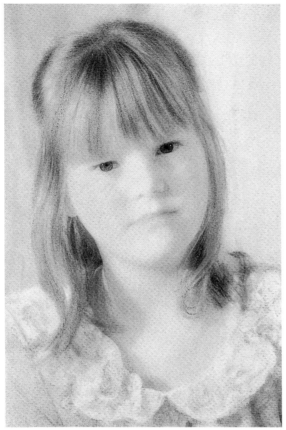

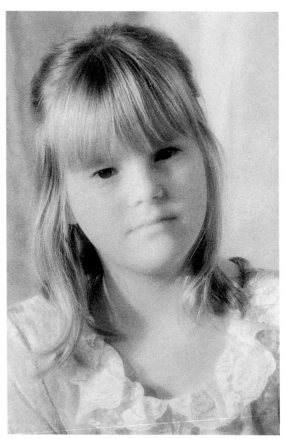

I worked with pastel pencils to handcolor "Samantha" on Luminos Tapestry paper.

For this version of "Samantha," I used Marshall oil pencils on Oriental Portrait FB-N paper.

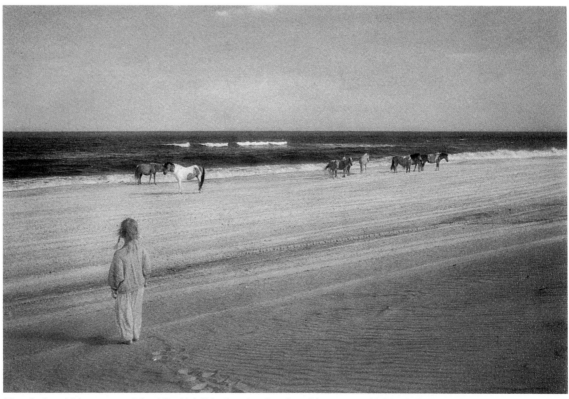

I handcolored "Assateague Island," which I'd printed on Luminos Mer paper, with Marshall oil pencils.

USING PENCILS AND PAINTS

I prefer pencils for handcoloring. I find that color pencils are clean, convenient, and simple to use: their sharp points facilitate coloring on small areas and tight spots with maximum control. They work well with textured papers, too. The large variety of colors and pencil types available makes it easy to achieve an almost airbrushed effect on some images. Pencils will give a natural or soft color to the print, especially if you rub in the color well.

You can use several types of coloring pencils on one print; however, if you plan to color with pastels, you should use them first. Pastel pencils won't go on top of some oils and watercolor pencils.

Pencils usually don't work well on glossy papers. The only exceptions are when the print is precoated with a PM solution (a mixture of turpentine and linseed oil) or a spray. And remember, once a paper is coated with this substance, it is very hard to successfully take color out. Inevitably a telltale smudge or a dull spot is left on the print. There is also the possibility of scratching the surface. You can, though, use tube oil paints on glossy papers, but again only after you've pre-coated them with a PM solution.

An image handcolored with tube oil paints looks quite different from an image handcolored with pencils. Tube pigments seem to sit on top of the paper. They aren't as transparent as pencils (if the pencils have been applied properly). You can blend color from pencils into the paper by using a soft tissue wrapped around your finger and moving in circular motions. This technique makes it easy to blend two or more colors or to layer colors.

If your budget allows you to buy just one set of pencils, Marshall oil pencils are the best choice. If your budget allows two sets, get Conté pastel pencils, too. With these two sets, you'll be able to handcolor just about anything.

Berol Prismacolor Pencils
Made in the United States, these wax-based pencils come in a range of 120 colors and are excellent choices for coloring on matte or semi-matte photographic papers. Prismacolor pencils aren't water soluble; however, you can dissolve them in Turpenoid or turpentine and apply them to artist paper. These pencils overlay nicely but are hard to blend without rubbing or without the help of Turpenoid or turpentine. You can use these pencils to add intense color to line work or small areas by dipping the pencils directly into the Turpenoid or turpentine and applying them to the print. I prefer working with Turpenoid because it has

no odor. Turpenoid Natural is nonflammable, doesn't irritate your eyes or skin, doesn't emit harmful vapors, and works as well as turpentine.

To blend these pencil colors without Turpenoid or turpentine, try a Mars Staedtler eraser. Gently rub the eraser in a circular motion until one tip is full of pigment. Then use that tip to blend, again in a gentle circular movement. Don't apply pressure as you work: you'll erase the color, instead of blending it.

Caran d'Ache Neocolor II Crayons
These water-soluble painting crayons, made in Switzerland, enable you to apply a heavy coat of color to the print. The colors are vivid and intense. You can use the crayons wet or dry, or slightly melted for an encaustic effect. Encaustic is a painting technique that involves the application of pigments in a hot wax. (To partially melt the crayons, place your print on top of a piece of glass that is resting on a heating pad. As you touch the crayon to the print, the color will melt into place.)

Caran d'Ache Neocolor II water-soluble crayons.

Caran d'Ache Watercolor Pencils
These pencils, also made in Switzerland, come in 120 colors. They have full, rich pigments and are very lightfast. The pencils take very well to the new RC papers, such as Luminos RCR paper and Kodak P-Max Art paper. The pencils' greatest attribute is their versatility: they can be applied dry or wet. For a heavy application of color, dip the pencil in water and apply the pigment in layers. For subtle coloration, apply the color dry and blend with a damp cotton swab.

Conté Pastel Pencils
Made in France, these are probably the softest pastel pencils available on the market. They come in 48 intense, pure colors, with excellent choices in

Conté pastel pencils.

a cotton swab or tissue. The only drawback regarding Marshall oil pencils (as of this writing) is the limited variety in certain color categories, such as flesh tones.

Schwan Stabilo Carb-Othello Pastel Pencils
Manufactured in Germany, these 72 pastel pencils fall somewhere between the Conté and Derwent pencils with regard to hardness. They are medium-soft and have the most beautiful selection of orchids, pinks, violets, and muted yellows available on the market.

Marshall oil pencils.

Schwan Stabilo Carb-Othello pastel pencils.

the red spectrum. You can use these pastel pencils on everything, from matte photographic papers, photocopier prints, and photo transfers to rough or textured artist papers. You can blend the colors with a cotton swab or your fingertip; you can also lightly blend them with water via a dampened cotton swab.

Derwent Pastel Pencils
These pencils, which are made in England, are harder than Conté pastel pencils and can scratch some photographic papers, such as Ilford Multigrade Matte paper. The pencils can also scratch Luminos Classic warm-tone pearl and pastel papers. But among the pencils' 90 shades, there is a beautiful panoply of colors for the landscape. You'll find subtle earth tones, soft creams, and a wide variety of greens.

Derwent Watercolor Pencils
You can apply these watercolor pencils, also made in England, dry or wet. They come in 72 colors, and the pigments are vibrant and lightfast. They have a broad palette of cool greens and blues, as well as a good selection of warm yellows.

Marshall Oil Paints
Marshall oil paints, made in the United States, come in tubes and are specially designed for working on photographic prints. The paints, which aren't as opaque as regular oil paints, come in 52 colors. You can apply these Marshall oil paints with either a brush or cotton swabs. They mix and layer well, and you can use them on any precoated photographic paper and on color copier prints.

Marshall Oil Pencils
Marshall oil pencils, also made in the United States, are soft enough to cover all semi-matte and matte photographic papers without precoating. You can use them on most pre-coated glossy papers as well. These 14 oil pencils also blend readily with a little help from

Schwan Stabilotone Pastel Sticks
These wax-based materials, which are also made in Germany, combine a pastel crayon and a watercolor paint in one coloring stick. The 30 colors are deep and rich, and you can apply them dry, wet, or slightly melted for an encaustic effect. Unfortunately, Stabilotones are big and thick and, therefore, don't offer the control that small pencils afford.

Shiva Oil Sticks
A product of the United States, Shiva oil sticks are made from pigment mixed with linseed oil and blended wax. They come in 50 colors, are very lightfast, and differ from oil pastels in that they contain siccative oil and certain driers that allow them to dry in days rather than weeks.

These oil sticks form a skin over their tips, which you must peel off before use. This self-sealing characteristic is convenient and user-friendly. There are no tubes to squeeze or tops to unscrew. You can apply the pigment directly from the stick onto the paper. They go easily on matte papers and all RC papers. Another application

Shiva oil sticks.

method is to dip a brush in turpenoid, run it across the tip of the oil stick, and make a transparent oil wash that you can then apply to the print.

Shiva Permasol Transparent Oil Colors

These beautiful oil paints are transparent and extraordinarily brilliant straight from the tube. The 18 colors can be readily blended or layered. They are ideal for coloring photographs, on either semi-matte surfaces or glossy stock, and can be used on surfaces for glazing as well. If you use Shiva oil colors on glossy papers, you should first use a pre-coat of P.M. solution.

The bonus is the size and price of the tubes. They weigh 1.25 ounces and measure about $1^{1}/_{2} \times 4$ inches, and cost approximately $4.00. This is favorable to photo oils, which cost about the same price, but which come in tubes that measure only $^{1}/_{2} \times 2$ inches.

Walnut Hollow Farm Oil Pencils

These oil pencils, made in the United States, are quite waxy and work well if you intend to layer color. Be aware that they don't merge into the paper for a subtle look or feel; they make a dramatic statement. They are appropriate for adding small areas of intense color and for imparting a heavy, solid look to an image. They are graphic and great for creating a comic-book-like coloring. These pencils readily go on smooth-surfaced RC papers and matte papers. They come in 36 colors, ranging from pastels to rich pigments, but they don't blend easily. They are similar to Berol Prismacolor pencils.

Sprays

It is a good idea to protect all of your prints with an acrylic sealing spray after handcoloring to prevent fading and to help keep the coloring lightfast. When you spray a print that you've handcolored with pastel pencils, you should first spray it with a workable fixative, such as Krylon Workable Fixatif. This type of spray is made especially for pastels and won't dissolve the pigments. After the fixative dries, protect the print with a final spray, such as Krylon Crystal Clear or a gloss finish.

Keep in mind that workable fixatives also make color layering easy. Simply spray the colored print,

wait until it is dry, and then add another color on top of the first. After spraying, lay your prints flat to dry. Otherwise, if the spray was a bit heavy and dissolved some of the pigments, it will run down the print. The following sprays are good choices.

Krylon Crystal Clear

This spray has a nice luster finish; it is neither glossy nor matte, and it enhances or slightly saturates the colors in prints that have been handcolored with pastel or oil pencils.

Krylon Kamar Varnish

This spray has a glossy finish, intensifies color, and adds brightness and sparkle, especially when used on pastel pencils. Kamar Varnish is actually made to protect oil, acrylic, and watercolors between paint sessions; however, it provides a gloss finish on pastels, too.

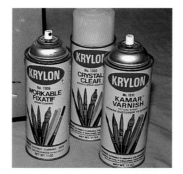

Krylon sprays.

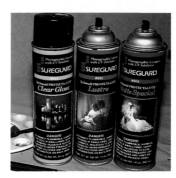

Sureguard sprays.

Sureguard #931 McDonald Pro-Tecta-Cote, Matte Special

This isn't a full matte spray, so it isn't as completely flat as the Pro-Tecta-Cote, Matte spray. The Matte Special spray works quite well with images that are printed on watercolor paper and reworked with pastels. I use this spray on Iris prints.

Sureguard #921 McDonald Pro-Tecta-Cote, Lustre

This is a good spray to use on both photographic and watercolor papers because of its soft luster finish. It adds a bit more sparkle to the image than the Matte Special spray.

OIL AND PAPER DON'T MIX

You can't apply oil paint directly onto artist papers. Over time, the acids in the oil paint will make the papers hard and brittle, and they'll disintegrate. This problem isn't new. Throughout history, painters have coated their canvases and artist papers with an opaque ground of gesso in order to prevent the disintegration of their materials and, therefore, their work.

As mentioned earlier, a ground is a barrier between the damaging ingredients in oil paint and either the canvas or the paper. Gesso is the name of the white powder that is mixed with glue size to form the surface upon which an oil painting is done. Size is created by mixing water with dry glue, which is made from animal hide, rabbit skin, or some other animal skin. Size is used for its sealant properties.

You can apply oil paint to standard photographic papers, fiber-based photographic papers, and RC papers because of their built-in barrier between the surface and the paper base: the emulsion coating. But applying oils does pose a problem for photographers who are printing on artist papers and want to enhance the image with such paints. This is because an opaque ground, like gesso, will coat and cover the entire image. Gelatin, a purer form of glue made from animal bones instead of the hide, is actually a better ground than gesso. In addition, gelatin is transparent.

George Stegmeir, an artist and technical consultant for Grumbacher for more than 18 years, has found a solution, literally, to this problem. He has come up with a mixture of gelatin and water that constitutes a transparent ground. This coats and protects the print on artist papers while forming a barrier between the oil-based pigments and the paper fiber.

The Gelatin Ground and the Iris Print

A gelatin ground also enables photographers to apply oil paint to Iris prints, which had proven difficult to do, as did applying watercolor. An Iris print is a digitally generated image made on an Iris printer, which is the state of the art in printmaking. The Iris printer can be modified to print on artist papers. The difficulty lies in the water-soluble inks used in the creation of an Iris print. If you use watercolor paints on top of these printing inks, the inks will dissolve and lift off the paper.

But turpentine and Turpenoid won't dissolve the inks. Watercolor paint and turpentine don't mix

either; all you get is a rubbery clump of pigment. Even though an oil-paint wash with turpentine will work, oil paints on paper without a ground will eventually destroy the paper fibers.

Iris prints don't necessarily need reworking. The colors in Iris prints are quite rich beautiful, but, of course, only if the colors in the original print that was scanned were rich and beautiful. However, if you want to rework the print to change or to add color or form, and you want to do so with oil paints, you have a problem again.

You can spray the Iris print with Sureguard Pro-Tecta-Cote, Matte Special spray to help set the inks and to protect the print from ultraviolet (UV) rays. Be aware, though, that not even three coats of Pro-Tecta-Cote can provide an adequate barrier for reworking the print with oil paint. Because the inks of the Iris print are water soluble, you need to spray the print with an acrylic spray, such as Sureguard Pro-Tecta-Cote or Krylon Crystal Clear, before coating with the gelatin ground. This will help set the inks.

Formula for Gelatin Ground

This recipe can size three to four sheets of artist papers. All you need is a 7-gram packet of Knox Unflavored Gelatin (available at your local grocery store) and 5 ounces of warm water. For a larger quantity, to coat more than four sheets of paper (depending, of course, on the paper size), use 50 grams of Knox Unflavored Gelatin for every 1 liter of warm water. If you have leftover gelatin, you can store it in a sterilized jar in the refrigerator for 7 to 10 days.

Combine the gelatin and water, and let the mixture sit overnight in a covered container or for at least four hours. Then heat the cloudy mixture gently in a double boiler, stirring constantly, until the mixture clears. Don't boil the mixture. Gelatin is mostly protein and will denature if overheated.

It is a good idea to coat a test strip of the paper you plan to use in order to see how the ground looks. If it is shiny when it dries, too much gelatin was used. Dilute the mixture by 10 percent or until you find the shine disappears from the paper's surface when dried. To test whether or not the paper has a proper ground, place a drop of linseed oil on the dried, coated surface of the test paper, and let it stand overnight. In the morning, turn the paper over and check for an oil spot. If there is none, the paper has been properly sealed.

OIL AND PAPER DON'T MIX

You might want to tape the edges of the print with masking or packing tape in order to keep the borders clean. To coat the Iris print, use a 4-inch-wide brush to apply the gelatin ground with light, even strokes. Don't use a thick coat on the print. Then make a single pass with the wide brush in one direction across the surface of the print. Lift the brush, and wipe off any ink that you might have picked up. Next, wipe the picked-up inks off the taped borders. Repeat this procedure until you're finished coating the paper. Let the print dry. The gelatin coat will darken the colors in the print and turn them slightly golden, but the oil paints will cover this golden cast.

I coated the print with a gelatin ground to prevent acids from the oil sticks I'd planned to use from reaching the paper fibers. I then handcolored this Iris print entitled "Taxi Stand on the Grand Canal," originally photographed in Venice, with Shiva oil sticks.

COLOR BLENDING

The difficulty most often encountered with handcoloring is the application of too much solid color. To minimize this problem, pay attention to the tones in the print, and use shading techniques. Layer the color by holding the pencil on its side, and rubbing back and forth by moving your wrist. On a rough paper, the grain will show through; on a smooth paper, the pencil will leave a uniform tone throughout, and the marks of the tip of the lead won't be visible. Apply heavy color in the midtones, which are the dark- to light-gray areas, and very little color in the high tones, which are the light-gray to white areas of the print.

After coloring, go back with a kneaded eraser and pull out color in order to put in highlights. In some cases, you can successfully obtain highlights by using the Cadmium Yellow Deep Marshall oil pencil. This color is particularly good for sunlight and sparkle. A note of caution: If you color at night using a tungsten light source, be judicious in your use of yellow. Since the light source itself is yellow (not blue, like daylight), you won't see the yellow coloring and you'll over-color the print. Wait for daylight to apply yellow to your print, or wait until daylight to check the yellow tones before you apply a coating spray to the print. Remember, too, that you're coloring over tones of gray and black (if you haven't brown-toned the print). If you apply yellow over black, the image will take on an ugly green tinge.

There is a science to the art of color blending. A little study will save you time and money. The very best way to learn about color is to study nature. Look closely at a tree, a leaf, or a flower, and see how many hues and variations of color you can find. Study water, sunsets, and foggy days. Observe how a color changes with various atmospheric conditions. Go to museums and study paintings. Books on the paintings of the masters are helpful as both reference material and inspiration. However, don't depend upon them or try to copy them. Everyone has a preferred color palette. You like certain color combinations, and you'll use those colors more than others. Don't feel embarrassed, threatened, or intimated by your choices. If you like them, someone else will, too.

After printing "White Donkey in a Mexican Village" on Agfa PR 118 paper, I handcolored the image with Marshall oil pencils.

APPENDIXES

SELECTING AN ARTIST PAPER

Papermaking is itself an art, and the artist papers used can be an essential facet of the finished photographic image. Size, color, and surface texture open up new avenues via which you can translate a negative. For example, a textured paper will drastically alter or enhance the mood, feel, and look of an image. However, the most important consideration in selecting an artist paper, as in selecting a photographic paper, is that of permanence.

Remember, an image or print doesn't just sit on top of the paper, but rather becomes an integral part of the image itself. The presence of acids (which are used to soften and whiten the fibers during the papermaking process) will contribute to the paper's deterioration. So look for acid-free papers; these either don't have free acids or have a pH of 6.5 or higher.

In addition, to achieve the highest degree of permanence, the paper fibers should be pure cellulose in nature, i.e., plant tissue and fiber. Cotton is 100 percent cellulose, and high alpha wood pulp is 93 percent cellulose. Both fiber constituents are regarded as excellent in terms of permanence.

The second factor you must consider when selecting an artist paper is the paper's surface. Smooth surfaces show the most detail, and the resulting images will look photographic in nature. Textured surfaces, on the other hand, will make the images appear more painterly because of the loss of detail and the breakup of the visual perception of them. And more texture, in turn, will add to the tactile quality of the images. Be aware, too, that Oriental papers can be translucent and/or have foreign particles introduced into the pulp. These particles can easily enhance images or, just as easily, ruin them.

The third factor to think about is sizing, which controls how pigments are absorbed into a paper. Sizing reduces the overall absorbency in a paper and makes the sheet of paper more resilient in terms of working and reworking on its surface. Since sizing affects absorbency, it can work for or against you, depending on the process you're involved in. For example, if you want to do an etching, a waterleaf paper, which has no sizing, will work well: because it is so absorbent, the inks or pigments sink deep down into the fibers. For printmaking, a waterleaf or lightly sized paper is a good choice, while doing a watercolor calls for a sized paper: you don't want the pigments or paints to be completely absorbed into the paper.

A sized paper is also the best choice for doing Polaroid image transfers. The dyes won't go too deeply into the paper, which makes it easier to pull the negative off the artist paper without it sticking. If you were to use a waterleaf paper for a Polaroid image transfer, the negative would undoubtedly stick, and you wouldn't get a clean pull.

Some papers have sizing applied only to their front sides, while others are tub-sized. A tub-sized paper has been completely submerged in a sizing bath, thereby causing the sizing to be uniformly distributed throughout the sheet. This enables the surface to be worked and reworked, as in coloring. For this reason, heavily sized or tub-sized papers work well for transfers.

The last paper feature you need to consider is the vast variety of colors that artist papers come in. As the saying goes, beauty is in the eyes of the beholder. You have many colors to choose from to create the effects you want.

Basic Paper Terms

Paper, as it exists today, is a relatively recent technological development. Flax, cotton, and now, wood cellulose are cut and beaten while in water. This process separates the individual fibers and makes them uniform in length. The water hydrates the fibers and unites them to form pulp.

The pulp is then transferred to a mold that will form sheets (or rolls) of paper as the water drains away from the drying pulp. Some of the new paper might be sized by putting it through a warm gelatin bath. This is very important for certain printing and painting techniques, as well as when a strong paper stock is desired. New paper that isn't sized is known as waterleaf paper. It is best suited for etching and lithographs because of its softer consistency; it absorbs the inks better and molds better to the etched plate.

A finished paper might have a rough or smooth surface. Naturally this has a great deal to do with the quality of the original pulp and its processing. Most paper is finished by being run through a series of

rollers that may be operated at various pressures and temperatures to achieve the desired surface texture. Hot-pressed (HP) papers have a smooth surface, cold-pressed (CP) papers have a more textured surface, and rough papers have a very textured surface. Understanding the following paper terminology will help you choose the best paper for the project at hand.

Acid-Free Paper: This kind of paper is free of acidic materials and has a pH of at least 6.5.

Basis Weight: Weighing 500 sheets, or one ream, of the standard size of a paper type determines its basis weight. Paper is also sold by this pounds-per-ream weight, typically 90 pounds, 140 pounds, 300 pounds, 600 pounds, etc. The basis weight gives only an approximation of the thickness of the paper since the standard sizes for different papers are so varied. A ream of $19\frac{1}{2} \times 25\frac{1}{2}$-inch paper weighs less than a ream of 24×36-inch paper that is otherwise identical because of the size difference. (European etching and printmaking paper weights are given in grams per square meter.)

Bast Fibers: This group of fibers is commonly used in Japanese papermaking. It includes flax, hemp, jute, gampi, kozo, and mitsumata. Flax, a plant that is grown for its fibers, is used for making linen yarn and paper; its seeds yield linseed oil. Hemp is a tall Asian plant whose tough fibers are used to make rope, coarse fabric, and paper. Jute, which is grown in East India, has strong fibers that are used to make burlap and papers. Gampi comes from a tree of the same name. It is used in Japanese papermaking because it produces smooth, strong sheets of paper. Kozo, which comes from the mulberry tree, is the most frequently used fiber in Japanese papers; its long, tough fibers result in very strong, absorbent papers. Finally, mitsumata produces a soft, very absorbent paper with a lustrous quality.

Cold-Pressed Paper: This kind of paper is run through unheated rollers. This process gives cold-pressed (CP) paper a textured, medium-rough surface.

Deckle Edge: These are the natural, fuzzy edges of handmade papers. Deckle edges are simulated in mould-made and machine-made papers by a jet stream of water while the paper is still wet. Handmade papers have four deckle edges, while mould-made and machine-made papers usually have two.

Hot-Pressed Paper: This kind of paper is produced by pressing the paper through hot rollers or plates after the formation of the sheet. Hot-pressed (HP) paper has a smooth, hard surface. This characteristic permits good detailed work. If you do transfers with HP paper, you'll obtain the most information possible, as well as a photographic look to the final images.

Internal Sizing: This sizing is added to the pulp during the beating phase, before the sheet is made.

Laid Paper: This type of paper has a prominent pattern of ribbed lines in the finished sheet.

pH: A paper's pH is measured on a scale from 1 to 14. Artist papers are treated with an alkaline substance to control acidity. A pH of 7 is neutral, so papers with a pH higher than 7 are alkaline, and those with a pH lower than 7 are acidic. Papers with a pH of 6.5 to 7.5 are generally considered neutral.

Ply: This term denotes a single web of paper. Paper can be used by itself, as in 1-ply paper, or laminated onto one or more additional webs as it is run through the machine. One-ply paper then becomes 2-ply paper (2 webs), 4-ply paper (4 webs), etc. The higher the ply number, the thicker and stronger the paper.

Rag Paper: Technically this term refers to paper made from cotton or linen rag fiber. Rag papers contain between 25 percent and 100 percent cotton fiber pulp, which is indicated as a percentage of the total fiber content, for example, 25 percent rag. The higher the rag content, the stronger the paper.

Rice Paper: This term is a common misnomer applied to lightweight, traditional Japanese paper. Rice alone can't produce a sheet of paper. Japanese papers are made from bast fibers. However, rice flour was at one time used as a sizing agent.

Rough Paper: This kind of paper is subjected to only the slightest pressure through the rollers. Some rough papers are given a texture with felts and embossed pressings. These are the heavily textured surfaces produced by minimal pressing after the sheet is formed.

Size: Material, such as rosin, glue, gelatin, starch, and modified cellulose, added to the stock at the pulp stage or applied to the dry paper surface to provide resistance to liquid penetration. The amount of the sizing used during the papermaking process gives the paper its absorbency or hardness. The more sizing, the harder the paper surface. Paper charts explain how much sizing each paper has: L.S. stands for little sizing; M.S., for moderately sized; and H.S., for heavily sized. Watercolor papers, for example, vary from moderately to heavily sized.

Surface Sizing: This term refers to sizing applied to the paper after it has been formed. Most Western papers are internally sized. The additional conditioning with surface sizing further controls the paper's absorbency.

Tub Sizing: During this surface-sizing process, the dry, newly formed sheet of paper is passed through a tub-size bath or vat and is sized. This produces a

deeper sized paper and reduces the overall absorbency of the paper. A tub-sized paper is quite resilient when you work and rework it. Many watercolor papers are tub-sized.

Vellum Finish: This is a slightly rough or "toothy" surface on a sheet of paper.

Waterleaf Paper: This kind of paper has little or no sizing. Like blotter paper, it is very absorbent. If dampening is desired, you can spray this paper with an atomizer.

Watermark: This is a design on the surface of the paper mould. Also known as the logo, it causes less pulp to be distributed in that area and results in the transfer of the design to the finished sheet. True watermarks can only be accomplished on handmade or mould-made papers.

Watercolor Papers: Many watercolor papers are tub-sized, which makes them very resilient when rubbing in or painting in color. As such, they are excellent for transfers.

High-Quality Papers

When you decide which paper to use for a certain project and effect, you should always buy the best-quality paper you can afford. For example, for image transfers, the papers that work best are hot-pressed (HP), smooth, heavily sized watercolor papers, such as Fabriano Artistico and Arches watercolor papers.

You can use either a waterleaf paper, which has no sizing, or a cold-pressed (CP), or textured, paper for transfers, but you must alter your technique accordingly. It takes less time for the dyes to migrate into waterleaf papers, and sometimes the negatives will lift some of the papers' fibers when pulled away. It is more difficult to get a perfect transfer and lift from a CP paper because of the paper's rough surface. The dyes don't always get down into the crevices of the paper, thereby leaving blank spots.

Rough or CP papers work best for most emulsion transfers. As the emulsion dries, the image takes on the properties of the paper. The 140 lb. and 300 lb. papers are the easiest papers to work with because of their weight. They are less flexible when wet and won't dissolve in the water.

I prefer to use the papers listed below because I've tested them; I know that they are of high quality and that they work. You may discover others that you prefer. (The Daniel Smith Catalog has an excellent selection of papers and competitive prices. The company's customer-service representatives are quite knowledgeable and helpful. If you aren't familiar with the papers, send for sample packets. For a small fee, you can get a sample of every paper the company carries. For more information, refer to the List of Suppliers on page 159.)

RECOMMENDED PAPERS

Paper	Composition	Color	Sizing	Weight*	Surface	Uses
A. K. Toyama	Handmade, high kozo content, swirling fibers throughout	Light to creamy beige	Light	50 lb.	Very textured, rough surface	Emulsion transfers
Arches Cover	100% cotton, acid free	White, buff	Moderate	250 gm/m, 270 gm/m, 300 gm/m	Slightly textured surface takes pastel pencils very easily for handcoloring	Emulsion transfers, photo transfers
Arches 88	100% rag, acid free	Bright white	None (waterleaf)	250 gm/m, 350 gm/m	Smooth, very absorbent surface gives great detail in print	Quality printing in silk screening work, photo transfers
Arches Watercolor	100% rag fibers, neutral pH	White	Heavy	90 lb., 140 lb., 300 lb., 400 lb., 555 lb.	Cold-pressed, hot-pressed, rough	Emulsion transfers, image transfers, photo transfers, Iris prints, 300 lb. handcoated silver emulsions; very versatile for any media
Daphne	Handmade	Cream, light tan	None	Lightweight, medium weight, heavyweight	Lightweight paper is translucent and tissue thin; medium-weight paper has a strong, smooth, hot-pressed-like surface; heavyweight has an extra-strong, smooth surface	Photo transfers

RECOMMENDED PAPERS

Paper	Composition	Color	Sizing	Weight*	Surface	Uses
Fabriano Artistico	100% cotton, mould-made	Off-white	Heavy	90 lb., 140 lb., 300 lb.	Unique, strong surface has great absorbency	Cold-pressed, hot-pressed, rough image transfers work well for handcoating; emulsion transfers (CP or rough); photo transfers; Iris prints; handcoated silver emulsions (Silverprint and Liquid Light); good for handcoloring and reworking with all types of color pencils
Fabriano Classico .5	50% cotton, acid free	Bright white	Heavy	140 lb.	Slightly hard surface	Emulsion transfers, handcoated silver emulsions, good resilience, great for handcoloring
Indian Village	100% cotton rag, handmade, no additives	Cold white	Heavy	200 lb., 300 lb.	Rough surface	Emulsion transfers, image transfers
Larroque Fleurs	100% cotton rag, handmade, has wildflower petals and fern leaves embedded throughout	Cream, white	Moderate	100 lb.	Toothy surface	Emulsion transfers, great for romantic portraits
Lenox	100% cotton, acid free	Slightly warm	Moderate	250 gm/m	Very lightly textured surface has great absorbency	Image transfers, photo transfers
Magnani Acqueforti watercolor	100% rag, acid free	Warm white	Heavy	140 lb.	Cold-pressed, textured surface with a slightly "laid" look	Handcoated silver emulsions, softer than Arches watercolor paper
Masa	Machine-made, made from sulfite	White	Internal, surface	40 lb.	Soft, absorbent surface	Photo transfers
Rives BFK Heavyweight	100% cotton, mould-made, acid free	White, buff, gray, tan	Moderate	280 gm/m	Soft, absorbent surface	Weighs more and is more heavily sized than the standard Rives BFK paper; heavyweight paper colors are more resistant to fading than other papers' colors
Rives White buffered	100% cotton, acid free	White	Moderate	250 gm/m	Soft, velvet-like surface	Emulsion transfers, image transfers, photo transfers, very versatile paper, good for many techniques, takes coloring well
Rives Heavyweight	100% rag, mould-made	Buff, white		85 lb.	Lightly textured, soft, absorbent surface	Emulsion transfers, image transfers, photo transfers, lighter than Rives BFK Heavyweight, extremely versatile paper, good for all printmaking techniques
Rives Lightweight	100% cotton	Buff, white	Moderate	50 lb.	Smooth, soft, supple surface is ink receptive	Photo transfers, weighs less than Rives BFK Heavyweight papers
Somerset White	100% cotton, acid free	Pure white	Light	250 gm/m, 240 gm/m, 300 gm/m	Satin, textured surface	Emulsion transfers, handcoated silver emulsions, Iris prints, very strong paper, great for printmaking
Tableau	Very strong, acid free, made from abaca hemp fiber	White	Light	30 lb.	Toothy, coarse surface	Image transfers, photo transfers

* European printmaking and etching paper weights are designated in grams; watercolor paper weights are designated in pounds.

EFFECTIVE PAPER/PEN/PENCIL COMBINATIONS

Papers	Coloring Mediums	Results
Agfa Multi-Contrast Classic MCC 118 FB paper (replaces Agfa Portriga Rapid #118 paper)	Carb-Othello pastel pencils, Conté a Paris pastel pencils, Derwent pastel pencils, Marshall oil paints, Marshall oil pencils	• has a semi-matte surface with a bit more luster • receives coloring just as PR #118 did, with the added bonus of being a multigrade paper • has a wide tonal range in the midtones (Zones IV, V, VI) • takes pastel pencils, Marshall oil paints and oil pencils, and Shiva Permasol oil paints well. *For best results:* • apply color most heavily to the midtones, apply very little solid color to the higher zones (lighter tones in the print), and add color to the highlights for accent only • layer color with a tissue wrapped around your finger, and then blend lightly with a circular movement • use a kneaded eraser to remove any excess color • preserve with Krylon Crystal Clear when finished.
Forte Bromofort Elegance paper	Marshall oil pencils	• is a fiber-based, semi-matte, hard, white finish paper with a cool tone • takes any type of pencil, but oil pencils blend most easily on its surface • requires watercolor pencils to be worked with a Mars plastic eraser or left unblended.
Forte Fortezo Elegance paper	Marshall oil pencils	• is a warm-tone paper with a soft-white base • lends itself readily to portraits and nudes • has a similar surface to Forte Bromofort Elegance paper and takes coloring agents the same way.
Ilford Multigrade Mat Fiber paper	Berol Prismacolor pencils, Caran D'Ache watercolor pencils, Conté a Paris pastel pencils, Derwent watercolor pencils	• has a surface that takes a brighter, more saturated coloring than other papers, especially if you use wax-based pencils, such as Berol Prismacolors, or Derwent watercolor pencils • makes blending these pencil colors difficult but not impossible, so use a Staedtler Mars, or other plastic-based, eraser in a light, circular motion • work exceptionally well with multigrade mat paper, giving deep, saturated colors • should be applied lightly, otherwise they'll leave marks • must be blended gently. *For best results:* • preserve the image with Krylon Gloss acrylic spray, which deeply saturates the colors and perfectly complements the paper's smooth surface.
Ilford Multigrade IV RC Satin Finish paper	Marshall oil pencils, all watercolor pencils	• has a pure-white base • has a satin-smooth surface that takes subtle coloring with pencils very well, and that lets both oils and watercolors blend nicely • allows watercolors to applied heavily without any blending at all • is easy to process and quick to dry • can salvage the worst negative with a little assistance from filters #00 through #5.
Kodak P-Max Art RC paper	Caran D'Ache Neocolor II crayons, Carb-Othello pastel pencils, Conté a Paris pastel pencils, Derwent pastelpencils, Marshall oil pencils, all watercolor pencils	• is a graded paper with an unusual suede-like, resin-coated surface that accepts just about any type of pencil and lets you use all the water you want while painting without the paper buckling • produces an encaustic look in images when you warm it and use water-soluble Neocolor II crayons • lets you take the paper to the sink, wash it off, dry it, and start all over again if you're dissatisfied with the final image.
Luminos Antique Ivory RC pastel paper	Conté a Paris pastel pencils, Marshall oil pencils	• has an ivory base that imparts a vintage look to finished prints • requires a gentle touch during the application of pastel pencils because some can easily scratch the surface (Conté pastel pencils are the softest and least abrasive) • works well with the encaustic technique.

EFFECTIVE PAPER/PEN/PENCIL COMBINATIONS

Papers	Coloring Mediums	Results
Luminos Charcoal paper	Carb-Othello pastel pencils, Conté a Paris pastel pencils, Derwent pastel pencils, Marshall oil pencils, all watercolor pencils	• is the reverse side of Luminos Tapestry paper (see below) • has a smooth surface that makes it easier to rub off color than to rub it in • gives finished handcolored prints a more photographic quality, because the smooth surface enhances details • requires a delicate touch during coloring. *For best results:* • blend color with cotton swabs, fingertips, or a tissue wrapped around a fingertip • layer color • spray the print with a workable fixer after coloring, such as Krylon Workable Fixatif • when the print is dry, add another color on top of the existing one to create a subtle, gentle feel for the otherwise sharp, detailed final image.
Luminos Mer paper	Carb-Othello pastel pencils, Conté a Paris pastel pencils, Derwent pastel pencils, Marshall oil pencils	• is slightly toothy • has a pure-white base, which gives it a sharp, snappy look • takes oil and pastel pencils equally well.
Luminos RCR paper	Caran D'Ache Neocolor II crayons, Carb-Othello pastel pencils, Conté a Paris pastel pencils, Shiva Permasol oil paints	• has the feel of a thin artist paper • has a rough, resin-coated surface and a canvas look • works with any type of pencil if you color with a heavy hand and/or use a lot of color, thereby leaving more pigment on top of the paper. *Caran D'Ache Neocolor II crayons and Carb-Othello pastel pencils:* • serve beautifully to produce the encaustic technique. *Carb-Othello pastel pencils and Conté a Paris pastel pencils:* • work very well on Luminos RCR paper • work the best and blend the most readily without pre-coating.
Luminos Tapestry paper	Carb-Othello pastel pencils, Conté a Paris pastel pencils, Derwent pastel pencils	• is the best paper on the market for imparting texture to images • has a rough, deeply tactile surface that minimizes image sharpness and detail but produces a painterly look and feel • works well with slightly out-of-focus negatives because the rough surface camouflages their shortcomings. *For best results:* • layer colors • use Conté pastel pencils because their soft, powdered pigments fills the minute pits and valleys in Luminos Tapestry paper with color • spray the print with a workable fixer after coloring, such as Krylon Workable Fixatif • add another color on top of the existing one when the print is dry • use an acrylic spray to preserve the pigments and prevent them from smearing • lay the print flat to dry.
Oriental Seagull Portrait FB-N paper	Carb-Othello pastel pencils, Conté a Paris pastel pencils, Derwent pastel pencils, Marshall oil pencils	• has a cream base and yields warm blacks • has a toothy surface that makes it a perfect paper for handcoloring • has a luster surface and accepts oil and pastel pencils readily • works with watercolor pencils also, but they are more difficult to blend.
Oriental Seagull Portrait FB-R Warm Tone paper	Marshall oil paints, Marshall oil pencils, and Shiva Permasol oil paints	• has a beautiful cream base • has a smooth, semigloss surface that yields warm blacks and that takes oil pencils very well • lets you blend colors easily.

WORKING WITH A COPYSTAND

Most work on a copystand is copy work: making slides of your prints to send out to galleries, magazines, photography contests, and publishers, as well as to keep in your reference files. Sometimes this is the only representation of your work that a gallery owner or a contest juror will see. As a result, the slides should be true in color, sharp in focus, and professional-looking overall. But having a lab make slides of your work is quite costly, and once you send slides out, you seldom ever see them again. So it is economical to learn how to make your own reproduction-quality slides.

Selecting Film and Bulbs

Positive transparency film, color-reversal film, and slide film are all one-in-the-same film. They generate positive photographic images on a transparent medium that you can then project onto another surface. For simplicity's sake, I'll refer to this class of film as "slide film" for the rest of this section.

In the past, color slide film had very little exposure latitude. If underexposed, the resulting slides would be dark and muddy. If overexposed, the slides would be washed out and light. A third of a stop in either direction was the extent of the photographers' margin of control after metering. Today, however, because of improvements in the films, a variance up to one full stop in either direction from what would be considered ideal still produces slides with good results. Although this greater latitude gives photographers both a much wider comfort zone when working and a higher success rate, controlling exposure remains crucial to creating color-saturated slides without loss of information. The most important caveat is: The more light that strikes slide film during exposure, the lighter the slides will be. And the less light that strikes slide film during exposure, the darker the slides.

BULBS BALANCED FOR TUNGSTEN FILM

Type	Color Temperature	Wattage
ECA	3200K*	250 watts
ECT	3200K	500 watts

*K stands for Kelvin. Kelvin is a unit of measurement used to indicate the color temperature of light.

These bulbs give off an orange/yellow light and have up to a 6-hour lifespan. ECT bulbs are brighter—give one more stop light—than ECA bulbs. Wattage becomes an important consideration only when you work with color film. A bright bulb will lessen the exposure time. If, while working with color film and a low-wattage bulb, you require more than a 1-sec. exposure, you'll get a color shift. In order to avoid this color shift, you must use a high-wattage bulb. Choose your bulbs and wattage carefully. High-wattage bulbs give off more heat. Select your bulbs depending on your needs.

BULBS BALANCED FOR DAYLIGHT FILM

Type	Color Temperature	Wattage
BCA #1	4800K	250 watts
BBA	3400K	250 watts

These bulbs give off a blue light. They cost about as much as tungsten-balanced bulbs but last only three hours. Be aware that it is common for bulbs to work beyond their projected lifespan. However, as they age, their color temperatures decrease, and this alter the color in slides as well. Time your copying sessions. After three working hours with tungsten-balanced bulbs, and two working hours for daylight-balanced bulbs, I discard all the bulbs.

Controlling Exposure

Knowing your camera's controls will help immensely when you make slides. One way to control exposure is to adjust the aperture. By closing down or opening up, you control the amount of light that enters the lens and strikes the film plane. For example, an $f/8$ aperture lets in twice as much light as the next aperture setting, $f/11$.

Another approach involves regulating the shutter speed. A slow shutter speed, such as 1/15 sec. when 1/30 sec. is normal, allows more light to strike the film plane, and the resulting slide will be lighter. Conversely, a fast shutter speed, such as 1/250 sec. when 1/125 sec. is normal, permits less light to strike the film plane, so the resulting slide will be darker.

A third option requires the use of the compensation dial. Each dot in between the numbers (for example, +1 . . +2 and -1 . . -2) on the compensation dial represent 1/3 stop. After the camera's meter indicates the proper combination of aperture and shutter speed for the available light in a particular situation, adjust the compensation dial to give the exposure more or less light as you think the situation dictates.

Finally, you can adjust the film-speed dial. If you set the ISO at a higher speed than called for, you'll get a darker slide, with more density and saturated colors.

If you set the ISO to a lower speed than necessary, you'll get a lighter slide in both density and color.

Consider the following examples. If you're shooting Kodachrome 64 and you want a slightly darker slide, adjust the ISO dial to the next slash or dot *after* 64 (which is ISO 80). This gives you a 1/3 stop faster shutter speed, less light, and a darker slide. In effect, you've tricked the camera's meter into calculating for a faster film.

Suppose that you're using Kodachrome 64 and you wish to have a slightly overexposed slide. Here, adjust the ISO dial to the next dot or dash *before* 64 (which is ISO 50). This setting produces a 1/3 stop slower shutter speed, more light, and a lighter slide. Here, you've tricked the camera's meter into calculating for a slower film.

Using a Copystand

You can position a copystand anywhere, but you should be aware of a few important considerations. First, the illumination from other light sources can throw off your color film. The best approach is to place the copystand in a windowless room, turn off all the lights in order to ensure complete darkness while you work, and then turn on the copystand lights. If you don't have such a room at your disposal, wait until dark before you use the copystand.

Several kinds of copystands are on the market. I prefer the type that has two adjustable arms on either side of the base. These arms make it easy to eliminate glare from the prints, and the two light sources on each side provide even light distribution.

The first step is to load the film into the camera. Next, set the ISO. Put the camera on automatic. Use a sharp macro lens or a lens that has a macro setting. For example, a 55mm macro lens enables you to focus at about 10 inches from the subject. I use a Nikkor 55mm F2.8 lens, which focuses from infinity down to half-life-size, with a 1:1 reproduction ratio.

Next, set the aperture. Remember, this is flat work, so you don't need to be concerned about depth of field. An aperture of $f4$ or $f/5.6$ should work well if the lens is sharp at that aperture. Each lens has an aperture at which it is the sharpest. As a general rule, this setting is two stops down from the smallest aperture on the lens. If your lens' smallest aperture is $f/22$, count backwards two stops, to $f/11$. This is the sharpest aperture for that particular lens. (Don't confuse this setting with the largest depth of field. I'm referring to the actual properties of the glass itself here).

An $f/4$ or $f5.6$ aperture will also enable you to get a sharp image without a slow shutter speed. This is a concern when you work with color film. A long exposure will result in a color shift.

Connect the shutter-release cable to your camera—this will eliminate vibration—and attach your camera to the copystand column. Next, arrange your prints according to size and/or color saturation. This step reduces the number of times you need to raise, lower, and focus your camera, thereby saving working time with the bulbs. Turn on the copystand lights, and turn off all other light sources. This is crucial if you're working with color film. External lights will cast color onto the film that you might not notice but that the film will definitely record.

Place the gray card down on the base of the copystand under your camera. Then look through the viewfinder to make sure that you fill the viewfinder area with the gray card. Press down on the shutter release, and get a meter reading.

If you have an aperture-priority camera, select the aperture and read the shutter speed that the camera meter indicates. This is your standard exposure combination. For example, if you selected $f/5.6$ and the camera's meter indicates a shutter speed of 1/15 sec., this will be the setting that you'll manually set and use for the entire shoot—as long as you don't change bulbs, films, or the aperture setting.

If you have a shutter-speed-priority camera, select a shutter speed of about 1/8 sec. or 1/15 sec., and meter with your camera. Use whatever aperture the camera's meter indicates. This is your standard exposure combination. For example, if you selected 1/8 and the camera indicated $f/4$, this will be the combination you'll manually set for the entire shoot—unless you make any changes in lighting, film, shutter speed, or lens.

Now position the print that is to be copied on the base of the copystand underneath the camera. Adjust the height of the camera so that the print fills the viewfinder, and then focus. Analyze the print to be copied. Decide whether to use the standard setting (the gray-card reading that your camera has been calibrated to) or to give the print more or less exposure. You do this by studying the tonality of the print. For example, if the print's coloring is subtle and you're using slide film, you might opt to give the exposure one stop less light. So rather than $f/4$ for 1/8 sec., you use $f/4$ for 1/15 sec. This exposure combination will increase the color saturation in the slide.

When in doubt as to how to expose a slide, bracket the exposure. This way, you are sure to get one perfect exposure. I always bracket in the same sequence: standard, one stop under, and one stop over. If you use this system, when you look at your slides on the light table later you'll be able to understand what happens when you give the exposure more or less light. This, in turn, will result in less guesswork the next time.

Effective Exposure Combinations

Listed below are the film, ISO, and exposure combinations that have worked for me. These will provide you with a starting point; you can then make adjustments to suit your own body of work, your equipment, and the lighting situation at hand.

Copying Brown-Toned Prints on Color Slide Film

For this process, I use Kodak Ektachrome 200 EPD film and BCA #1 daylight-balanced bulbs. I set the camera dial at the speed the film is rated, 200. If the print is light or subtle in color, I decrease the exposure by one stop. Conversely, if the print is dark, I add a stop.

Copying Color or Black-and-White Prints on Color Slide Film

Here, I have two options. I sometimes work with Kodak 64-T Ektachrome Professional EPY film pushed to ISO 80 and ECT (3200K, 500-watt) or ECA (3200K, 250-watt) bulbs. On other occasions, I use Fujichrome 64-T RTP film at ISO 64 and ECT or ECA bulbs. Both of these films are excellent for copying prints onto slide film. I simply adjust the ISO as needed.

Keep in mind that if you're going to do a large amount of copying, it is a good idea to buy a block of 20 rolls of film, or to buy the film in bulk and bulk-load your own cassettes. Run exposure tests on the film before setting up to work. You must establish the filtration needed for perfect color slides of color prints, as well as for perfect black-and-white slides of black-and-white prints. To do this, you need a Kodak Color Checker, available at any good camera shop. This card contains color patches. To use the card, simply lay the card down and shoot it. Then when you compare this card with the picture or slide of the Color Checker, you can readily see if the colors are accurate or if they've shifted to a warm or a cold tone. This will help you decide if you'll need filtration the next time that you use the same film under the same lighting conditions.

For example, to get good black-and-white slides—not blue-and-white slides or brown-and-white slides—of a black-and-white print, you might need to use a blue color-correction (CC) filter. This kind of filter compensates for hue differences. Film batches have different emulsions, and the dyes are always balanced differently. So you must always do testing. CC filters are available in six primary colors—cyan, yellow, magenta, red, blue, and green—and come in increments from .05 to 50.

Another possibility is to use a yellow CC filter in order to achieve a warm tone in the black-and-white print. You might also decide to use light-balancing filters over the lens. These 80, 81, 82, and 85 series filters come in different strengths and overcome the "too warm" look to a slide. The strongest filters, the 80B series, correct 3200K tungsten light to 5500K daylight; these particular filters make it possible to shoot daylight film under tungsten lighting. I usually use an 81 filter, and my color slides of color prints are perfect. To copy black-and-white prints on color slide film, I typically use an 81 or 82 blue filter. These light-balancing filters produce good blacks and whites; I never get browns and whites.

When you've established the proper filtration for the film to obtain good black-and-white and color slides, write this information down. Then store it with the film for future reference. Keep in mind that you can freeze the film for up to three years.

You can buy CC filters in various densities from Calumet (see the List of Suppliers on page 159). A CC2.5 blue filter, a CC5 blue filter, and a CC10 blue filter are good to have on hand. If you need more color compensation than a CC10 filter can deliver, just stack a few filters to achieve the required density. You can also buy yellow CC filters in the same increments.

Copying Color Prints on Color Print Film

For this process, I use Fujicolor Reala 100 film at an adjusted film speed, ISO 64, and BCA #1 daylight-balanced bulbs. If the work being copied is dark, I add one stop. If the work is light, I decrease the exposure by a stop. I bracket when I am unsure.

Copying Handcolored Prints, Manipulated Polaroids, or Glossy Color Prints and Transfers on Color Slide Film

Here, I use Kodachrome 64 Professional PKR film and BCA #1 daylight-balanced bulbs. Set the ISO to the dot or dash after 64 (-1/3 stop) on your film speed dial. This will give you an adjusted ISO of 80. Use the gray card to meter and manually set the aperture and shutter speed as indicated by the camera's meter. If the print is light or subtle in color, minus one stop. If the print is dark, add a stop.

Copying Manipulated or Regular Polaroids, Color Photographs, and Handcolored Prints on Black-and-White Slide Film

For these various procedures, I use Polaroid Polapan CT Instant slide film, which has an ISO of 125, and ECA or ECT bulbs. First, I adjust the ISO to 60. If the print is light or has a lot of white areas, I subtract one stop; if the print is dark, I add one stop. I've found that when I copy old photographs, an 81A filter will yield a warm-toned black-and-white slide. This effect is even more noticeable when I work at ISO 50 instead of ISO 60.

LIST OF SUPPLIERS

Businesses and Manufacturers

Acufine Corporation
701 Corporate Woods Parkway
Vernon Hill, IL 60061
800-621-5488
Solarol

David Adamson Editions
406 7th Street N. W. at D
Washington, DC 20004
202-347-0090
High-quality Iris prints on artist paper

American Printing Equipment
and Supply Company
42-25 Ninth Street
Long Island City, NY 11101
718-729-5779
Professional brayers

Dick Blick
P. O. Box 1267
Galesburg, IL 61402
800-447-8192
Art supplies, including Shiva oil sticks

Calumet
890 Supreme Drive
Bensenville, IL 60106
800-225-8638
Photographic and studio equipment

Columbus Camera
55 East Blake Avenue
Columbus, OH 43202
614-267-0686
614-267-5526 fax
Equipment, outdated films, Time-Zero film

Daylab Corporation
400 East Main Street
Unit E
Ontario, CA 91761
800-235-3233
Slide printers

Freestyle Catalog
5124 Sunset Boulevard
Los Angeles, CA 90027
800-292-6137
Film, including duplicating film; photographic equipment and supplies

Gara Gear (MC Photographics)
2235 Harris Circle
Cleveland, TN 37311
615-339-1898
Filter folders, padded gear for photographic equipment

Graphic Center
P. O. Box 818
Ventura, CA 93002
805-383-6864
Hard-to-find equipment, used Polaroid equipment

The Jerry Catalog
P. O. Box 1105
New Hyde Park, NY 11040
800-827-8478
Art supplies, silk for transfers

Light Impressions
439 Monroe Avenue
P. O. Box 940
Rochester, NY 14607
800-828-6216
800-828-5539 fax
Archival supplies, books, framing needs, Perma-Life copier paper

Luminos Photo Corporation
5 Wolffe Street
P. O. Box 158
Yonkers, NY 10705
800-431-1859
FotoSpeed toners; Multigrade developers; Photographic papers, especially for handcoloring; Silverprint

Marshall Manufacturing Company
701 Corporate Woods Parkway
Vernon Hill, IL 60061
800-621-5488
Oil paints and pencils, P.M. solution, pre-coating sprays

New York Central Fine Art Supplies
62 Third Avenue
New York, NY 10003
800-950-6111
Art supplies, including Shiva paint sticks; artist papers; quality brayers at reasonable prices

Pearl Paint
308 Canal Street
New York, NY 10013
800-221-6845
Art supplies

Photographers' Formulary
P. O. Box 950
Condon, MT 59826
800-922-5255
406-754-2896 fax
Chemistry for photographers and printmakers

Polaroid Corporation
575 Technology Square
Cambridge, MA 02139
617-386-2000
Main offices

Polaroid Express
800-343-5000
Customer service provides product and technical information to facilitate ordering

Polaroid Laser Print Service
P. O. Box 911
El Segundo, CA 90245
800-421-1030
Laser copies of Time-Zero prints

Rockland Colloid Corporation
302 Piermont Avenue
Piermont, NY 10968
914-359-5559
Liquid Light

Daniel Smith
4150 First Avenue South
Seattle, WA 98124
800-426-6740
Art supplies, artist papers

Publications

Polaroid's Test Magazine
575 Technology Square
Cambridge, MA 02139
800-225-1618
Professional information on Polaroid equipment and films

Shutterbug magazine
5211 South Washington Avenue
Titusville, FL 32780
407-268-5010
407-267-1894 fax
Helpful articles and classified section for photographers

INDEX